# HISTORIC PHOTOS OF
# THE OPRY.

## RYMAN AUDITORIUM. 1974

PHOTOGRAPHY AND TEXT BY JIM MCGUIRE
FOREWORD BY GARRISON KEILLOR
OPENING REMARKS BY MARTY STUART

**TURNER**
PUBLISHING COMPANY
NASHVILLE, TENNESSEE    PADUCAH, KENTUCKY

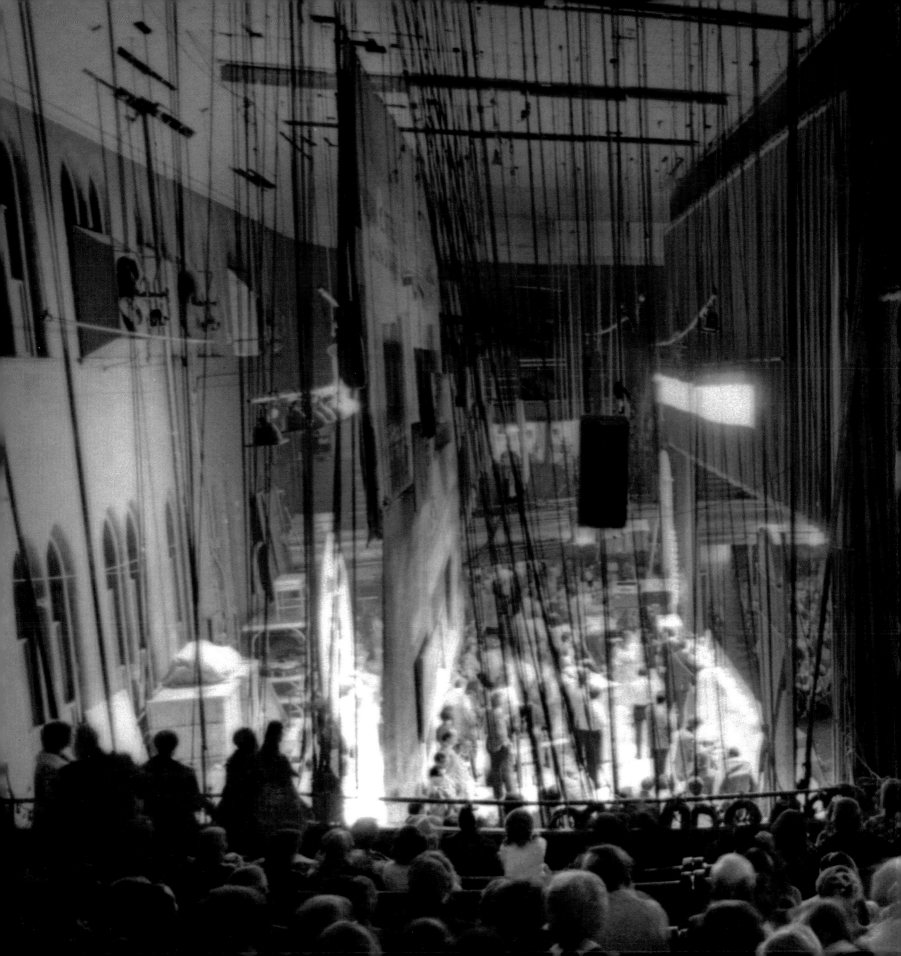

# HISTORIC PHOTOS OF
# THE OPRY

## RYMAN AUDITORIUM 1974

*Preceding Spread:* This view of a packed Saturday night performance is something that few who attended the Opry ever saw. It was shot from the last row in the balcony. These seats were not considered choice, but they provided the unsuspecting viewer a unique vantage point. Only from this angle could you see what was happening onstage, and backstage as well. Many times, what was going on backstage was far more interesting. The ropes were used to raise and lower the huge canvas backdrops, which were changed during different segments of the show to reflect who was sponsoring that portion of the broadcast.

Turner Publishing Company

200 4th Avenue North • Suite 950          412 Broadway • P.O. Box 3101
Nashville, Tennessee 37219          Paducah, Kentucky 42002-3101
(615) 255-2665          (270) 443-0121

www.turnerpublishing.com

*Historic Photos of the Opry: Ryman Auditorium 1974*

Copyright © 2007 Turner Publishing Company

Library of Congress Control Number: 2007929600

ISBN-13: 978-1-59652-373-9

Printed in the United States of America

07 08 09 10 11 12 13 14—0 9 8 7 6 5 4 3 2 1

# Contents

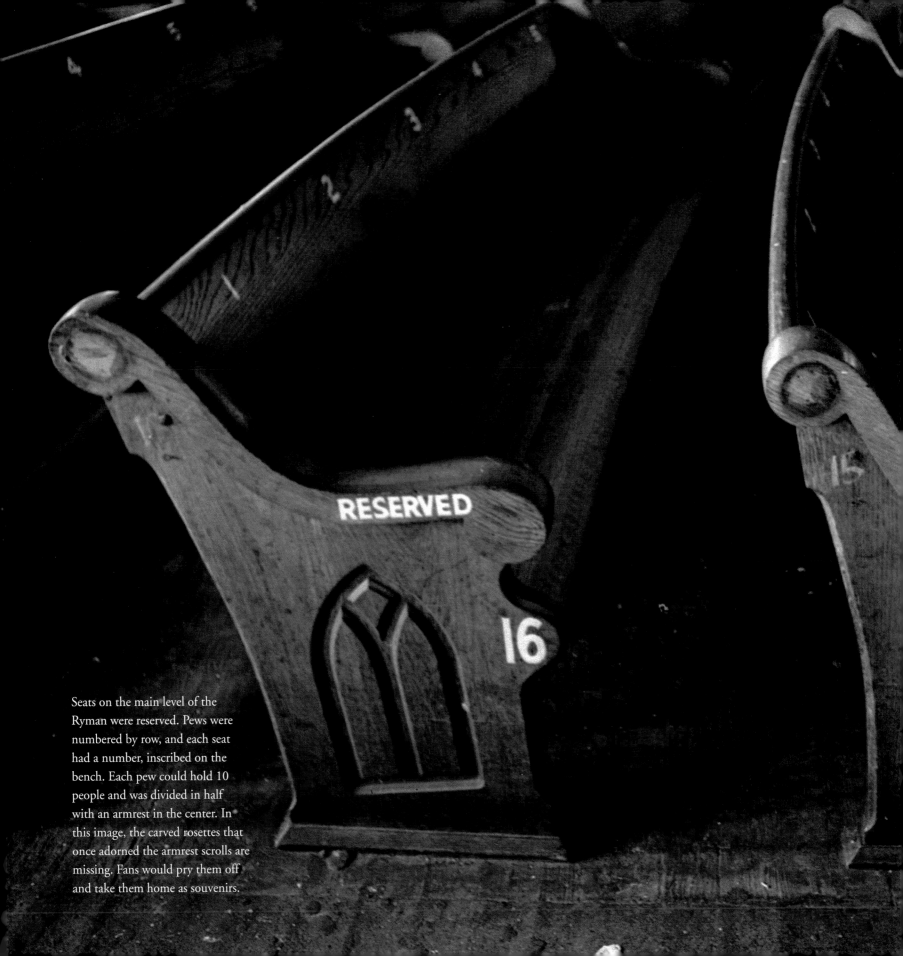

Seats on the main level of the Ryman were reserved. Pews were numbered by row, and each seat had a number, inscribed on the bench. Each pew could hold 10 people and was divided in half with an armrest in the center. In this image, the carved rosettes that once adorned the armrest scrolls are missing. Fans would pry them off and take them home as souvenirs.

# ACKNOWLEDGMENTS

This collection of images is a very nice little slice of an important part of Nashville's long musical history. I would like to thank some folks who share that common belief and who all put their personal stamp on this book. This could not have happened without you.

First, to the folks at the Opry: To Hal Durham, who was kind enough to give me his blessings, allowing me to hang out backstage and record those remarkable final Ryman performances. Also to Steve Buchanan, Melissa Fraley Agguini, and Brenda Colladay, who embraced these images from day one. A special thanks to Brenda, Les Leverett, and Charlie Collins for helping me tell the truth. I wish I had kept better notes.

Also thanks to Todd Bottorff, Gene Bedell, and Megan Latta at Turner Publishing for caring enough about Nashville and its rich history to publish this work. A special thanks to Megan for all the extra time and care she put into this project. And to Todd for going the extra mile to make it look great.

A big thanks to Garrison Keillor for being at the Opry that last night and for writing so beautifully about it. And for finding the time to give us some new thoughts on that experience, some thirty years later.

Also very gratifying is to have my old friend Marty Stuart on board. Thanks, Marty, for your friendship and a shared love of music and photography through the years.

Thanks also to Wendi Chapman for keeping me between the ditches, once more.

And a special thanks to Diesel and Django for all you do for me each day.

—JIM MCGUIRE

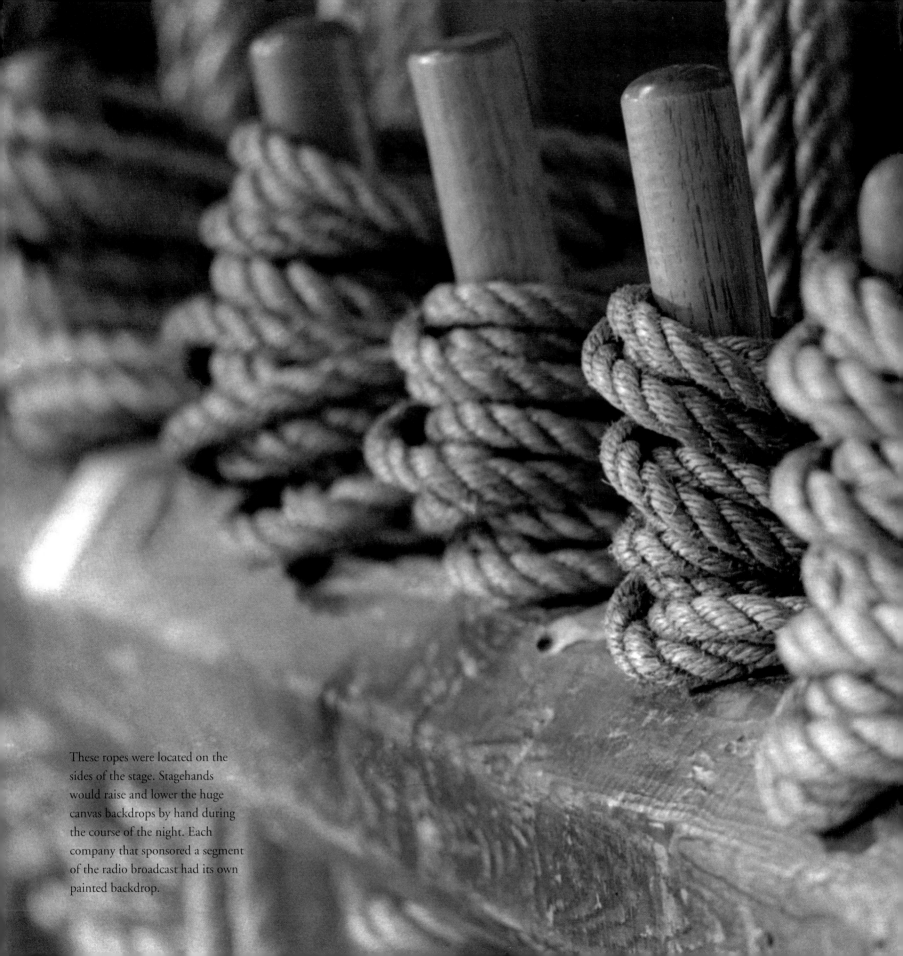

These ropes were located on the
sides of the stage. Stagehands
would raise and lower the huge
canvas backdrops by hand during
the course of the night. Each
company that sponsored a segment
of the radio broadcast had its own
painted backdrop.

# FOREWORD

The Ryman Auditorium is in the old redlight district of Nashville
where riverboat crews and factory men and farmhands came for liquor
and sex. This is important to understand: it wasn't about architecture
down there on lower Broadway, or Southern culture, it was about
feeling loose and easy and finding a woman to be loose and easy with.
So it was natural for Captain Tom Ryman, a famous sinner who had
come forward and repented at one of preacher Sam Jones' revival
services, to choose that neighborhood to build his Union Gospel
Tabernacle. A man does like a challenge. It opened in 1892, and Mr.
Jones stood in the pulpit and preached against the sins of the flesh
but also against greed. He cried out, "Selfishness! Selfishness! Hell is
selfishness on fire, and the great wonder to me is that some of you don't
catch on fire and go straight to hell by spontaneous combustion. You
love money more than your souls."

The revival business faded in the twentieth century and the
hall turned to entertainment. Wanting people to hear the gospel
clearly, the architect had designed a fine acoustic space, and Caruso
played here and Paderewski, John Philip Sousa, Jascha Heifetz,
tenor John McCormack. The stage was built for the Metropolitan
Opera's production of *Carmen*. Nijinsky danced on it. The New York
Philharmonic played. Nashville was a thriving city, home of Vanderbilt
University, the Athens of the South, and there was an audience here
for classical music. Hillbilly music belonged out in the sticks, to the
itinerant medicine shows that traveled from town to town, amateur
musicians shilling for hucksters peddling some quack medicine. Radio

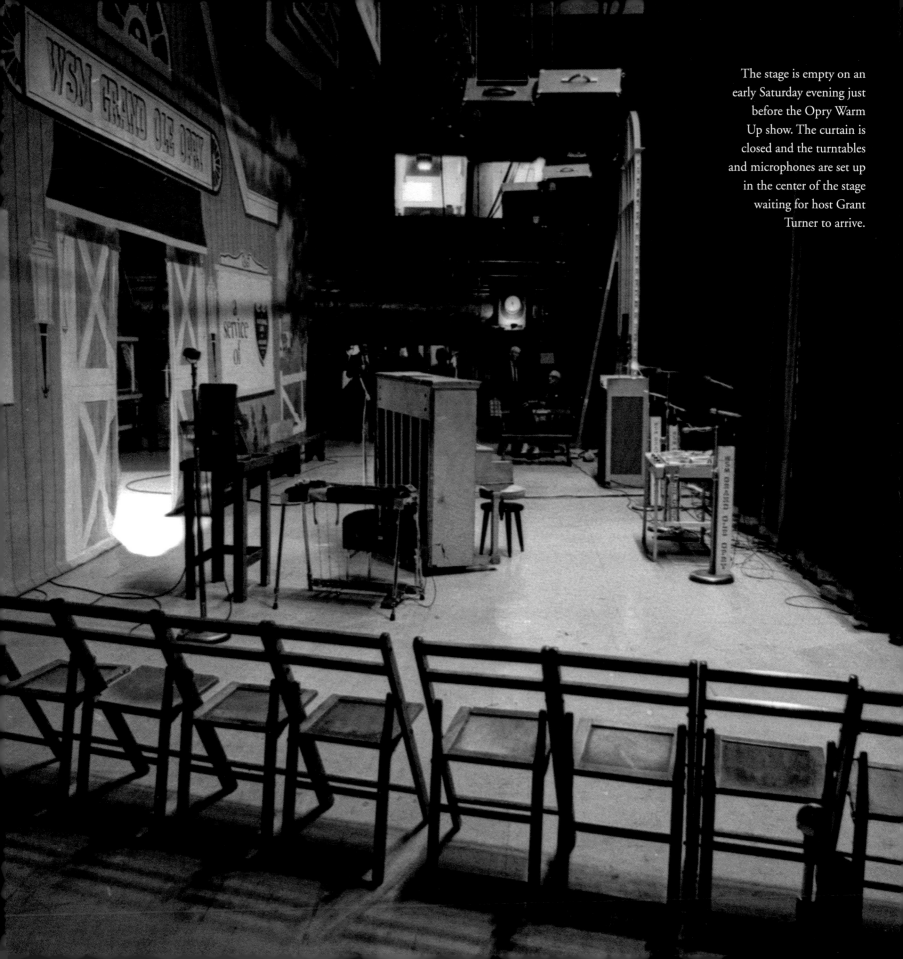

The stage is empty on an early Saturday evening just before the Opry Warm Up show. The curtain is closed and the turntables and microphones are set up in the center of the stage waiting for host Grant Turner to arrive.

changed that, and the phonograph, of course. The music got onto discs, and it was electrifying for southern rural people to hear performers on records and on the radio who sounded like them.

WSM (We Shield Millions), the radio voice of the National Life & Accident Insurance Company, started "The Grand Ole Opry" in 1925 and it moved into the Ryman in 1943. On June 11, 1949, Hank Williams made his debut, singing "Lovesick Blues." Opry announcer Grant Turner remembered looking into the audience that night:

> It was sort of smoky, although we had a no-smoking rule. It seemed as if the whole audience was just covered with a sort of blue haze, with him standing out there in the spotlight, and looking like he was suspended above the microphone. You got the impression that there was a coat hanger in his back attached to a rope strung to the ceiling . . . And how he worked that audience!

Minnie Pearl said, "He had real animal magnetism. He destroyed the women in the audience. And he was just as authentic as rain."

Loretta Lynn made her debut on October 15, 1960, singing "I'm a Honky Tonk Girl." She wrote:

> Ernest Tubb introduced me. I was on the Pet Milk part of the show. And I bought this dress to wear it was real thin and had big puffed sleeves. It looked like a party dress. Lester Wilburn's wife cut my hair and got me ready. I remember going out on the stage and I remember tapping my foot. I was so scared I don't remember anything else.

The Opry left in 1974 for the suburbs but music fans kept coming by to commune with the ghosts. They wanted to come inside and look around, though the building had been left to molder, with big holes in the roof, and to be torn down, but the persistent curiosity of ordinary people persuaded WSM to open up the place for tourists and eventually to renovate it as a concert venue and TV studio. The Ryman reopened for business in 1994. One of the first shows to play in the renovated hall was *A Prairie Home Companion,* which was sweet, seeing as the show was conceived at the Ryman while watching the Opry's last show there, or what was thought at the time to be the last—the Opry has since returned part-time—and writing a story about it for the *New Yorker.*

Grandpa Jones was on that show, and Roy Acuff, Stonewall Jackson, Wilma Lee and Stoney Cooper, Bobby Bare, the Osborne Brothers, Jim and Jesse, Jim Ed Brown, and a flock of others, in a show somewhat overshadowed by the fact that President Richard M. Nixon would be in Nashville the next day for the first Opry show at Opryland. He was up to his

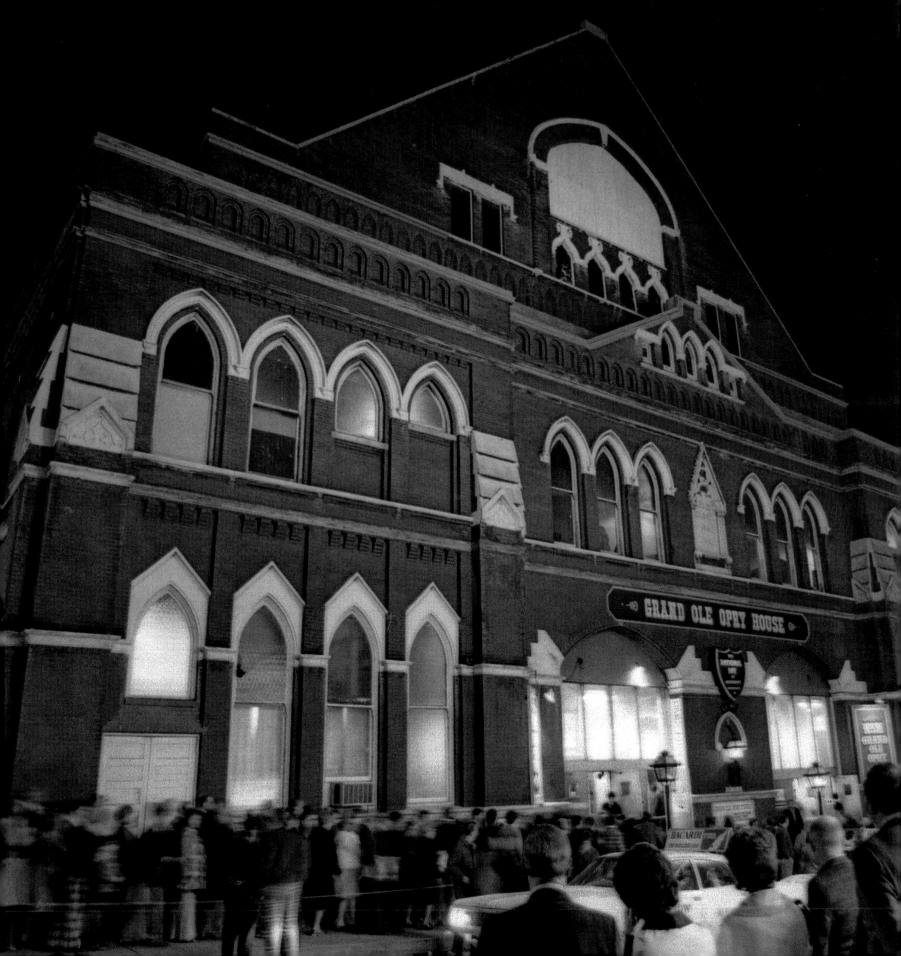

eyebrows with Watergate and looking for a friendly audience, which of course he would get at the Opry. So the March 15 broadcast was low-key, as I recall. I rambled around backstage talking to Fiddlin' Sid Harkreader and Grant Turner and Mr. Acuff and sat in the broadcast booth, a makeshift affair in the balcony, and up there it occurred to me that a person could go and do a radio show of this sort back in Minnesota if he wanted to. And so on July 6, 1974, we did the first live broadcast of *A Prairie Home Companion* at Macalester College in St. Paul. Tickets cost $1 for adults (50 cents for children), and the audience of 12 produced a modest gate, but we were persistent, and we still are.

And so is country music, which seemed sort of marginal in 1974. It has blossomed into alternative country, acoustic music, roots music, bluegrass, call it what you like, but you know it when you hear it. It welcomes you in to the circle as it did me on that rainy March night and I've stuck around ever since.

—GARRISON KEILLOR

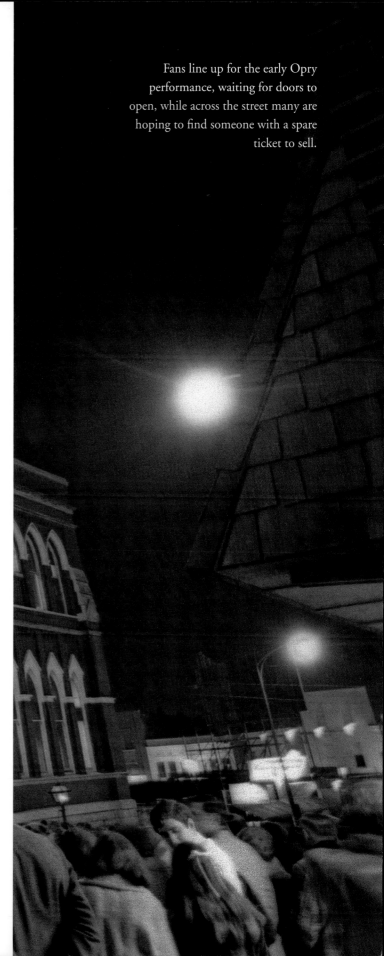

Fans line up for the early Opry performance, waiting for doors to open, while across the street many are hoping to find someone with a spare ticket to sell.

Photo Courtesy of John Nikolai

# Of Time and Lightning

In the early 1970s, Elliston Place in the west end served as Nashville's bohemian zone. It was an atmosphere that welcomed free-wheeling musical adventurers, poets, visual artists, comedians, songwriters, and recovering country singers and pickers who were looking for a new life following the Hillbilly Hollywood days of Nashville's fiddle-and-steel 1960s.

As Waylon Jennings stated, "The Hank Williams syndrome was dead." The question of the moment hinged on a line in Waylon's song "Are You Sure Hank Done It This Way?" He asked, "Where do we take it from here?" After countless seasons of corporate rule, the Music Row establishment had been momentarily overthrown by way of Willie, Waylon, Tompall Glaser, Jessi Colter, Captain Midnight, Cowboy Jack Clement, and Billy Joe Shaver's "Outlaw Movement." A renaissance was in the air and artistic freedom was the new law. Time has proven those days to be the closest Nashville has come to realizing its full creative potential. Elliston Place was the playground for all that potential and the people that the Outlaw Movement attracted.

The centerpiece of it all was a musical listening room called the Exit Inn. It was a sketchpad for all things creative. The first time I walked into the Exit Inn I was immediately taken by a beautiful collection of high-concept black-and-white portraits. Images of Doc Watson, Steve Young, Vassar Clements, Tut Taylor, and John Hartford hung over the bar. It was there and then that I discovered the work of Jim McGuire. I remember thinking "The whole world is in color and this man dreams in black and white. How fantastic." It was comforting. His work stood like the grounding force of an oak tree in the midst of calamity. They were quiet, stately images, and even in their silence they read like a letter from home.

Beyond the iconic imagery, I felt the presence of a pure artist, a visionary, a new world master. It impressed me that Jim McGuire had arrived in town with a camera and enough sensibility to use it to give visual appeal to the movement at hand. He championed this crossroads moment.

Photo Courtesy of Mark Tucker

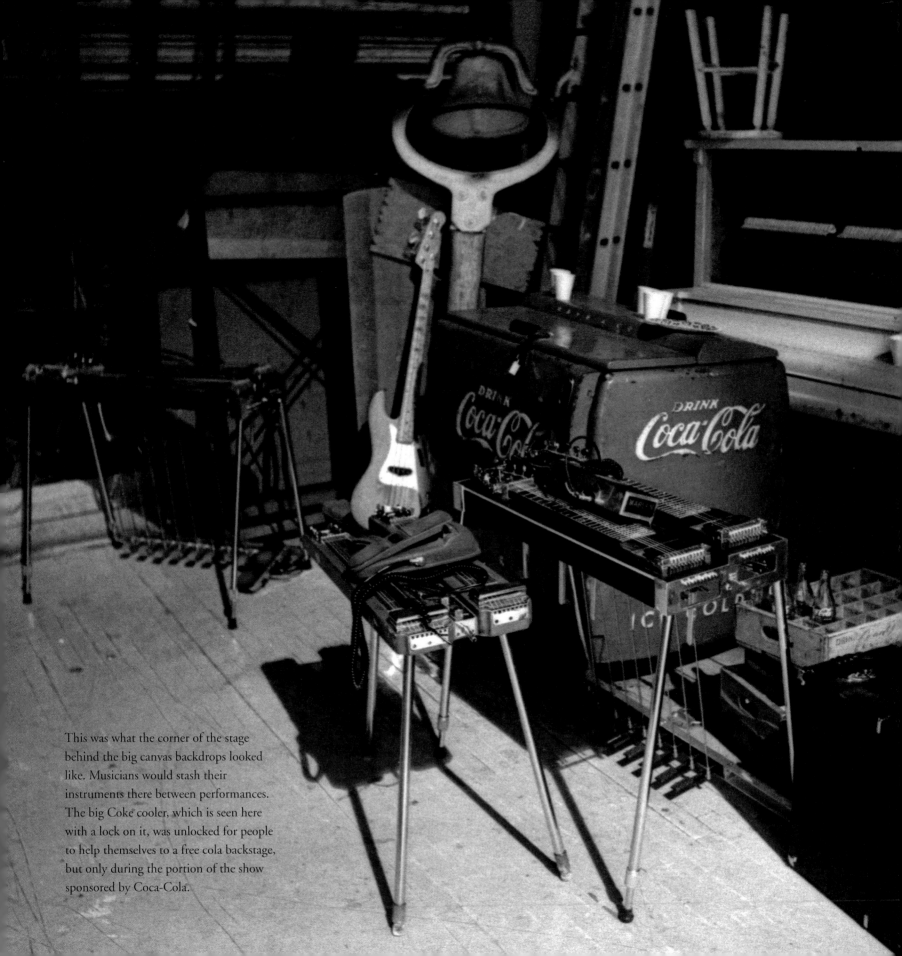

This was what the corner of the stage behind the big canvas backdrops looked like. Musicians would stash their instruments there between performances. The big Coke cooler, which is seen here with a lock on it, was unlocked for people to help themselves to a free cola backstage, but only during the portion of the show sponsored by Coca-Cola.

However, at the same time, he showed just as much regard for the roots that reached back into country music's past and beyond. McGuire's style parallels classic country music. He is anchored in tradition. His portraits are earthy, lyrical, soulful, and deceptively simple. They live on as straightforward sonnets that hit the heart like a Jimmie Rodgers song or one of Earl Scruggs' banjo solos. I call it accessible genius.

The first time I saw Jim's portrait of the Ryman Auditorium with lightning flashing above, it was hanging on Roy Acuff's wall. I remember saying to Mr. Acuff, "That's Jim McGuire's work, I know it is, and that's going to be his masterpiece." The King of Country Music responded, "I don't give a damn about that building, but I like that picture." McGuire's Ryman speaks. The image not only captures the emotion of the final days of the Grand Ole Opry at the Mother Church. It somehow sums up the end of an age, not just country music's but perhaps America's as well. I've often wondered if the water falling down from the sky was really rain or if perhaps it was tears.

Rain, tears, lightning, the echoes of a thousand Saturday nights, dead guitar strings, steel guitars, Hank songs, train whistles, fiddle tunes, faded rhinestone suits, and a vision of the grim reaper marching toward the Ryman with a wrecking ball in his hands, are but some of the things that danced across my mind when I stood on the steps of the old building twenty years after Jim McGuire created the portrait on the cover of this book. The occasion was the ribbon-cutting ceremony in which I participated to re-open the Ryman's doors to the world. It was a day of celebration, a victory. The Mother Church of Country Music had been rescued and given a new life.

While standing on those steps, listening to the speeches of various city officials, I could almost see the ghost of a lone photographer crouched down in the front seat of his 1955 Buick Special in the midst of a late-night thunderstorm at the outer banks of Captain Tom Ryman's church, camera ready, looking for magic.

Then, God clapped his hands and out of the darkness the lightning flashed . . . and McGuire caught it.

### —MARTY STUART

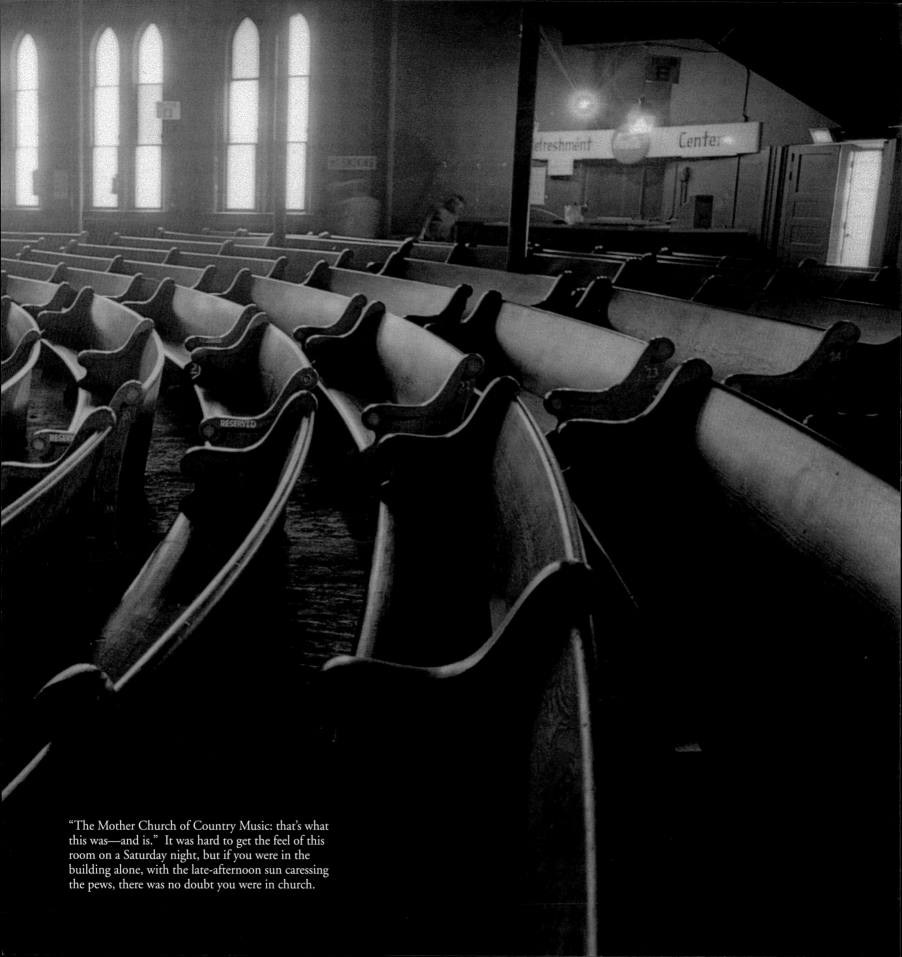

"The Mother Church of Country Music: that's what this was—and is." It was hard to get the feel of this room on a Saturday night, but if you were in the building alone, with the late-afternoon sun caressing the pews, there was no doubt you were in church.

# INTRODUCTION

In 1972, I moved to Nashville to produce records. I had been living in New York, shooting album covers, playing music in a little hillbilly band for fun, and I had just produced an album for a young Dobro player by the name of Mike Auldridge. Like most everyone moving to Nashville, I wanted to be near the music.

Well, I never did become a record producer. Instead, I got sidetracked by the photography business. During those early years, I found myself mis-spending a good deal of my time on Lower Broadway. If you were lucky, you could see Waylon or Willie or Kristofferson onstage at Tootsie's . . . catch a free midnight Jamboree at Tubb's Record Shop any Saturday night after the Opry . . . grab a cheap meal and run into John Hartford at Linebaugh's . . . play pinball with the Pinball Lady in the lobby of the Merchants Hotel . . . or catch a jam session at the Demon's Den where the best steel players in the world would come sit in with one another. It was alive and it was magic.

And then there was the Opry. Right there. Three bucks got you in. Best money I ever spent. I enjoyed many unforgettable nights in that old building, but finally the rumors started. Opryland was being built and people were talking about tearing down the Ryman once the Opry moved to the suburbs. One night, I cranked up enough nerve to ask Opry manager Hal Durham for permission to start photographing the remaining shows. Actually, it was just an excuse to get backstage. The images in this book, printed from negatives sitting in my darkroom for the last thirty-three years, are a pretty good record of what went on in that building those last months. Thanks to you Mr. Durham and to all those wonderful performers who made those last shows so memorable.

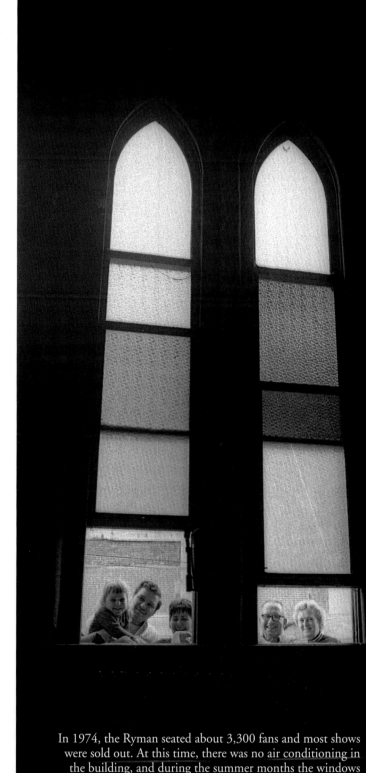

In 1974, the Ryman seated about 3,300 fans and most shows were sold out. At this time, there was no air conditioning in the building, and during the summer months the windows were left open for ventilation. Not only did this allow fresh air to flow in but also it allowed music to flow out into the streets. Fans who couldn't get tickets would often take in the show through the windows, free of charge.

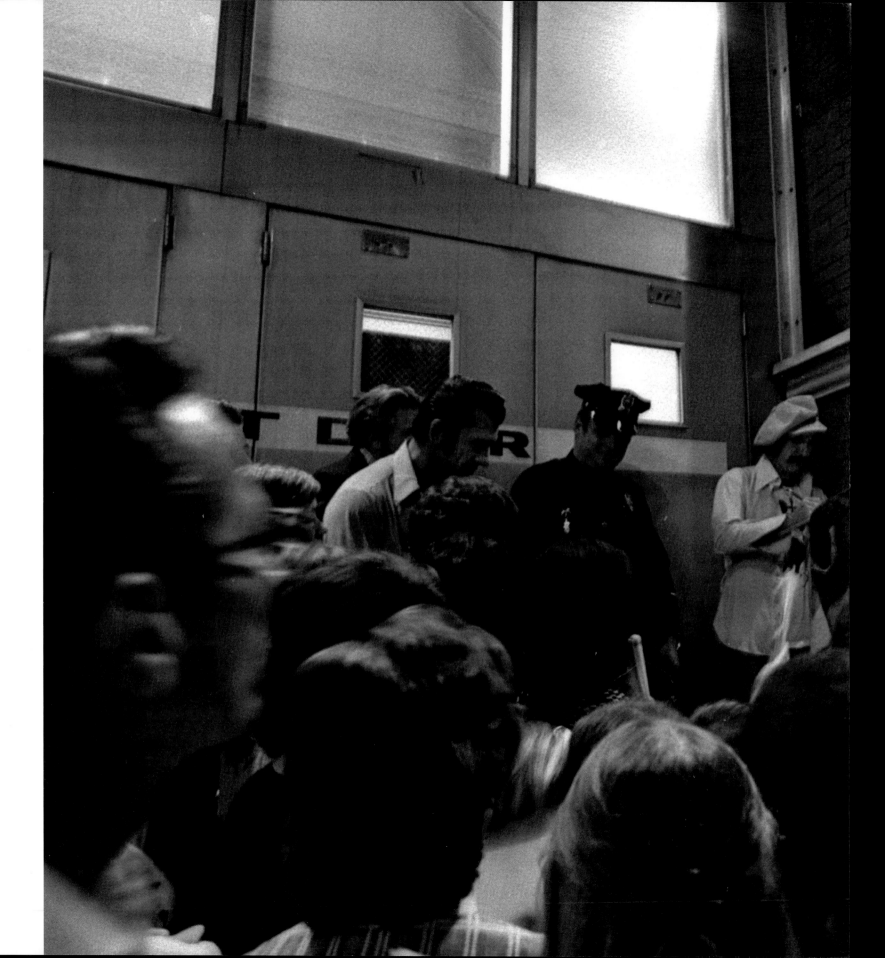

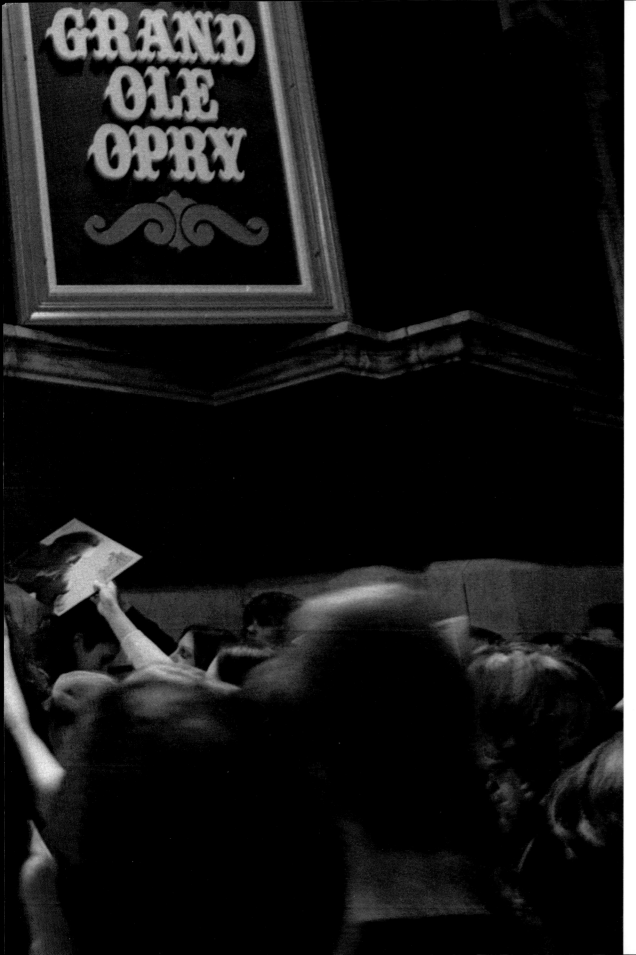

*Marty Robbins Signing*
The front steps of the Ryman on a typical Saturday night. Here Marty Robbins, in white hat, signs autographs for fans. He was one of the most popular performers and loved meeting the fans as much as they loved meeting him. It wasn't unusual for him to spend an hour or two with the fans after the show.

*Onstage*
This was the view that greeted performers as they walked from their dressing rooms toward the stage. The scene was very informal, with musicians, family, and friends all milling around. The folding chairs were reserved for the Opry dancers, should they need a rest between performances.

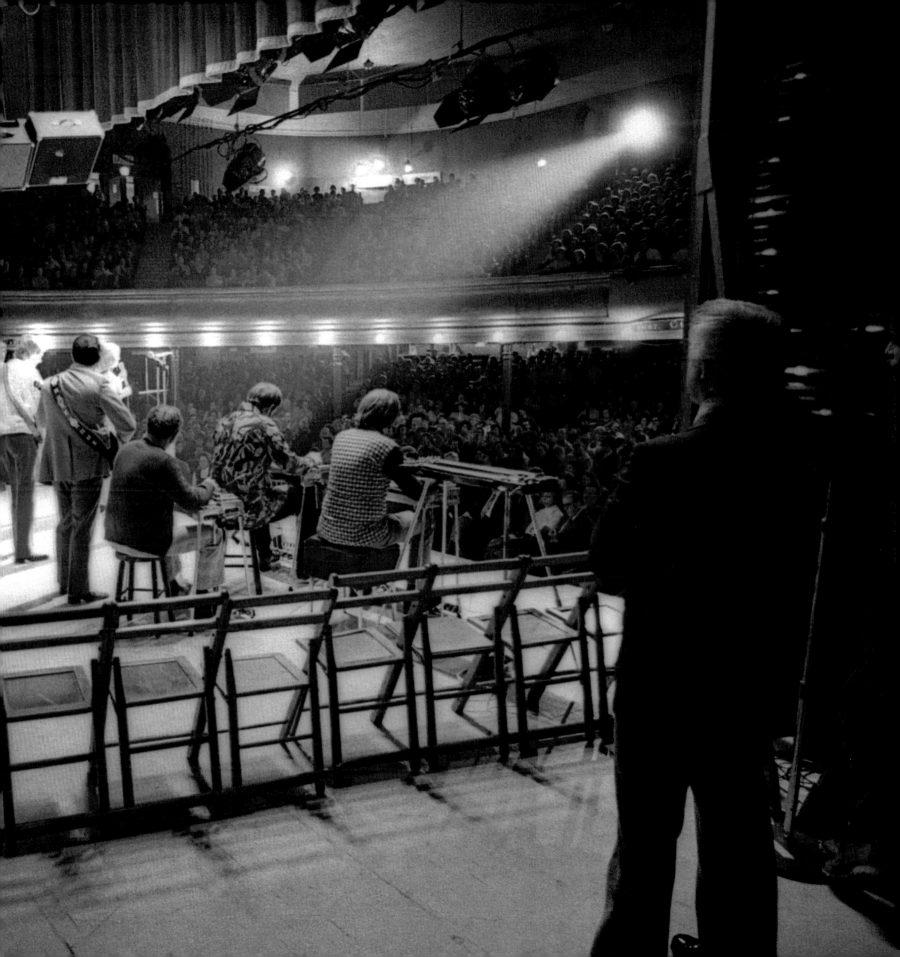

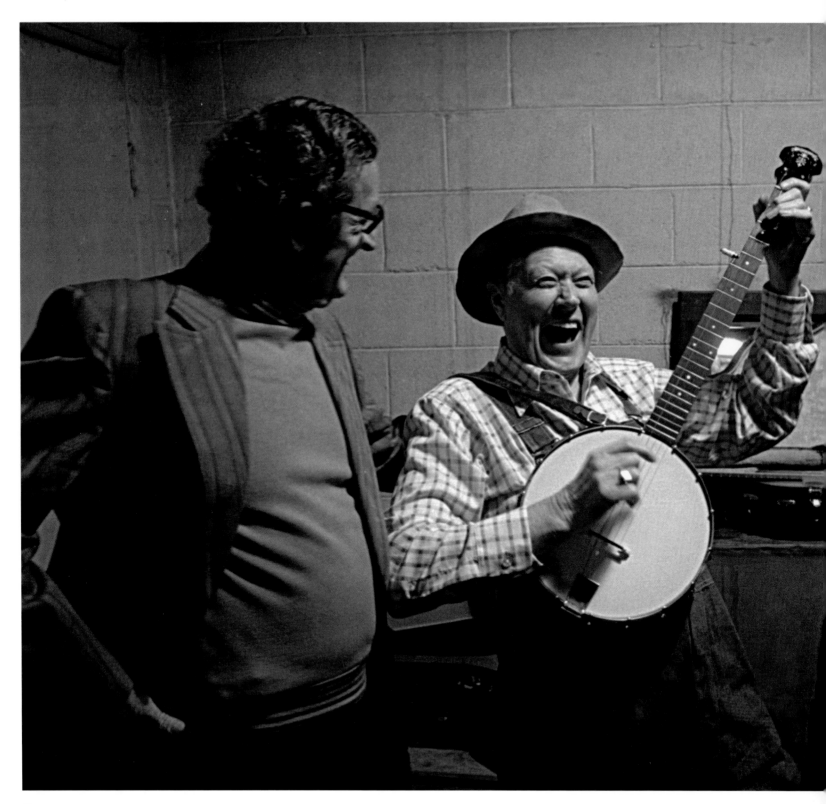

*Brother Oswald*
Bashful Brother Oswald of the Smoky Mountain
Boys breaks into a hilarious old-time song in
Roy Acuff's dressing room between shows, to the
delight of Sam McGee and other guests.

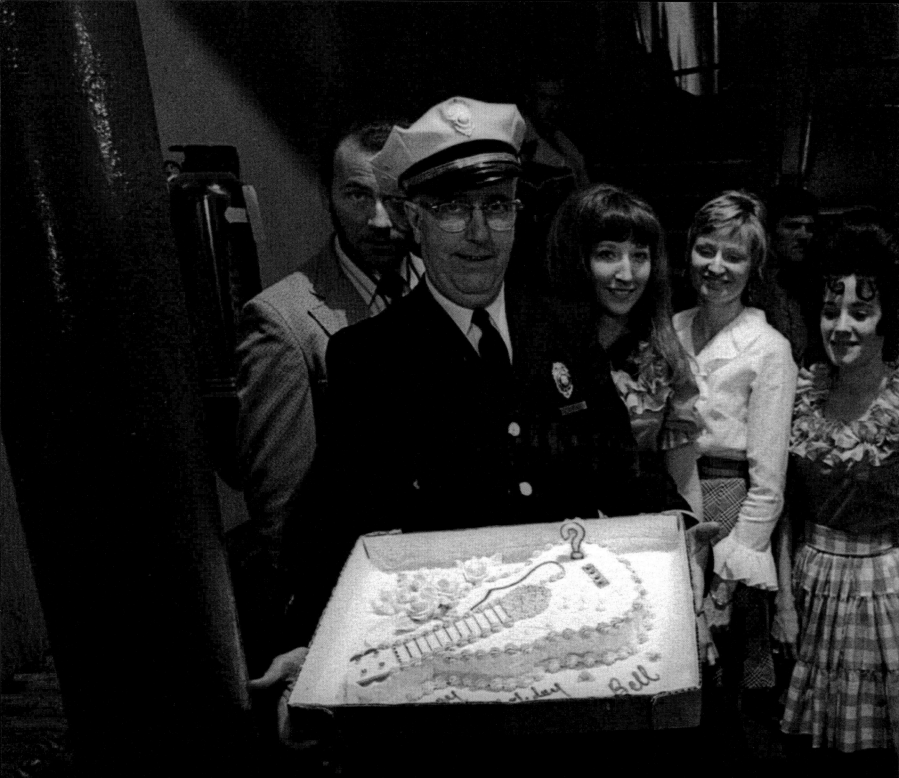

*Birthday Night*

Mr. Bell was the guard at the backstage door and was well liked by everyone. He decided who could come and go through that famous entrance. He had a list of the performers and their guests approved for entry, but sometimes lucky visitors could persuade him to let them stand backstage. On this night, the square dance troupe Tennessee Travelers presented him with a birthday cake.

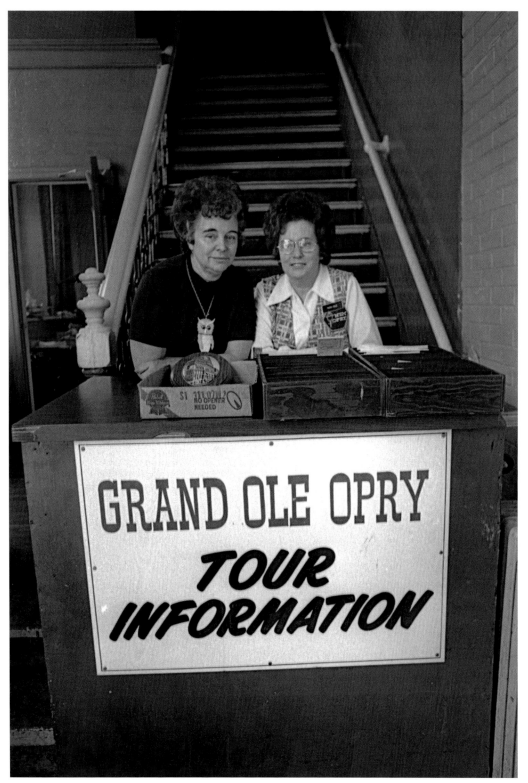

GRAND OLE OPRY
TOUR
INFORMATION

*Ticket Ladies*

Agnes and Ruth were the gals inside the Fifth Avenue entrance who would answer your questions and sell you tickets to tour the Ryman. The building was open during the week for the many tourists who wanted to see the Opry's home and stand on the stage.

10

*Balcony*

This is a view of the Ryman stage during a typical weekend performance. The heavy cables shown provided power for the stage lights. The vantage point is from the balcony—which wrapped all the way around to the back wall of the stage area—next to the console where the radio engineer sat during the live Saturday night radio broadcast. It provided him a clear, uninterrupted view of the entire stage and was strictly off limits to the audience.

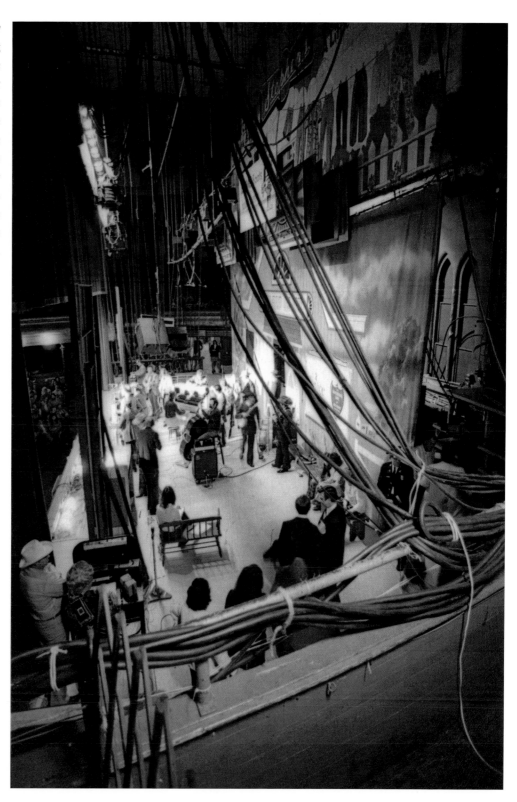

*Roy Acuff's Dressing Room*

In the last years of the Opry at the Ryman, Mr. Acuff had his own private dressing room. It was actually the back room of his museum, dubbed "Roy Acuff's Hobby Exhibit," in a shop that fronted Broadway. The back opened onto the alley across from the Ryman stage entrance and was a good bit larger than the dressing rooms inside the Ryman. The space accommodated the many friends and musicians who required an audience with the "King" of country music. Taking part in this jam session under the watchful eye of Roy Acuff are Howdy Forrester and Kenny Baker on fiddles, Jesse McReynolds on mandolin, and Benny Martin playing guitar.

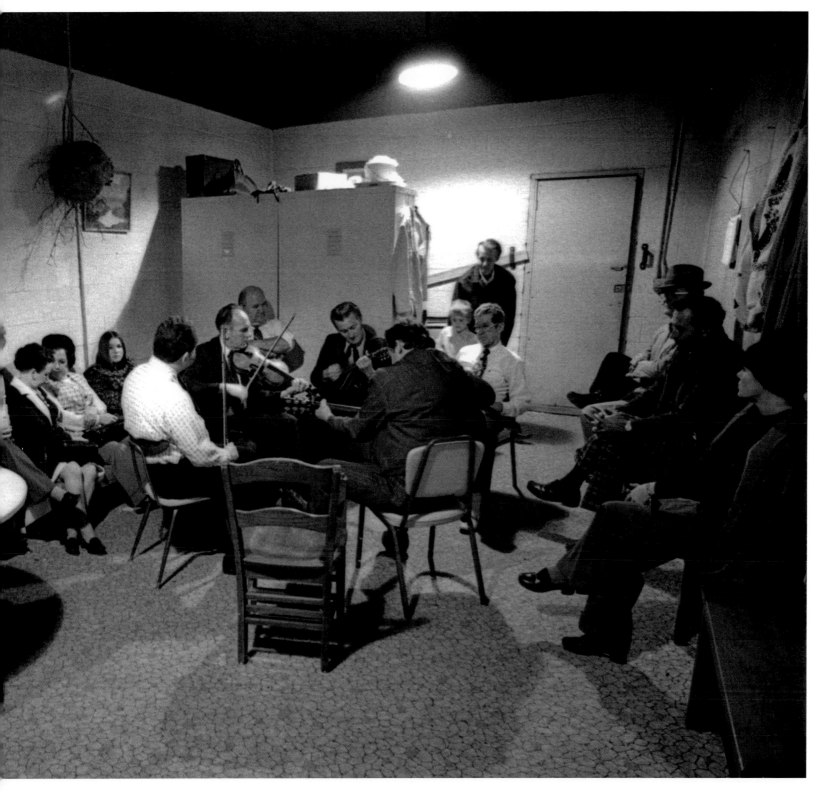

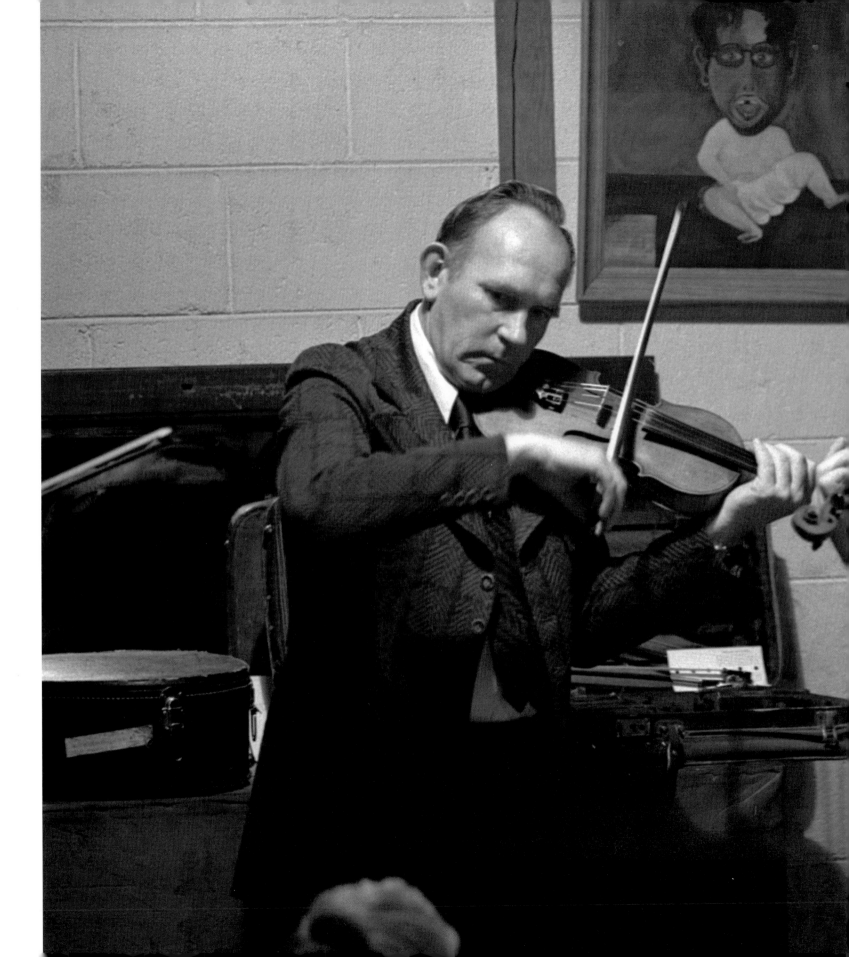

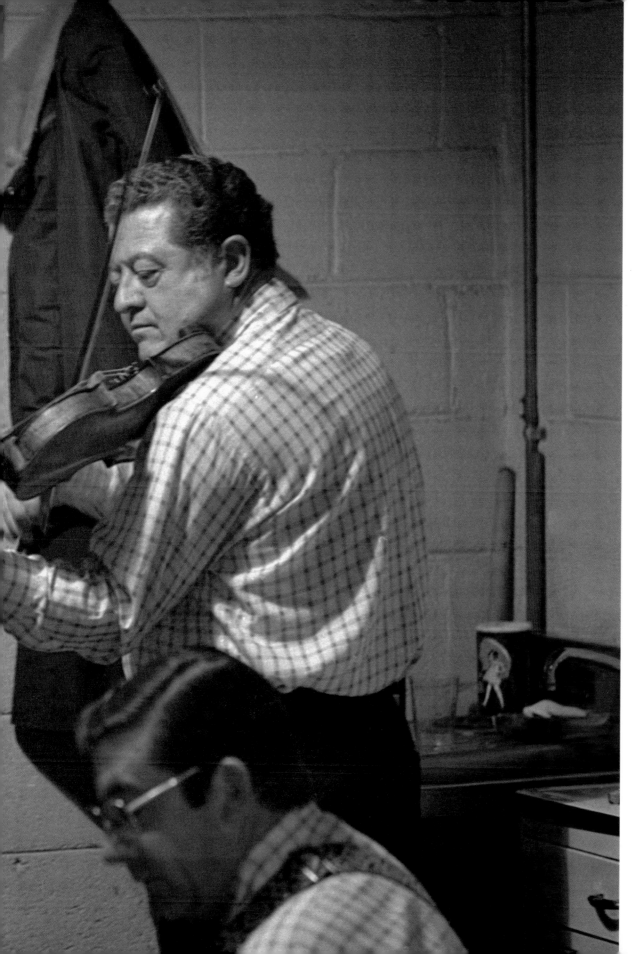

*Kenny Baker and Howdy Forrester*
Roy Acuff's dressing room was the scene of many impromptu jam sessions between Opry performances. Here are two of the most legendary bluegrass masters, Kenny Baker and Howdy Forrester, knocking one off. The unusual painting on the wall, a portrait of Bill Carlisle, was presented to Mr. Acuff by a fan.

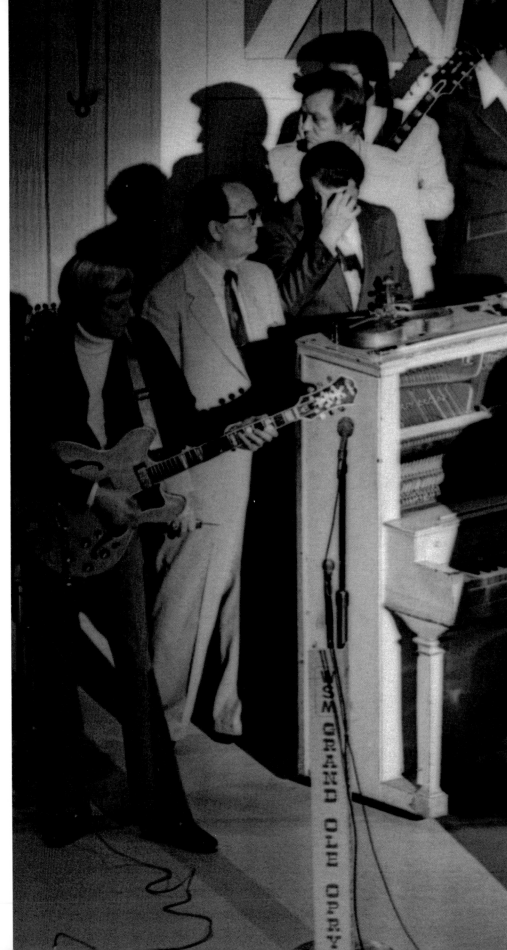

*The Willis Brothers*
Onstage during "Old Timers Night," January 18, 1974, are two of the original Willis Brothers, Guy and Vic, joined by C. W. Mitchell. Also onstage are, among others, Spider Wilson, Herman Crook, Burt Hutcherson, Kirk McGee, Goldie Stewart, and Harold Weakley.

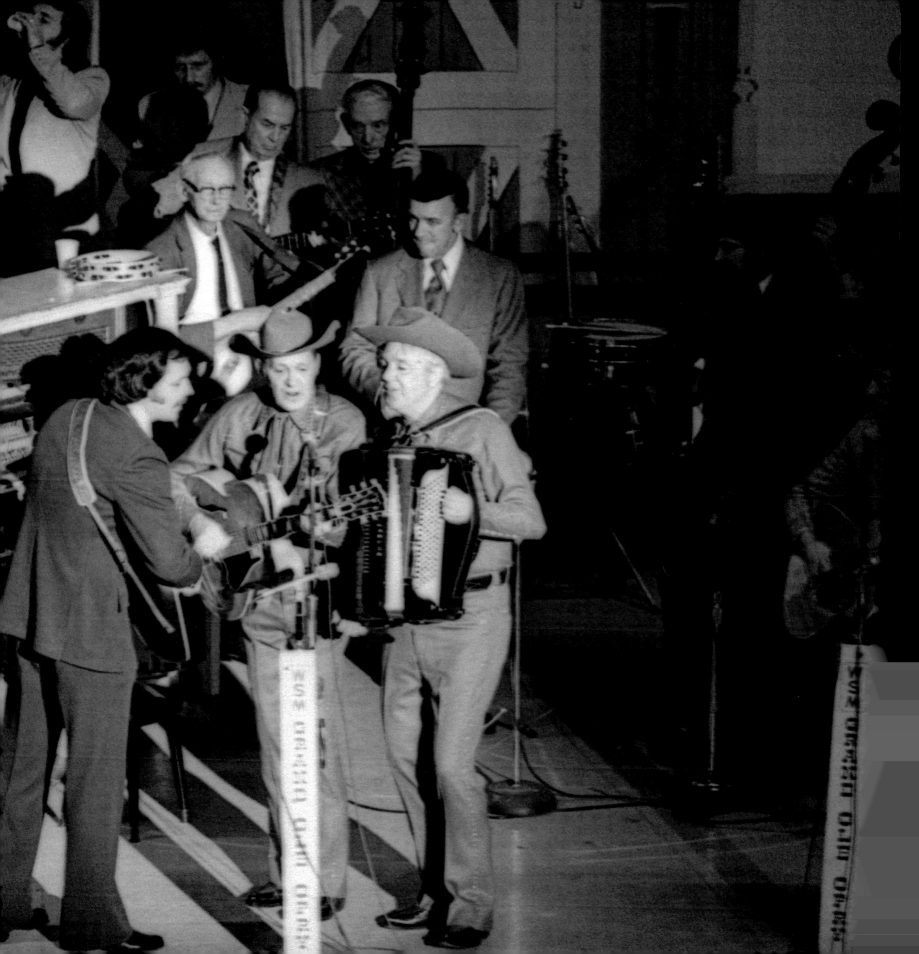

*Refreshment Stand*
These boys ran the refreshment stand on the upper level of the Ryman. They sold soft drinks, hamburgers, and hotdogs. It was a hot job, especially during the summer months.

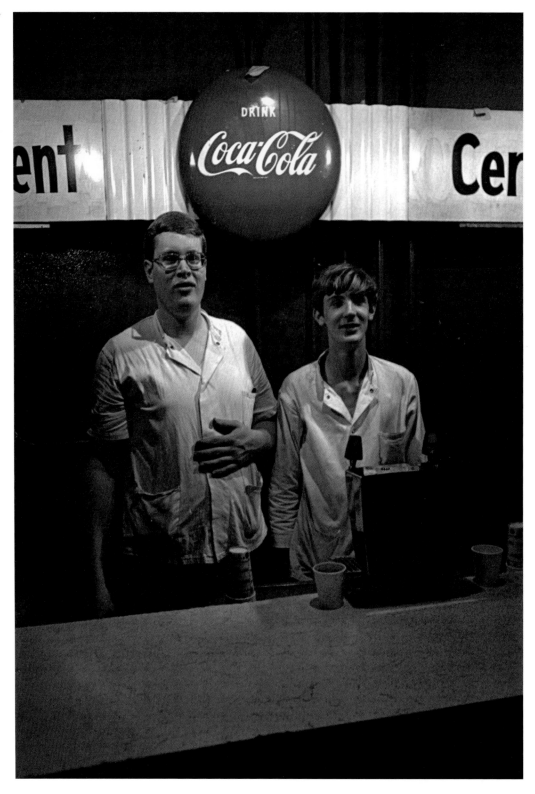

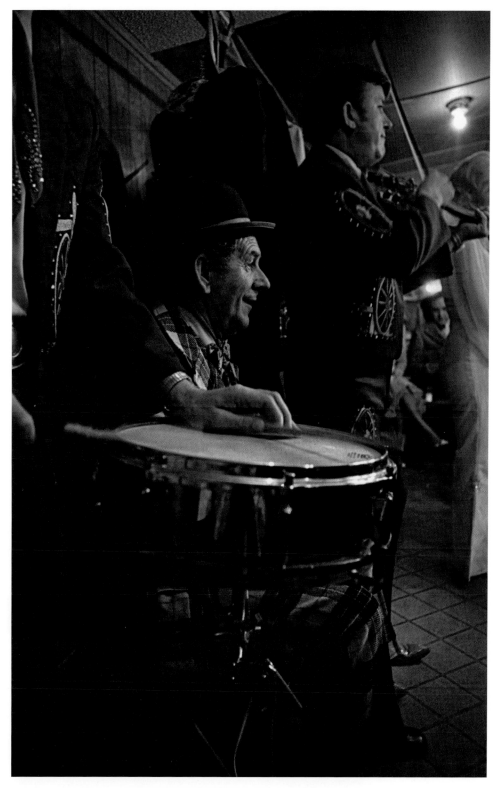

*Speck Rhodes*
Speck Rhodes played bass and was the comedian in Porter Wagoner's band, the Wagonmasters. He wore outrageous plaid suits and a derby and is seen here sitting in the dressing room next to fiddler Mac Magaha between shows.

19

*Sam McGee*
Sam and his brother Kirk grew up on a farm outside Nashville in Franklin, Tennessee. They were a popular fiddle-and-guitar duo and members of the Opry from the early days. Sam was known for his outstanding finger-picking guitar style, which he learned from a black blues musician as a teenager. He died in a tractor accident on his farm about a year after this photo was taken. Here he is saying good night to the audience, with bassist Goldie Stewart on the right.

20

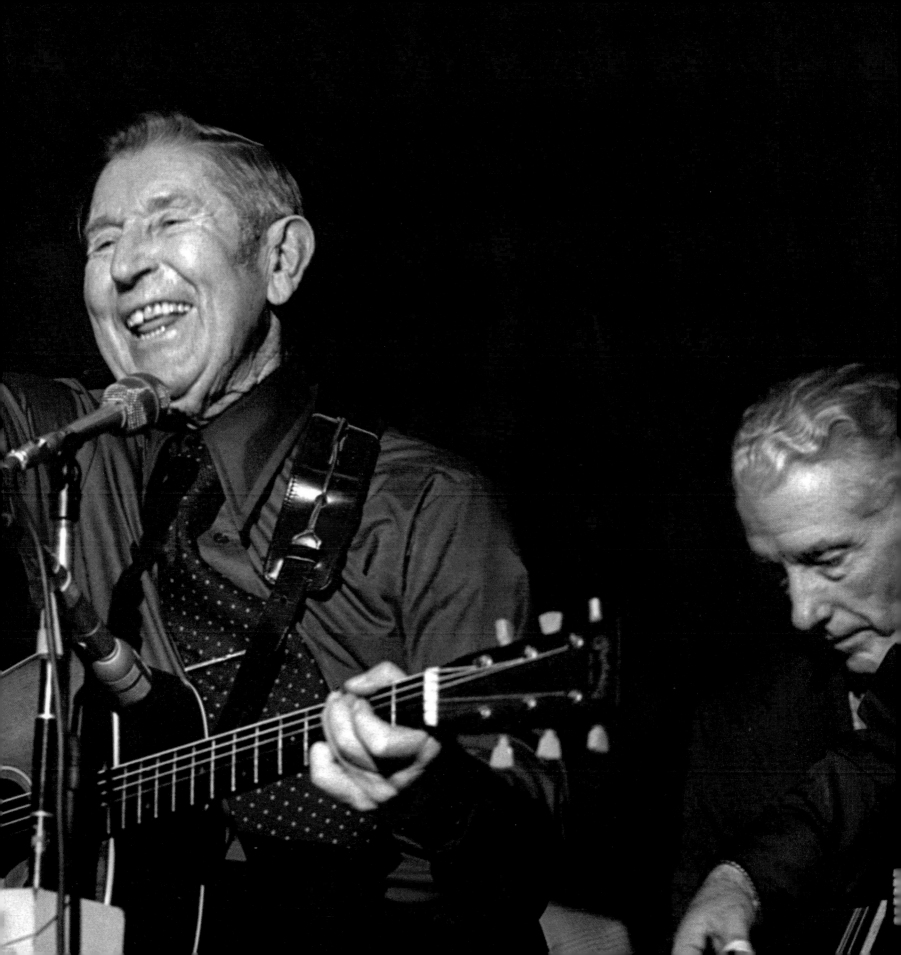

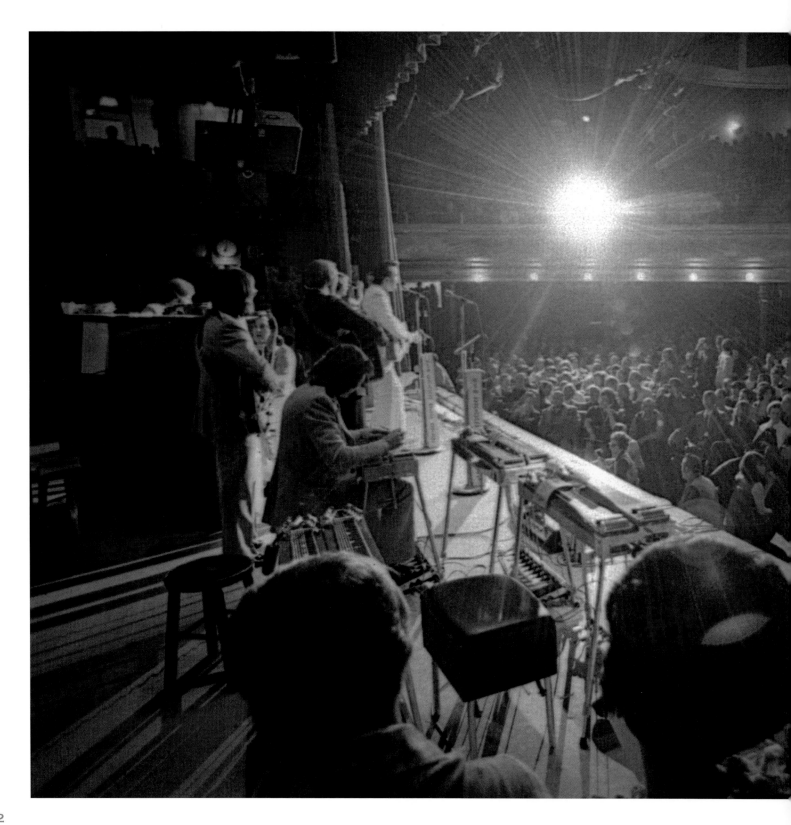

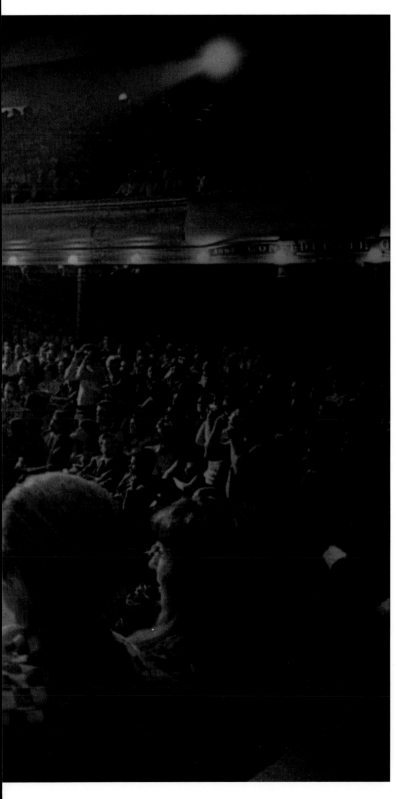

*The Stage*
This is the view from the side of the stage on any given night. Here the square dancers are taking a break and enjoying the show from their seats on the side of the stage while Bill Anderson performs.

*Acuff's Dressing Room*
Charlie Collins, a longtime member of Roy
Acuff's band, the Smoky Mountain Boys,
plays Mr. Acuff a fiddle tune. Although
Charlie is mostly seen playing guitar, he is
a first-class fiddle and mandolin player as
well. My older brother Tom is seated to the
left. He was in town to see some of the final
Opry shows.

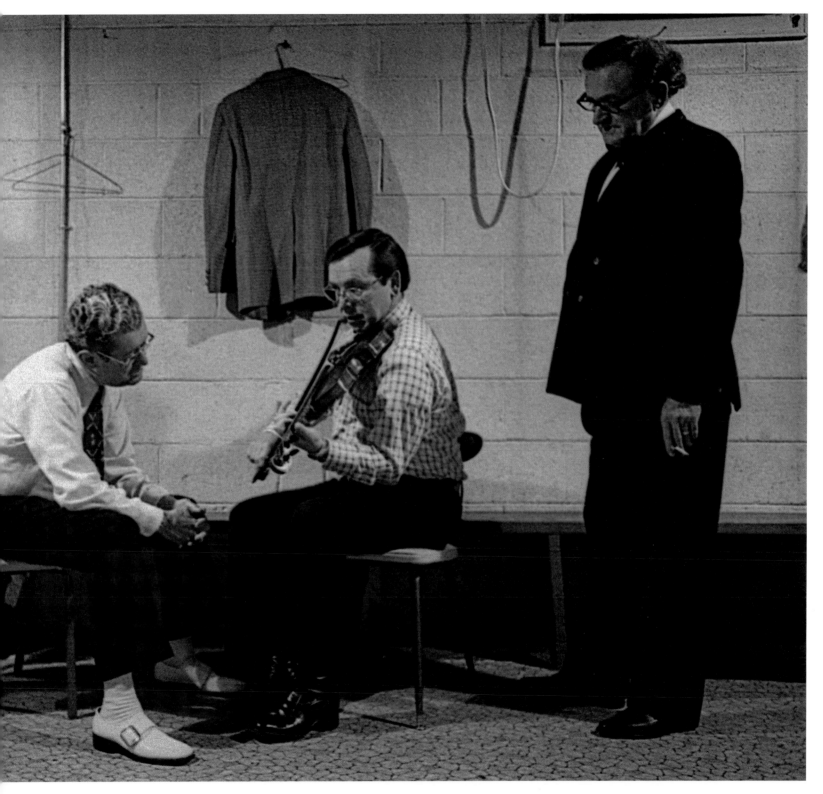

*Big Mon's Case*
This is the case that held Bill Monroe's famous 1923 Gibson F-5 Lloyd Loar mandolin, sitting in one of the dressing rooms. The case was painted in the 1960s by Dobro player and ex–sign painter Tut Taylor, and carries the inscription "Original Bluegrass Since 1927."

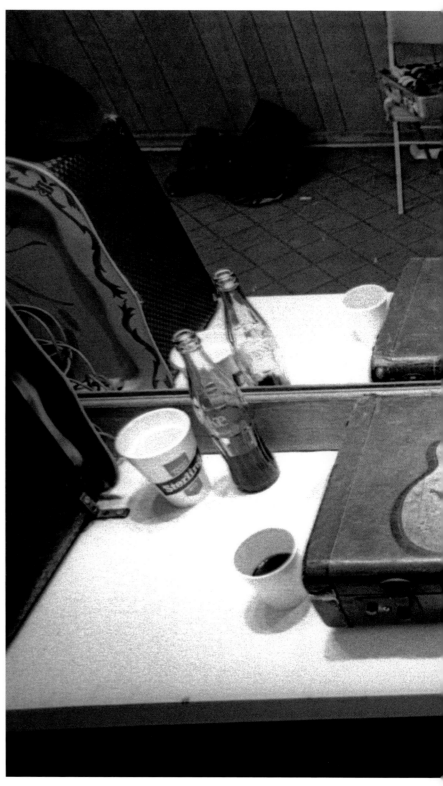

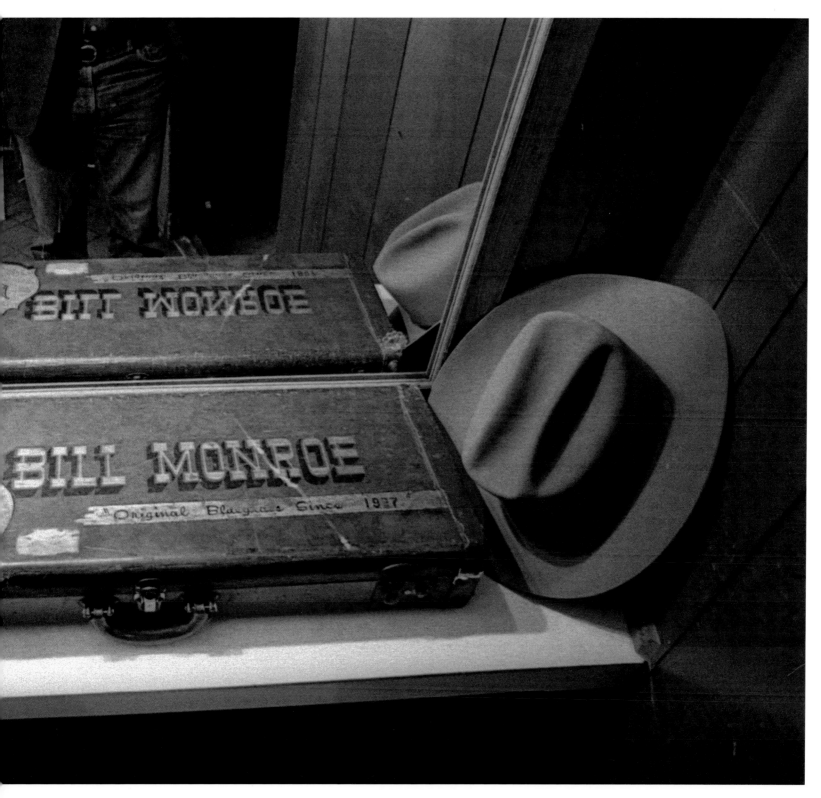

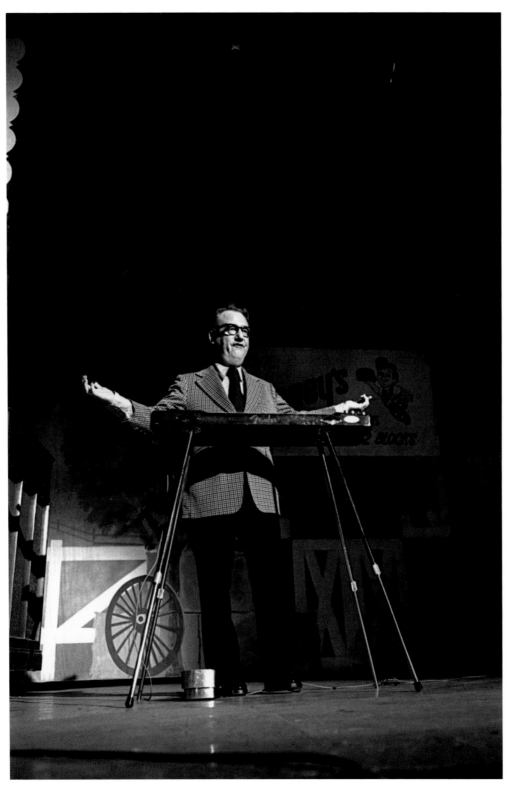

*Roy Wiggins*
Known to his friends as "Little Roy," Roy Wiggins played the old-style Hawaiian steel guitar—no pedals and standing. He played steel guitar with Eddie Arnold for many years, recorded solo instrumental albums, and also sat in with various singers on weekend Opry shows.

*Miss Loretta*
One of the most cherished country singers of all time, Loretta Lynn has been an Opry Cast member since 1962.

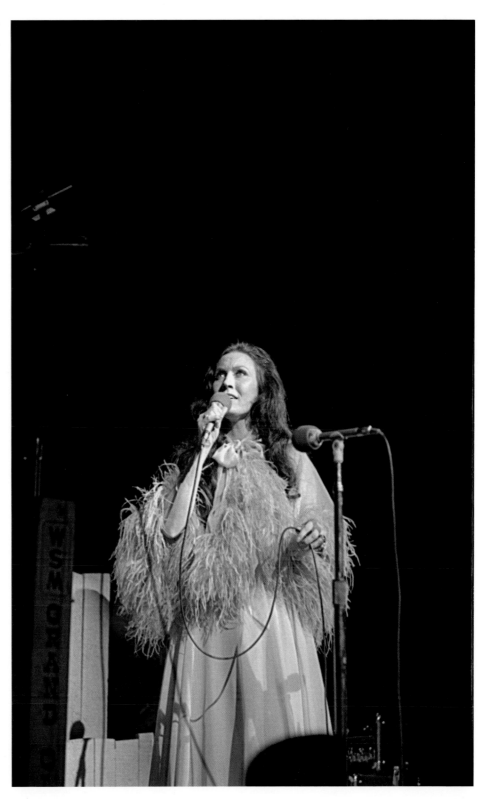

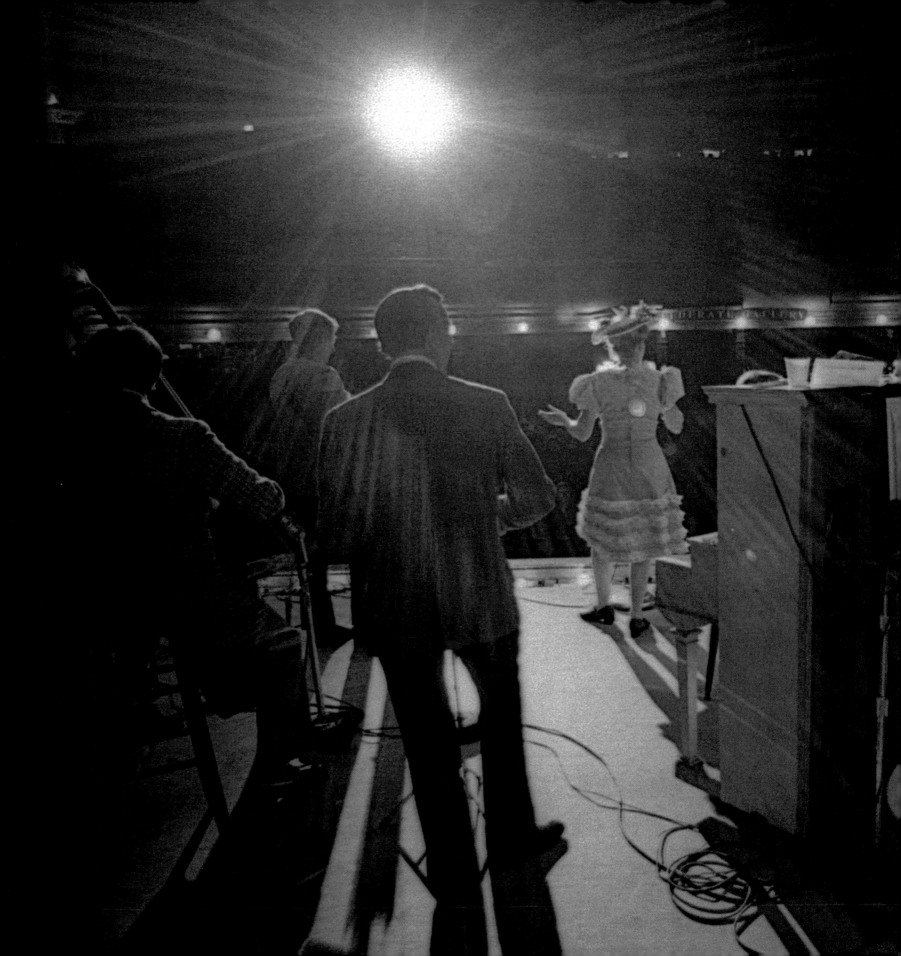

*Minnie Onstage*
Walking around toward the back of the stage during a live show, I caught this image of Minnie Pearl in the center of the stage telling one of her famous stories.

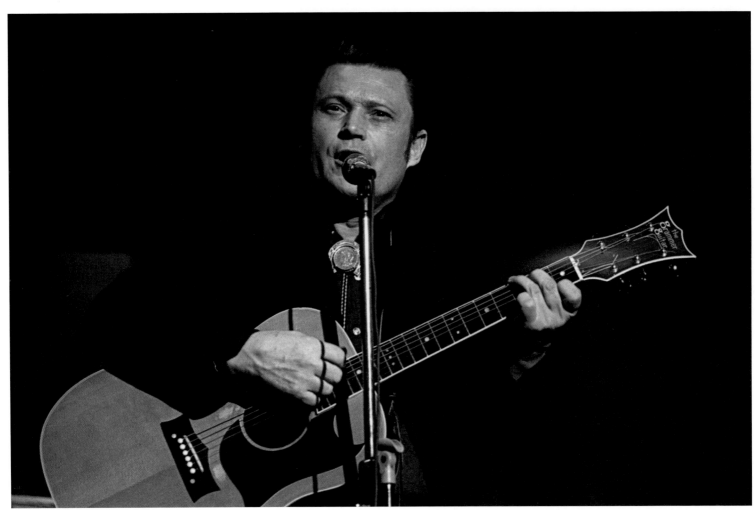

*Stonewall Jackson*
Named after the great Civil War general, Stonewall was actually related. He was one of
the purveyors of hard-driving honky-tonk music of the 1950s and 1960s.

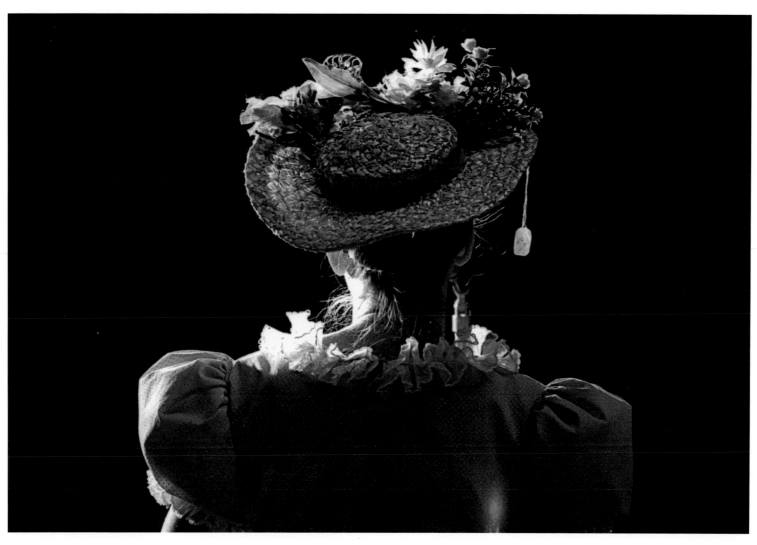

*Minnie's Hat*

An onstage shot during a live Saturday night performance. I was walking around backstage and this image just jumped out at me. Right time and right place.

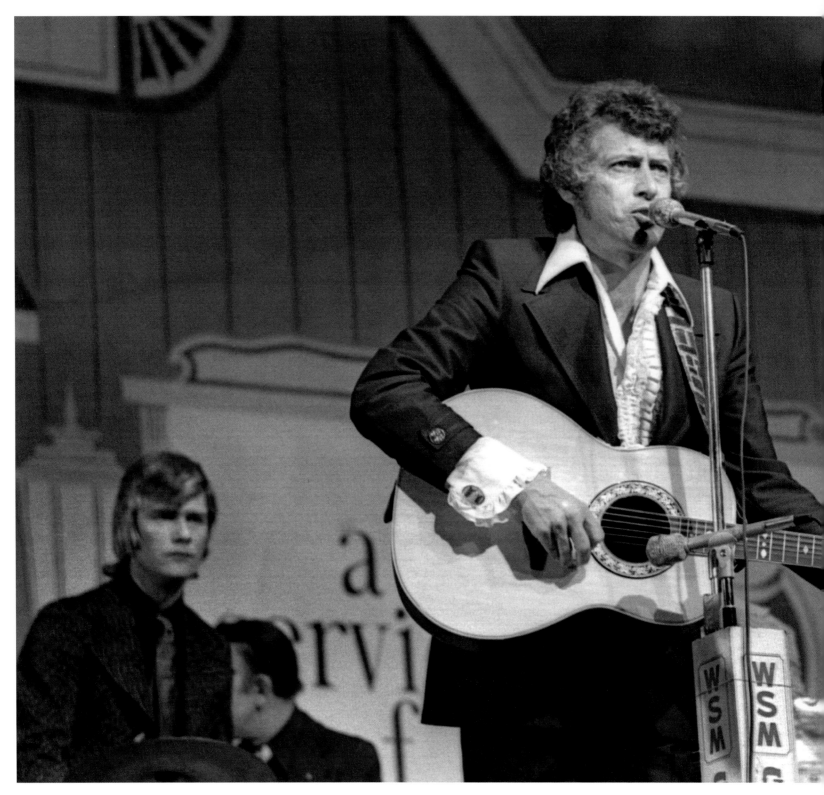

*Del Reeves*

Del Reeves was born in Sparta, North Carolina, in 1932 and named after Franklin Delano Roosevelt, who had just been nominated by the Democratic Party for president. In 1954, he signed with Capitol Records and later recorded with Decca, Reprise, and Columbia Records before landing at United Artists Records, where he enjoyed greatest success. Many of his early recordings were novelty songs, but he later had more serious country hits such as his 1968 truck driver anthem "Looking at the World Through a Windshield." He joined the Opry in 1966 and performed weekly through 2002. He died New Year's Day, 2007, from emphysema.

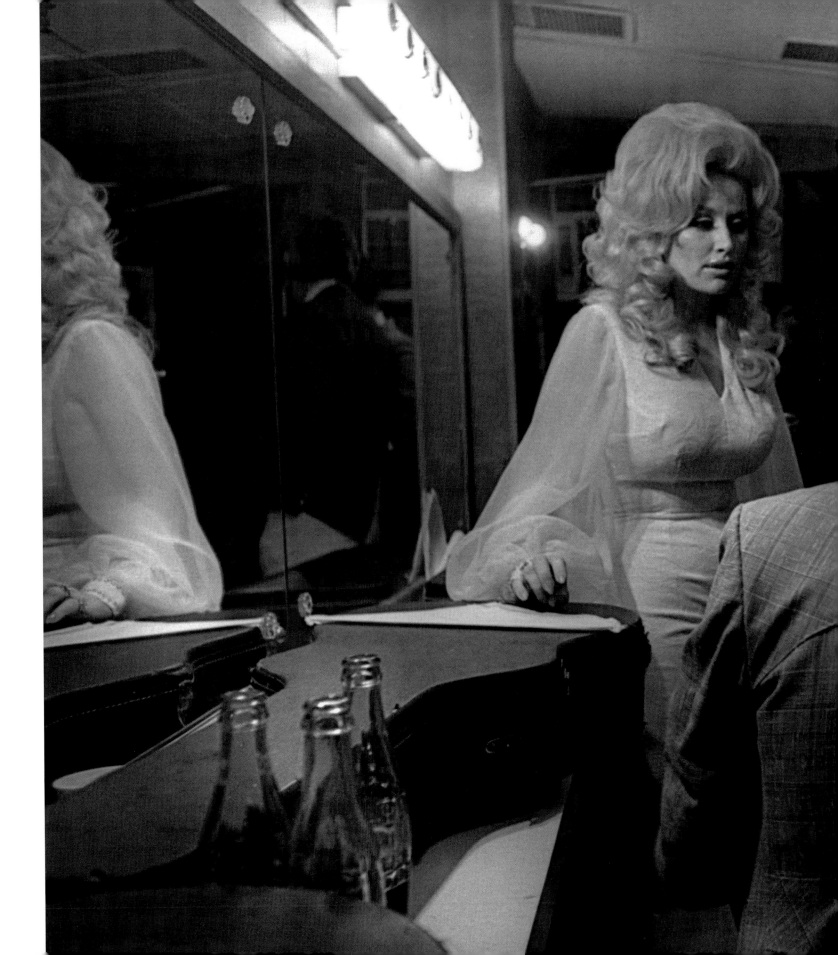

*Dolly and Porter*
Dolly Parton and Porter Wagoner are deep in conversation in a dressing room between shows.

*Saturday Night on Fifth Avenue*
This was the typical scene in front of the Ryman on any Saturday night. There were two shows, and fans from all over the world would line up down the block waiting for the first show to empty and for the doors to open for the late show.

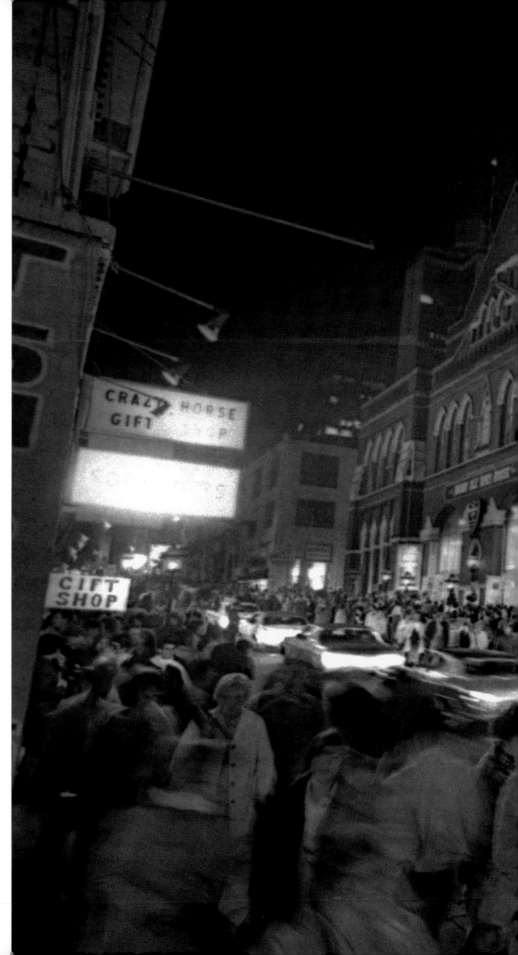

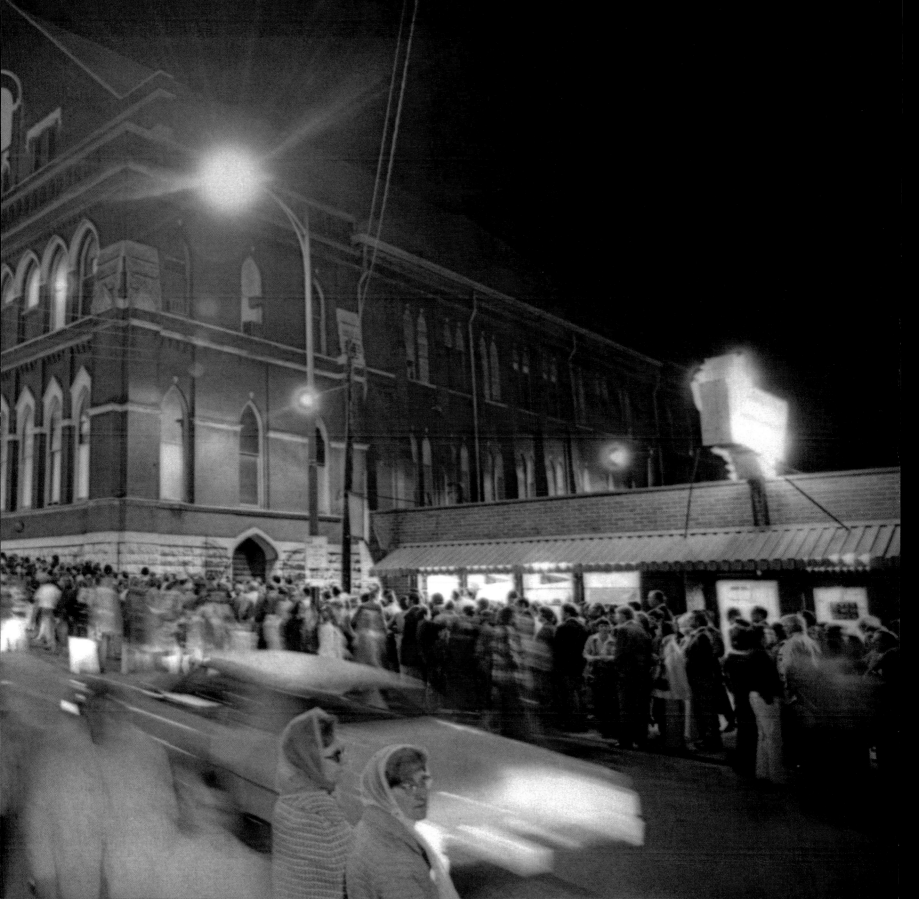

*Opry Warm Up Show*
Grant Turner sits at his microphone spinning records and taking requests from his perch on the Ryman center stage. This WSM radio show was broadcast live from the Ryman stage just before the Saturday night Opry began.

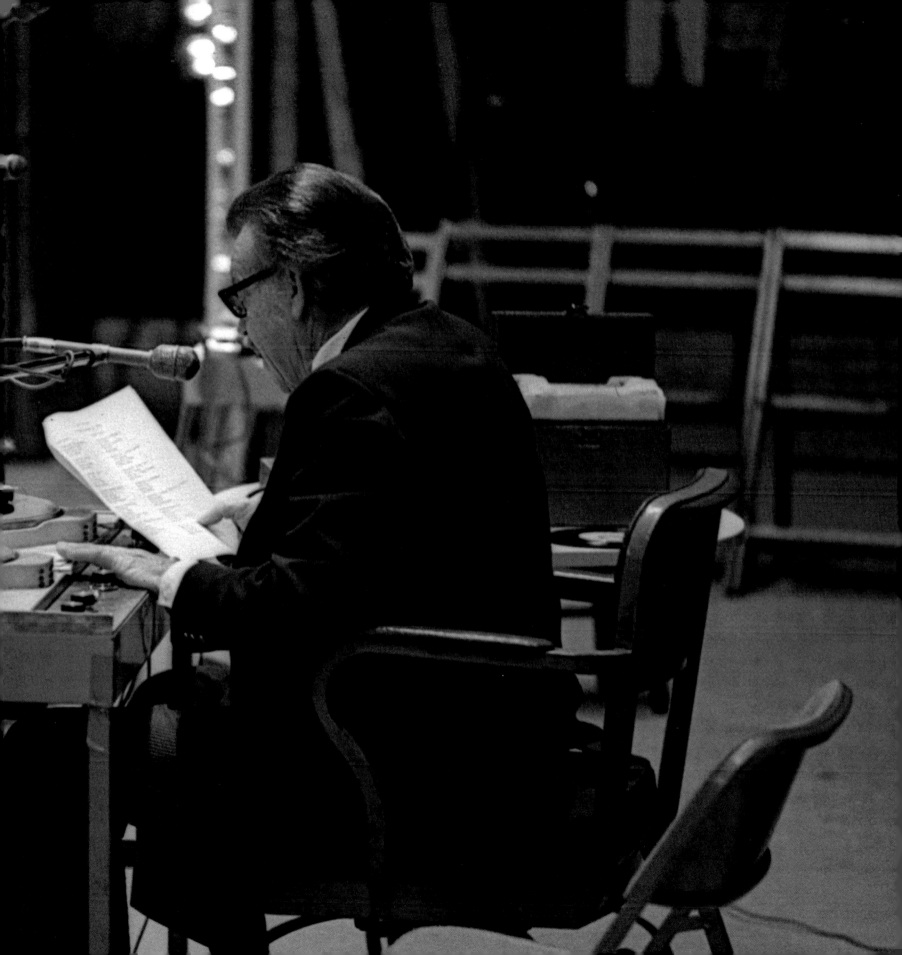

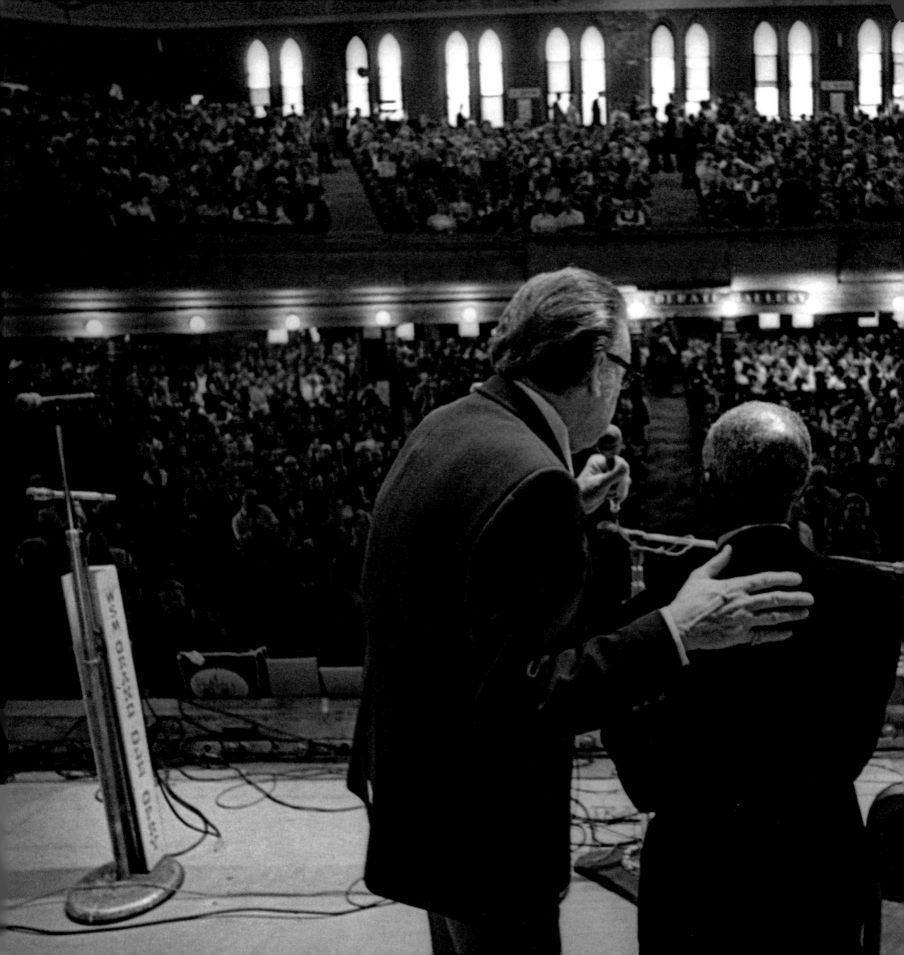

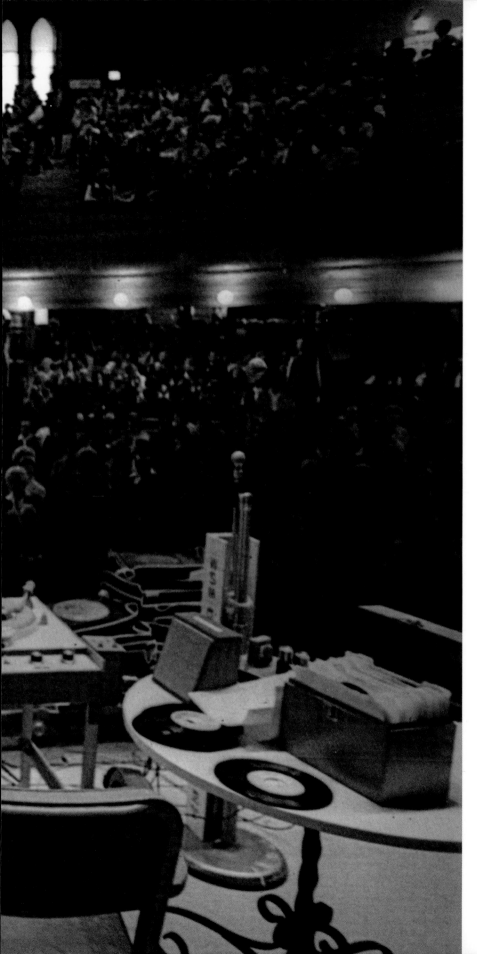

*Grant and DeFord*
Grant Turner introduces DeFord Bailey as his guest on the
Opry Warm Up Show.

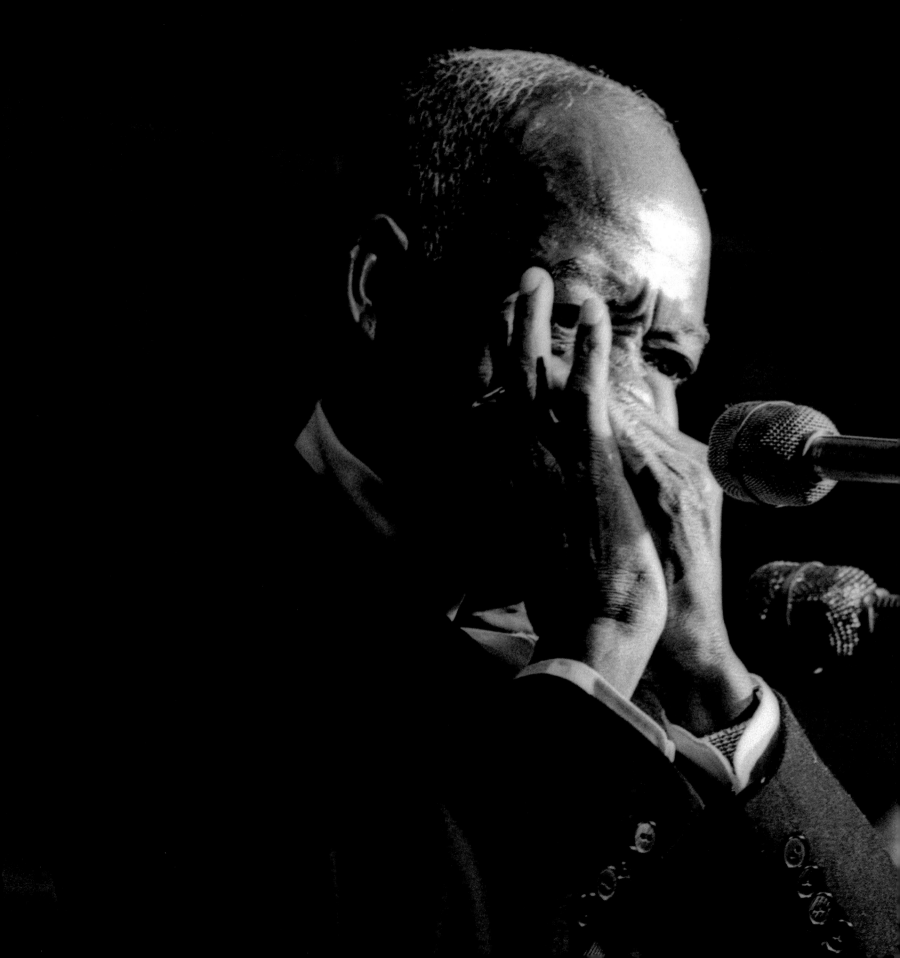

*DeFord Bailey*

Born 40 miles east of Nashville, the grandson of a freed slave, harmonica virtuoso DeFord Bailey was one of the first and most popular cast members of the early Grand Ole Opry. A self-taught harmonica player, he learned to play as a child in a very musical family. He was a tiny man, but when he took the stage and played his rousing country and railroad blues numbers, he was a giant. In the late 1920s, he received more fan mail and requests than anyone else on the Opry. When Roy Acuff first came to the Opry in 1938, DeFord was already a star and in his prime. He graciously offered to tour with Acuff to help introduce him to a wider audience and Mr. Acuff never forgot it. Here he performs on the Ryman stage during the "Old Timers Night" at age 75.

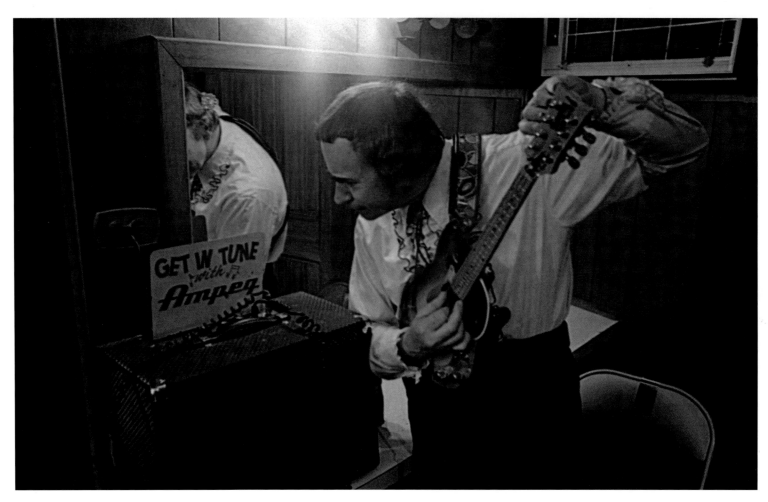

*Tuning Up*
In one of the dressing rooms, Oscar Sullivan, of Lonzo and Oscar, tunes
up using an amp. Ampeg, a company that made electric guitar amplifiers,
provided the Opry an amp for this purpose.

*Backstage Jam Session*
Held in Mr. Acuff's dressing
room, this jam session
includes Charlie Collins, Jesse
McReynolds, Tut Taylor, Kenny
Baker, Howdy Forrester, and
Gene Martin.

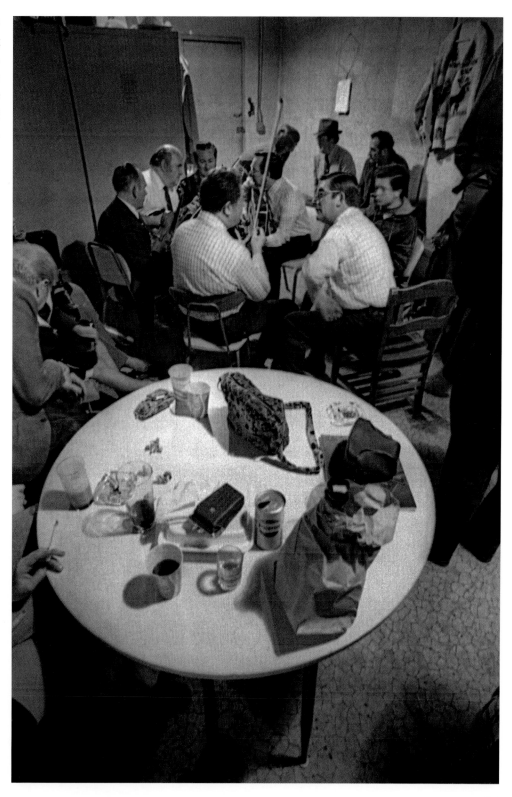

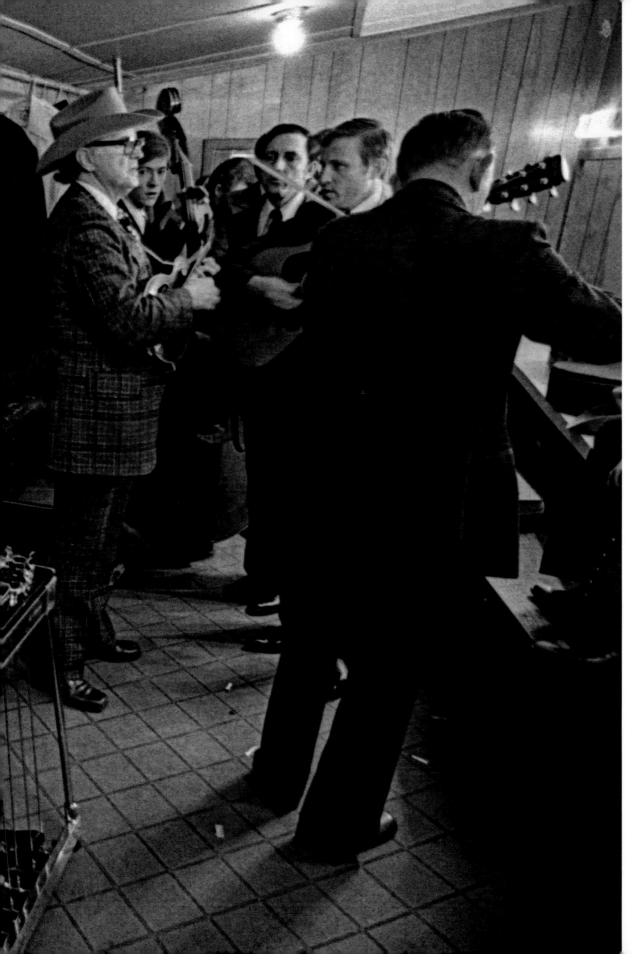

*Shared Space*
The cramped dressing rooms at the Ryman were a shared experience. Here Bill Monroe and his Bluegrass Boys are running down a tune while Bobby Black, the steel guitar player from Barbara Mandrell's band, is also working on a song.

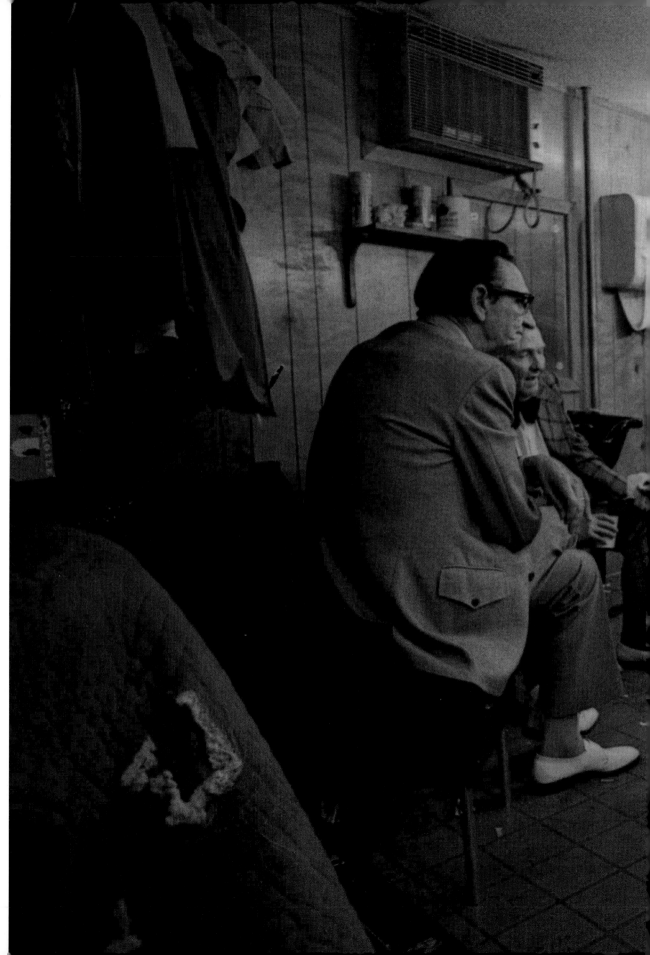

*Legends Reminisce*
Clyde Moody, Lester Flatt, and Curly Seckler, seated in a dressing room, talk about the old days. Moody was an early member of Bill Monroe's Bluegrass Boys, and Seckler played mandolin and sang harmony with Flatt and Scruggs in the 1950s in a band that is considered to be one of the all-time most important in country music.

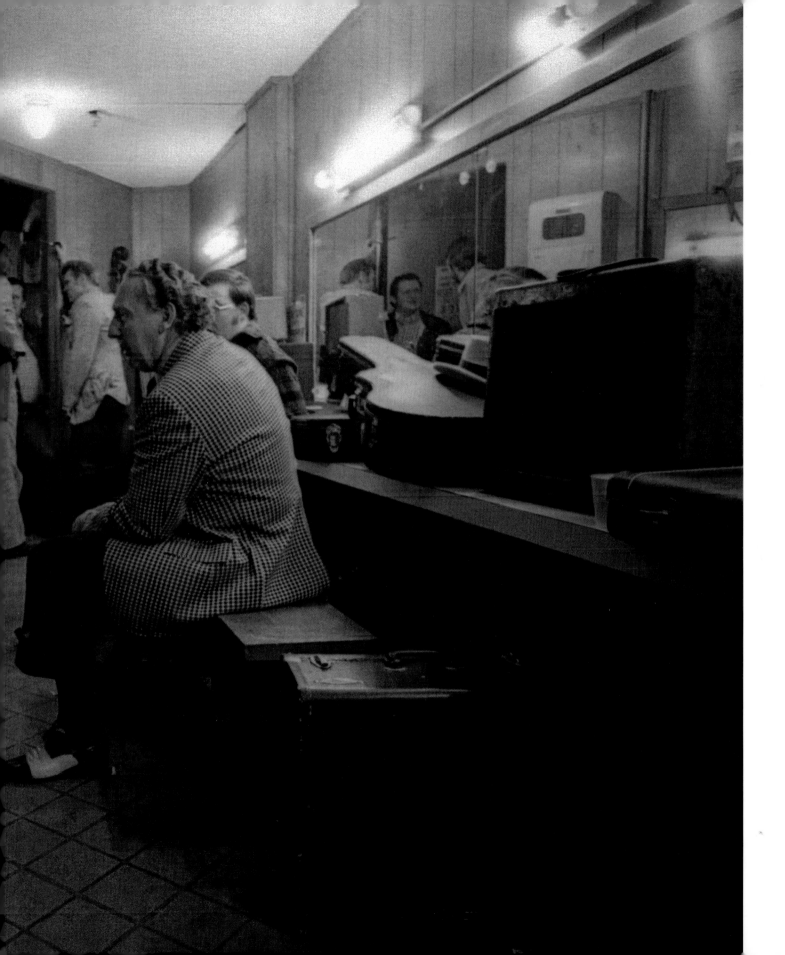

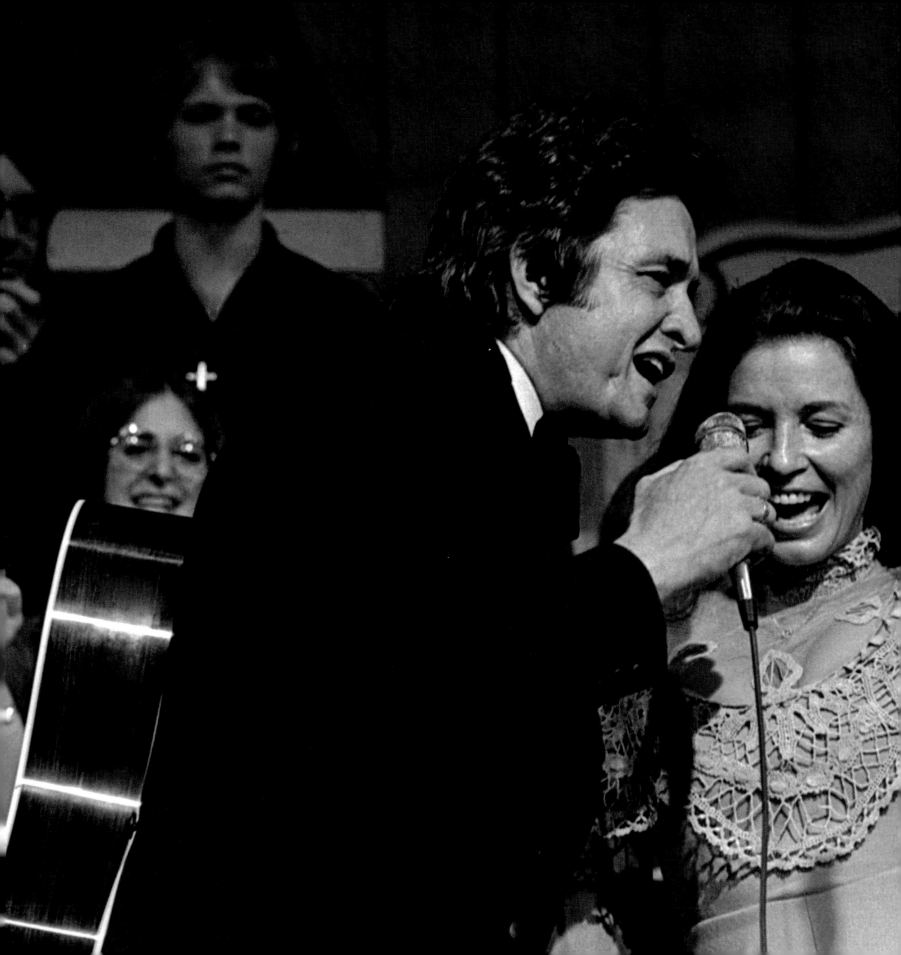

*Johnny Cash and June Carter Cash*
John and June in their prime. They are guests on the Reverend Jimmie Rodgers Snow's Grand Ole Gospel Show. This weekly gospel show took place right after the Opry. Here they are seen singing "Will the Circle Be Unbroken," hitting the last line of the last song performed on the Ryman stage that last night.

53

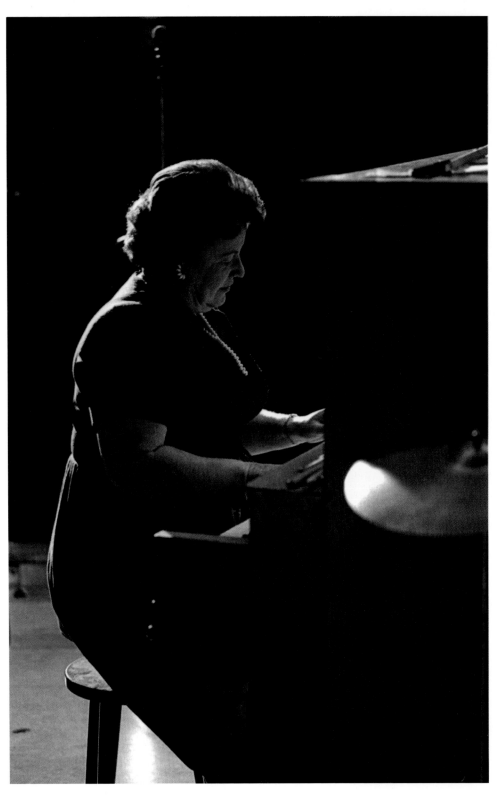

*Del Wood*
A Nashville native, born Polly Adelaide
Hendricks Hazelwood, shortened to
Del Wood, she began playing piano at
age 5 and grew up dreaming of one day
performing on the Opry. She was an Opry
member for many years and was famous for
her spirited ragtime piano instrumentals.

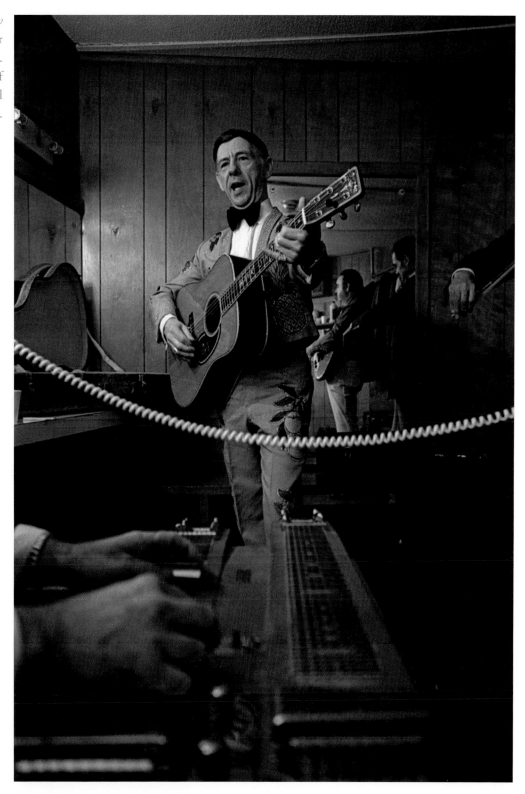

*Hank Snow*
Hank Snow rehearses a number with his band in a dressing room. In the foreground are the hands of Kayton Roberts, who played steel guitar with Hank for many years.

*Connie Smith*

A housewife singing locally in rural Ohio, Connie Smith was discovered and brought to Nashville by Opry star Bill Anderson. She had a unique, unflinching country voice and soon found herself with huge hit records in the 1960s. She joined the Opry in 1965 as a regular and later became known for her deep religious convictions that carried over into her music. She is seen here performing on the Grand Ole Gospel Show.

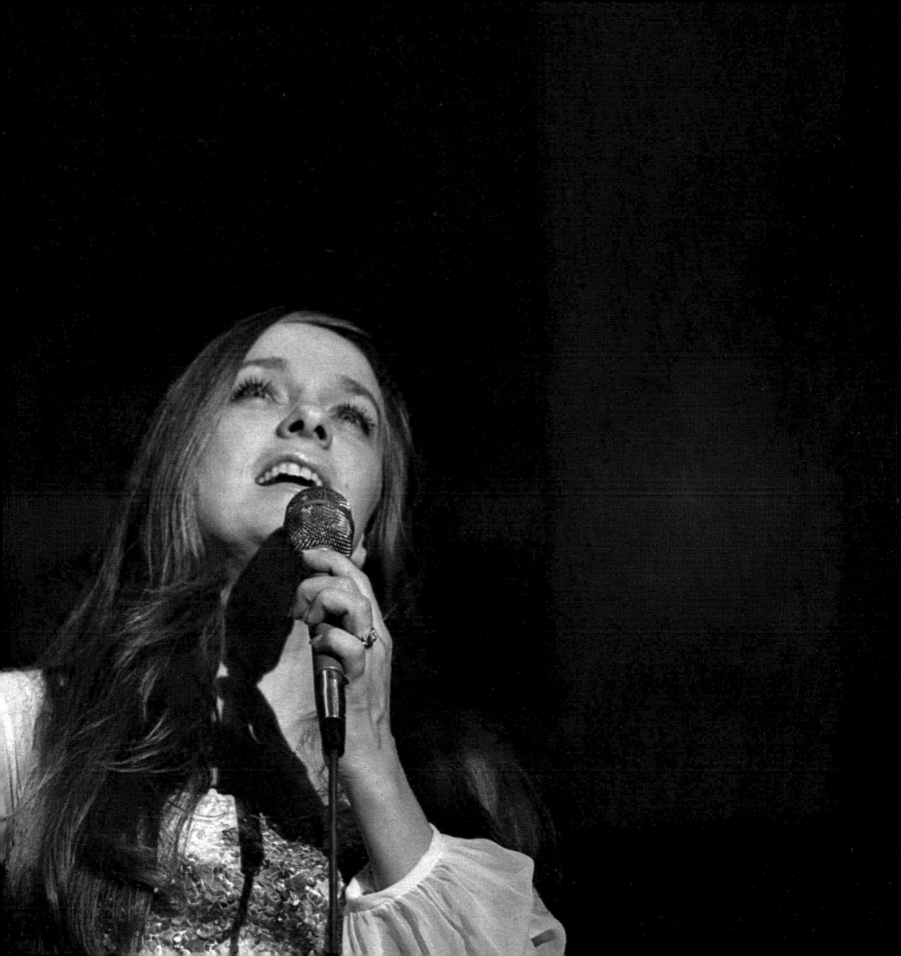

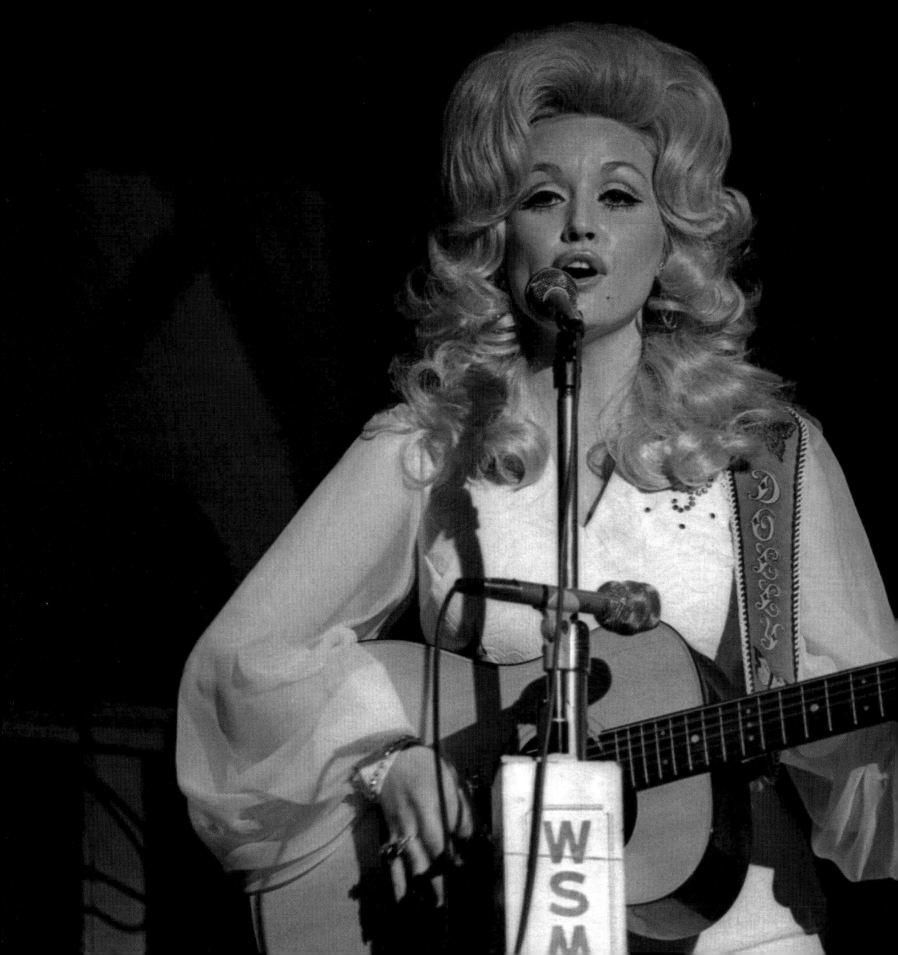

*Dolly Parton*
Dolly Parton in all her glory,
projecting a striking image onstage.

*Dancing Up a Storm*
Backstage on a Saturday night was
pretty much a continuous party. Here
some of the Opry dancers break into
spontaneous clogging as Sam McGee
and Goldie Stewart urge them on
with a lively tune.

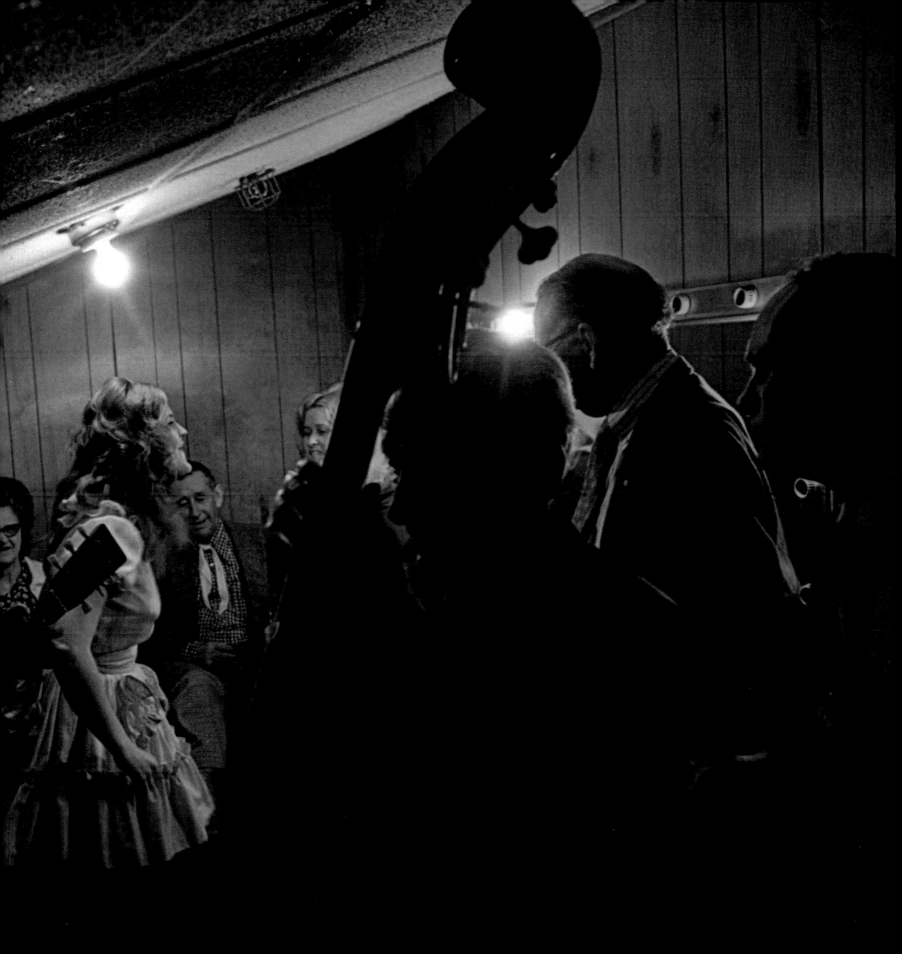

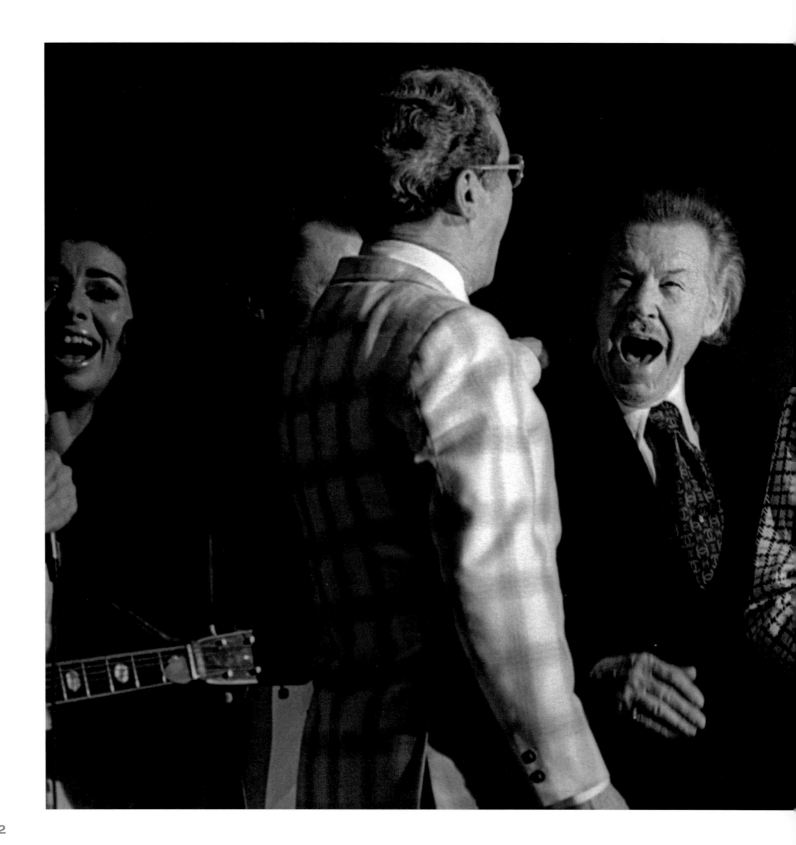

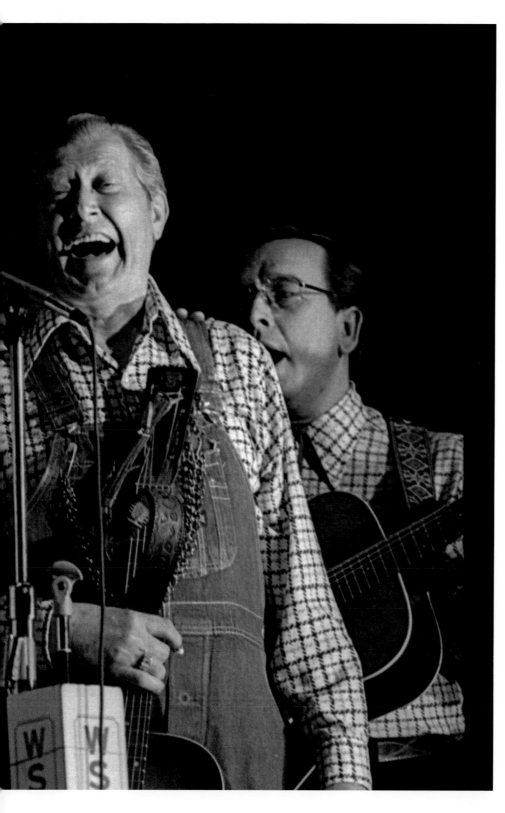

*Cutting Up Onstage*
The live Opry broadcast was always spontaneous and fun. Here Carol Lee Cooper, Roy Acuff, Grant Turner, Brother Oswald, and Charlie Collins share a good laugh onstage.

*Hank Snow's Guitar Case*
Hank Snow was not only a great singer and songwriter, but a gifted guitar player as well. He played a beautiful Martin D-45 and had this hand-tooled leather case made for it.

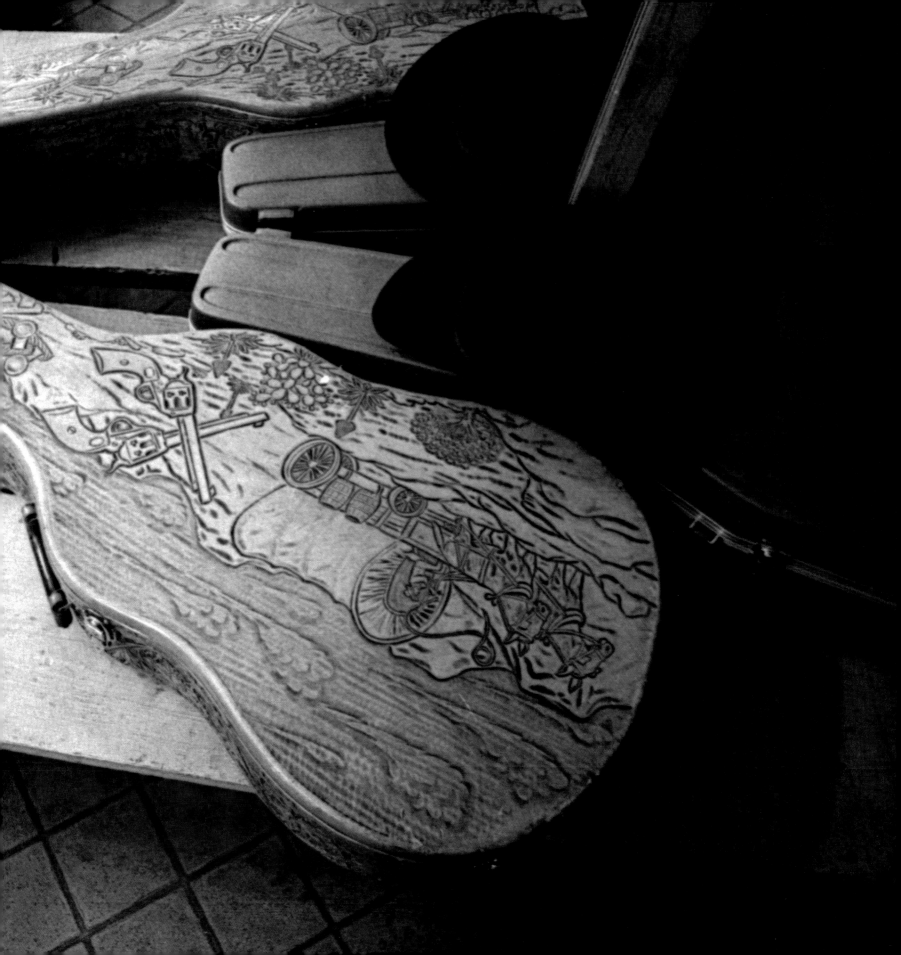

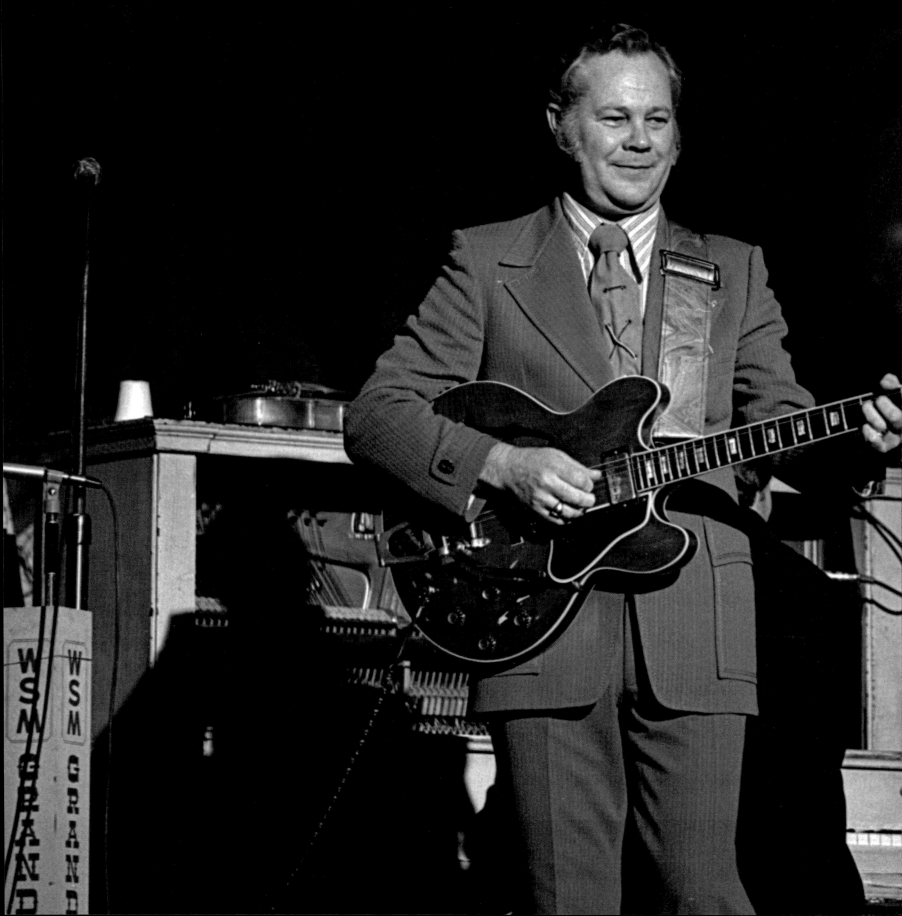

*Billy Grammer*
An Opry member since 1959, the same year he had a top-five country record, "Gotta Travel On," Billy Grammer was also in demand as a session guitarist. He founded the Grammer Guitar company, which produced guitars that he designed.

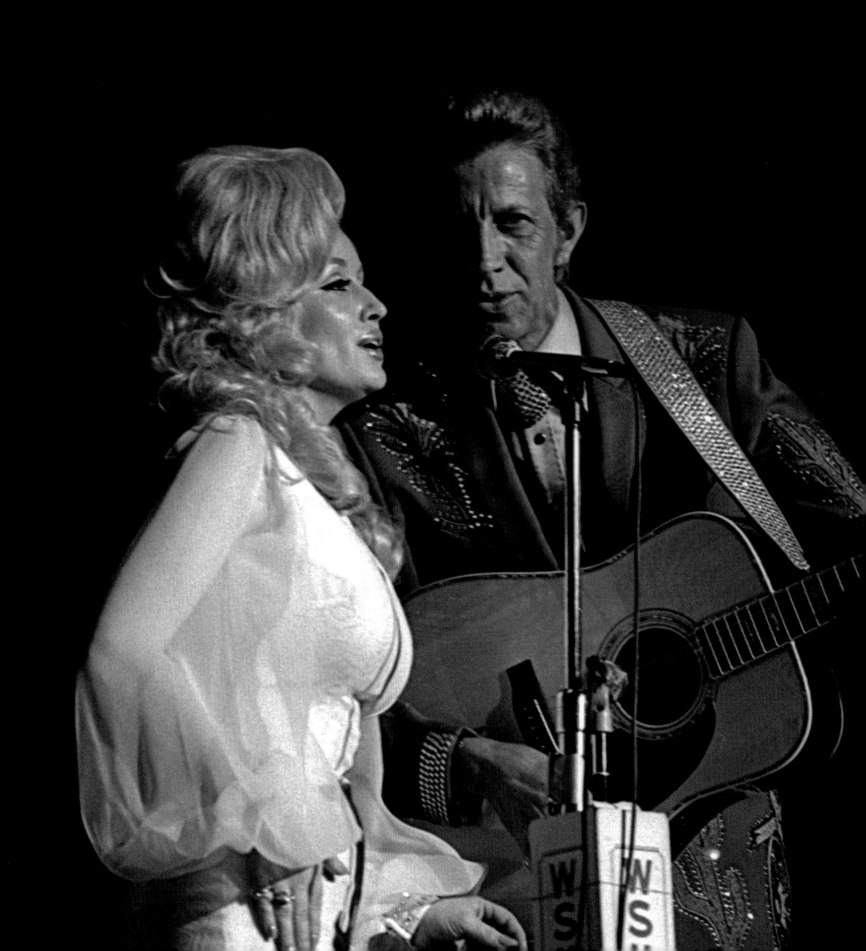

*Dolly and Porter*
Dolly Parton and Porter Wagoner sing one of their classic duets on a Saturday night show. It was always magic when they walked up to the microphone.

*Jan Howard*
A country girl from West Plains, Missouri, Jan Howard
began singing at the request of her husband, a young
struggling songwriter, Harlan Howard. She had many
country hit records in the 1960s and 1970s and has been
an Opry member since 1971.

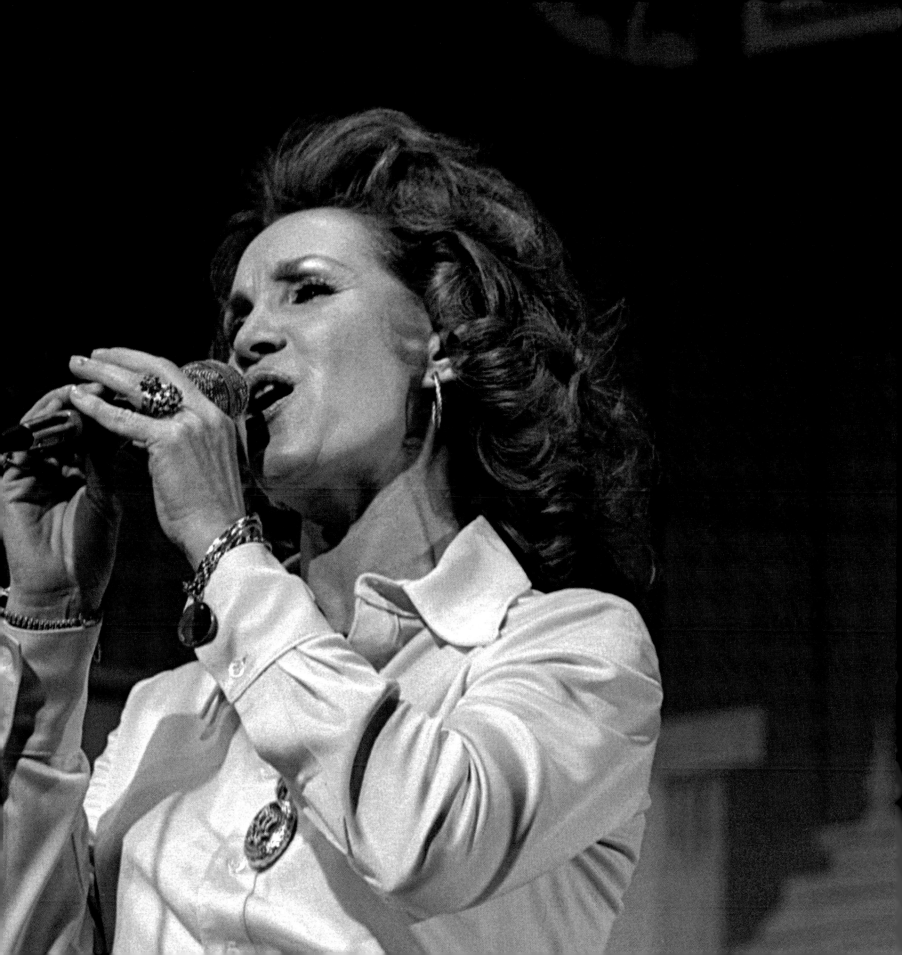

*Grant Turner*

Jesse Granderson "Grant" Turner was the voice of the Opry. He was an onstage and radio announcer for 47 years and was the one who kept the Opry moving. He announced guests, read commercials, and kept the radio audience engaged by waving his hands from the stage to call for applause from the live audience, as seen here.

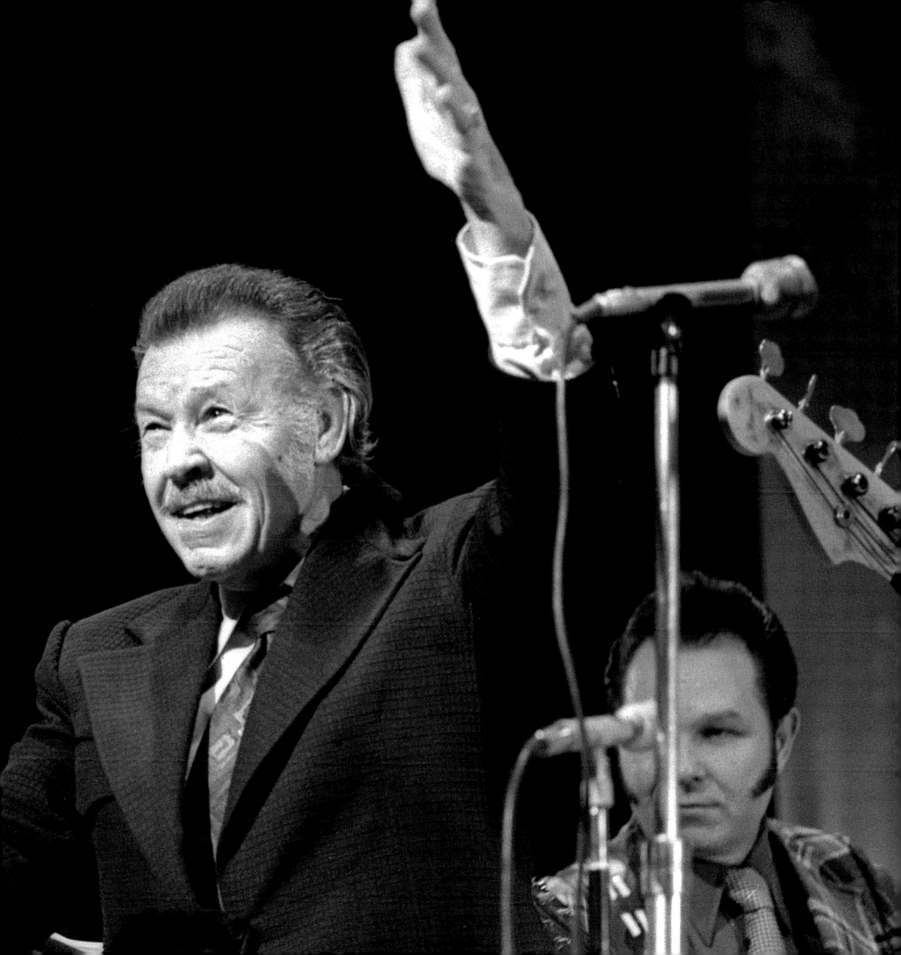

*Taking a Break*
Steel guitarist Weldon Myrick takes a
break backstage in front of the Opry
post office, where Opry members
picked up their fan mail.

*Tootsie's Orchid Lounge*
Fans check out the music spilling out of this world-famous beer joint. Customers could enter the front door on lower Broadway, but the back door was far more famous. It opened onto the alley across from the Ryman's backstage entrance and provided Opry stars and band members alike a place to cool off between performances.

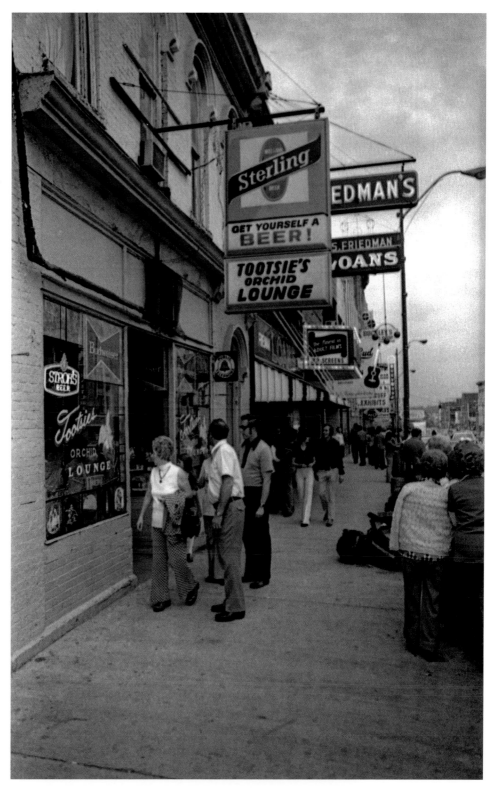

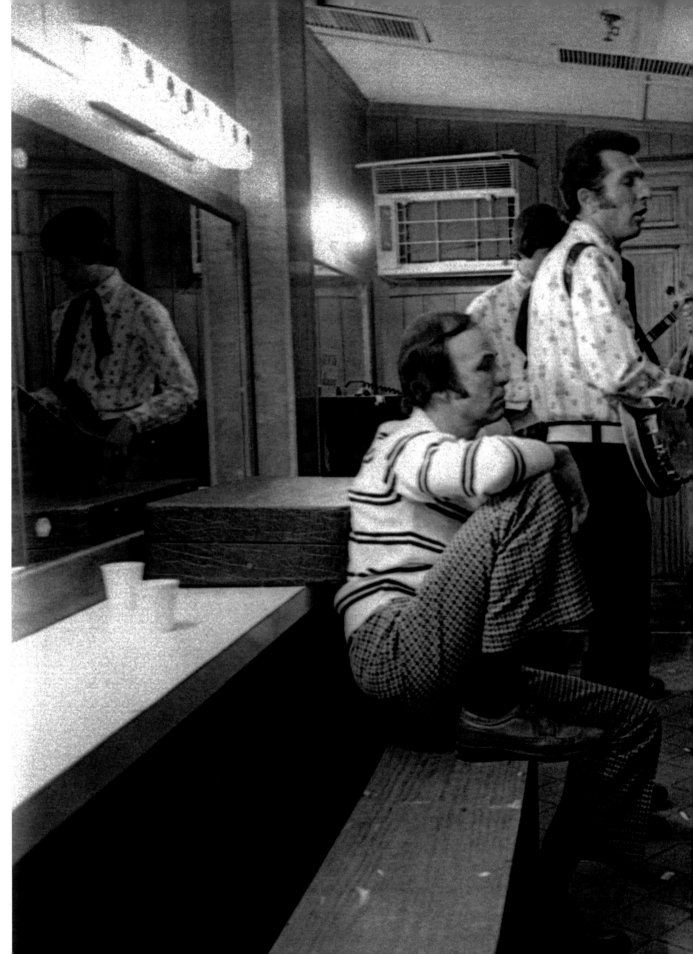

*Jim and Jesse*
Bluegrass brothers Jim and Jesse McReynolds rehearse a number in a shared dressing room with band member and banjo player Vic Jordan, before going onstage.

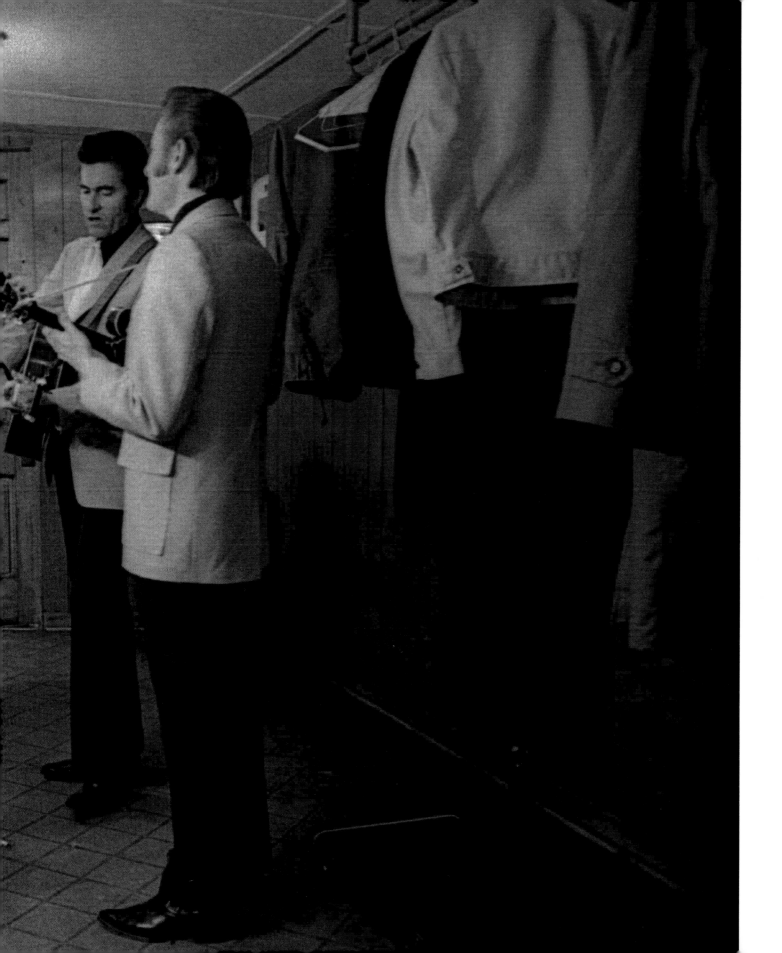

*Sid Harkreader*
A Middle Tennessee native, Sid Harkreader was known
as Fiddlin' Sid and was one of the first musicians to
play old-time fiddle tunes live over WSM radio. Here
at age 76, he returns to the Ryman for the 1974 "Old
Timers Night."

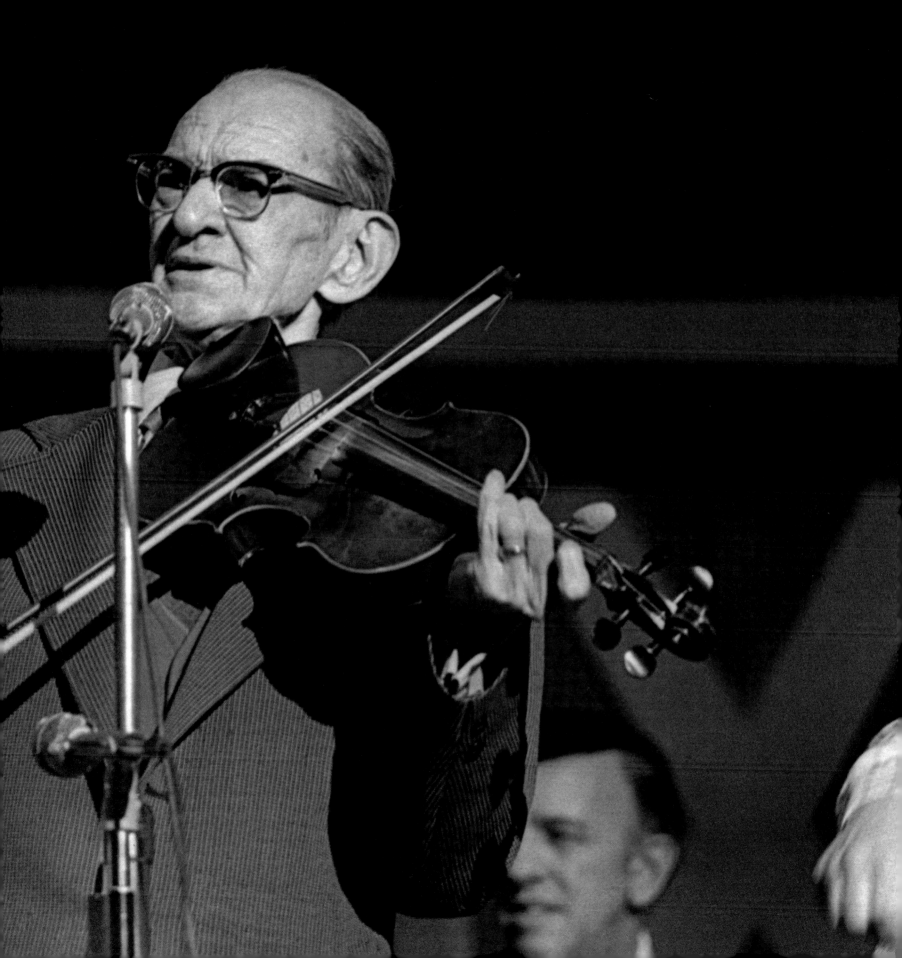

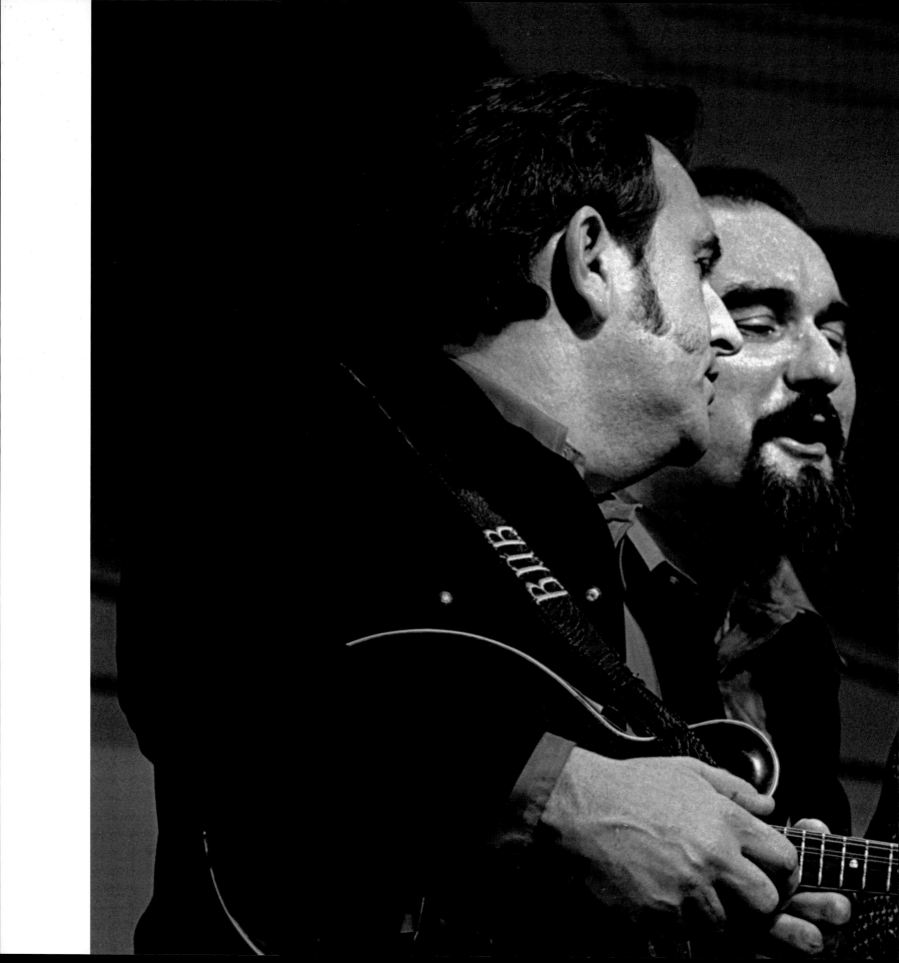

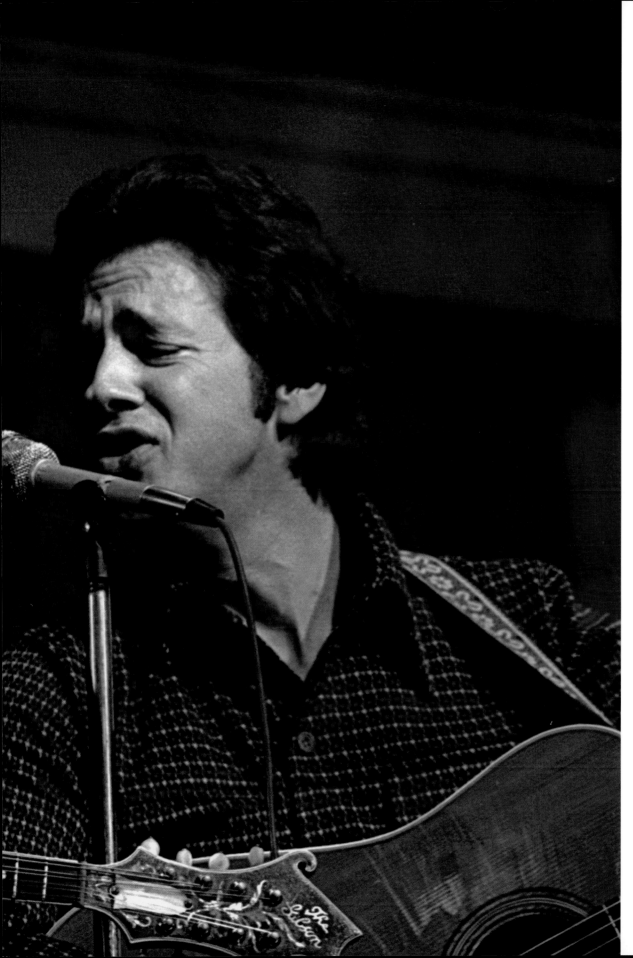

*The Osborne Brothers*
Brothers Bobby and Sonny
Osborne teamed up in 1953,
after stints playing with other
bluegrass luminaries, to form
one of bluegrass music's most
progressive acts of the time.
Shown here, Bobby with
mandolin, Sonny on banjo,
and band member Dale Sledd
sing one of their famous trio
numbers.

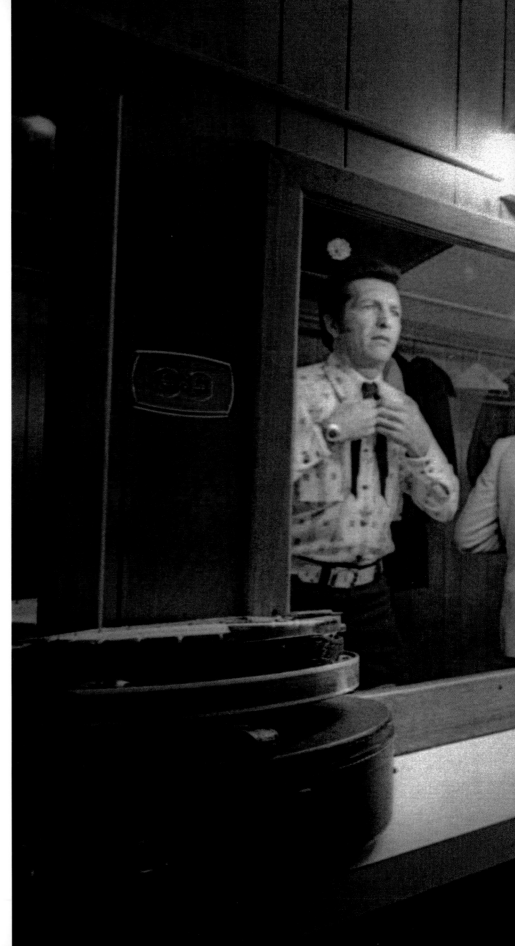

*Vic Jordan*
Banjo player Vic Jordan prepares
to go onstage. He played banjo
with bluegrassers Jim and Jesse
McReynolds.

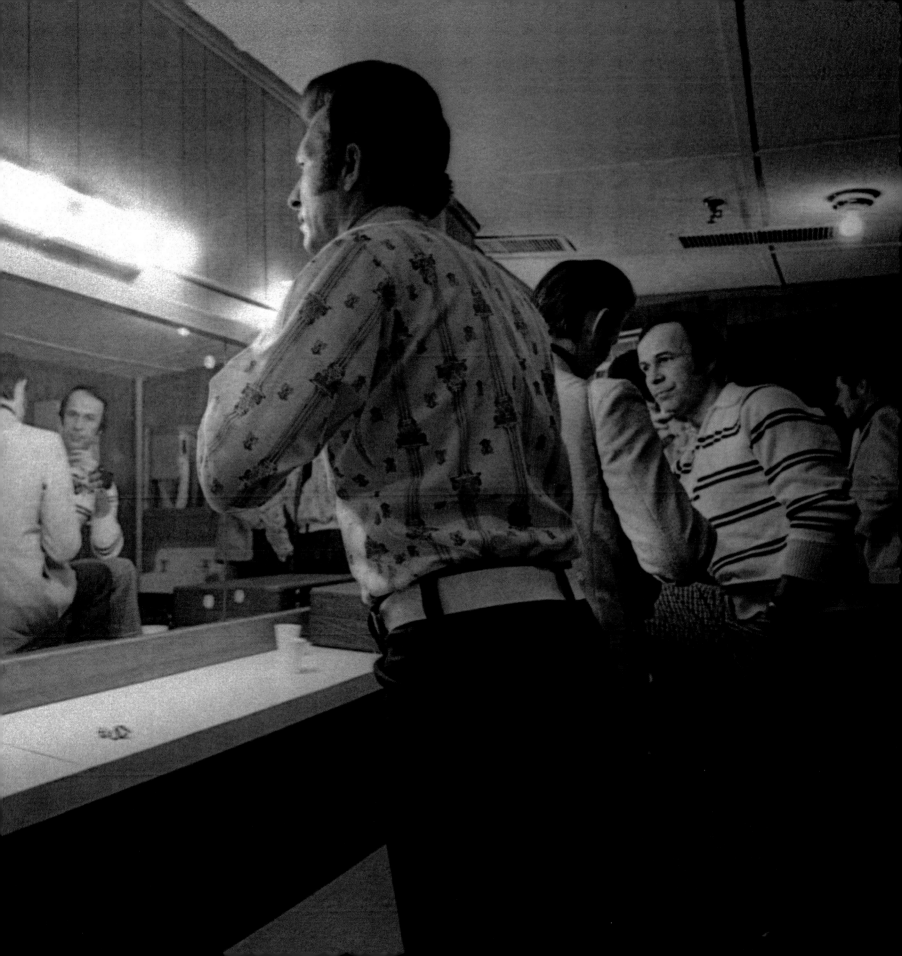

*George Morgan*

One of the great country crooners and father of country singer Lorrie Morgan, George came to the Opry in 1948 after a brief stint on WWVA radio in Wheeling, West Virginia. He died about a year after this picture was taken.

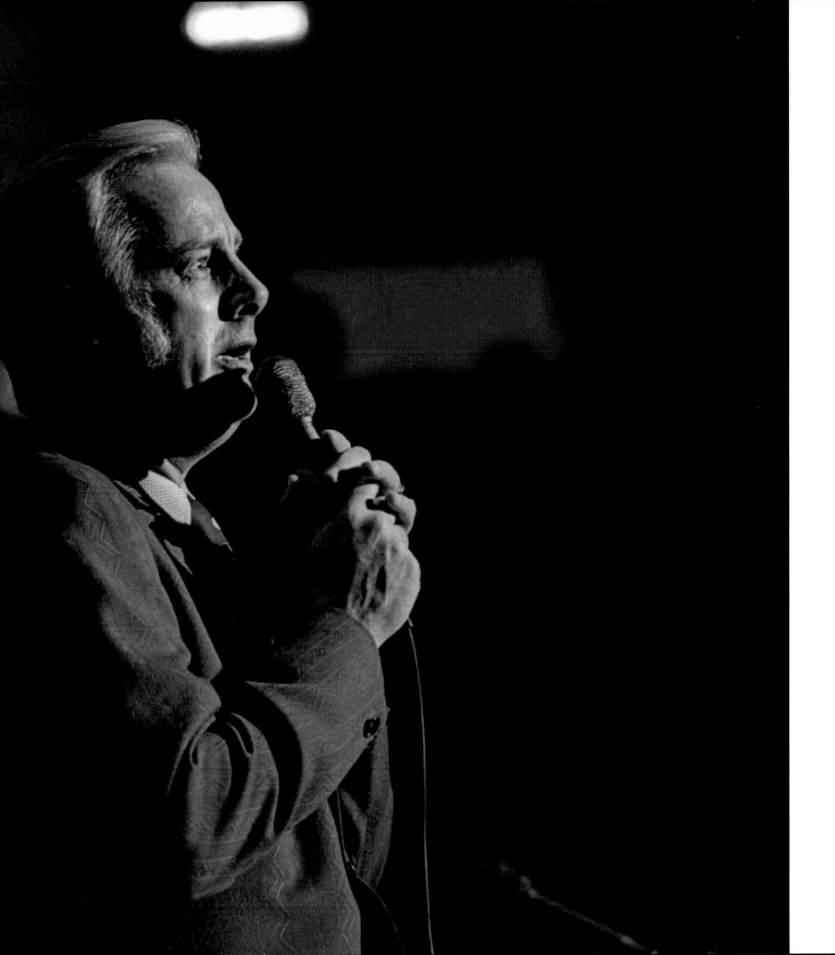

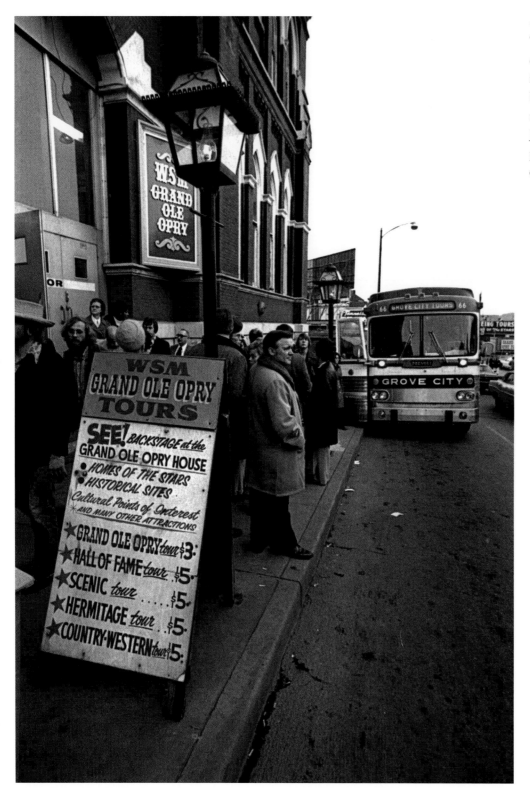

*Grand Ole Opry Tours*
The Opry had a side business that offered fans tours of everything from backstage at the Ryman to bus tours of stars' homes to scenic tours of Nashville and Andrew Jackson's Hermitage. Tickets could be purchased just inside the Fifth Avenue entrance.

*Going to Work*
Opry steel guitarist "Little" Roy Wiggins, in the white suit, walks to work as fans file in for the Saturday matinee. His music store, Little Roy Wiggins' Music City, was located just around the corner on lower Broadway. He played with the great Eddie Arnold for 25 years and was inducted into the Steel Guitar Hall of Fame in 1985.

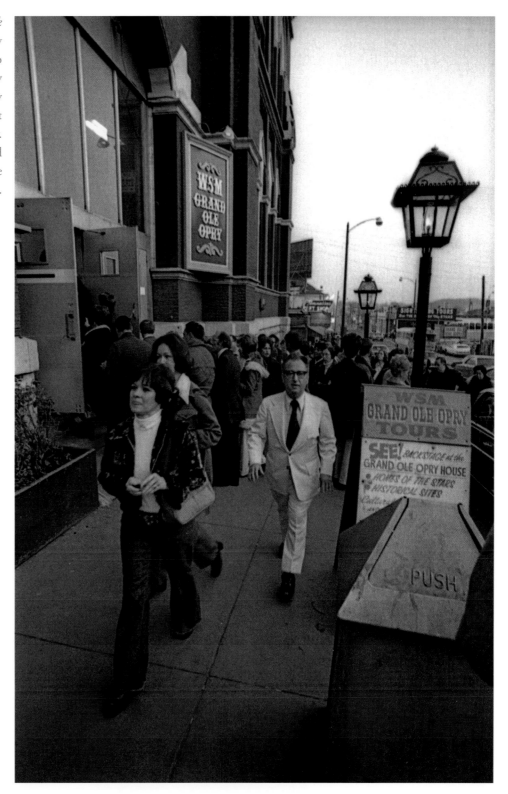

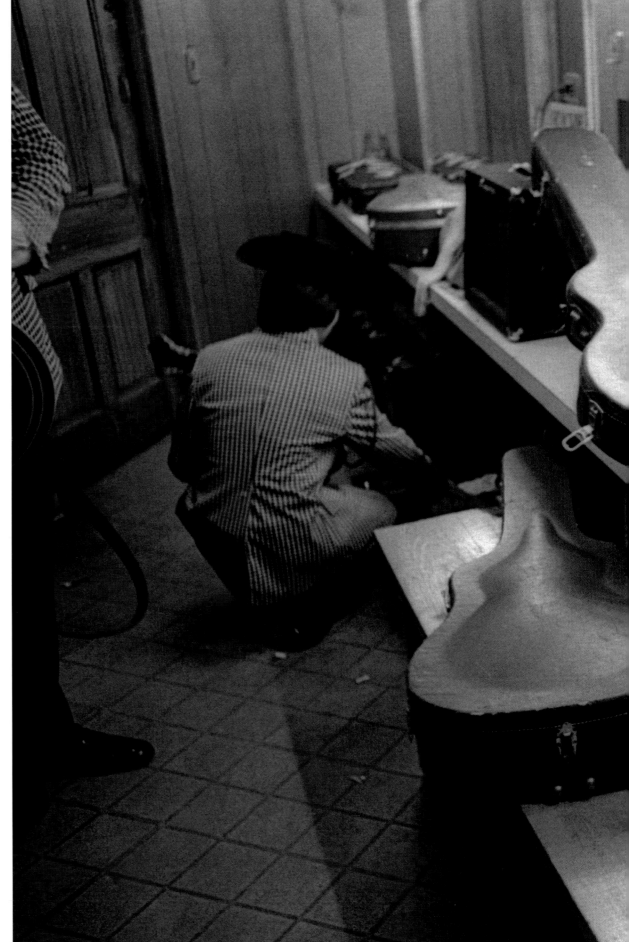

*Stacked Instruments*
The Ryman's dressing rooms were small and had to be shared by many different bands during the night. Precious instruments stacked high was a typical sight. That's Marty Stuart putting his mandolin away after a Saturday night performance with Lester Flatt's band, the Nashville Grass.

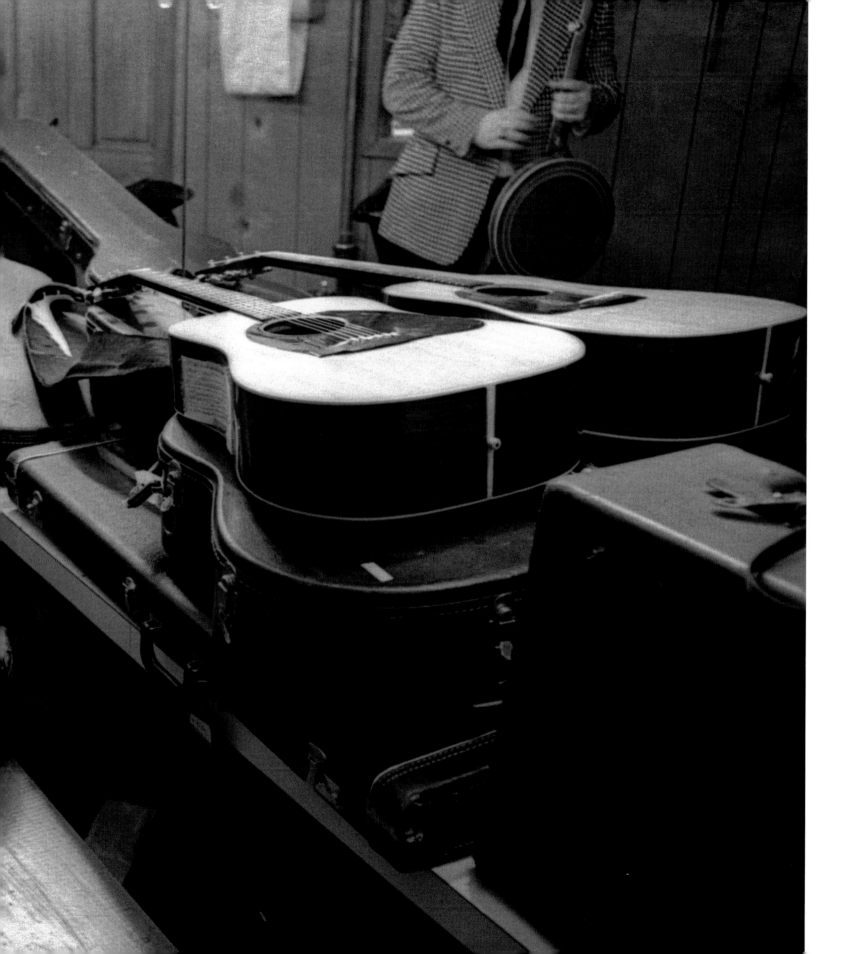

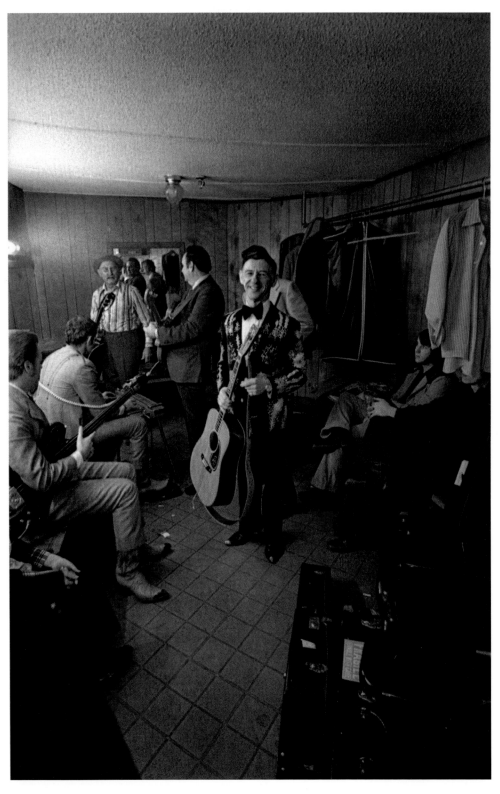

*Dressing Rooms*

The dressing rooms at the Ryman were shared by all performers and their bands and were dark and cramped. Hank Snow waits to go on and Grandpa Jones has just come off the stage as band members wait for their slot.

*Dolly Parton*
Although she still performed as a part of Porter Wagoner's show, Dolly also sang a solo number during most Opry appearances.

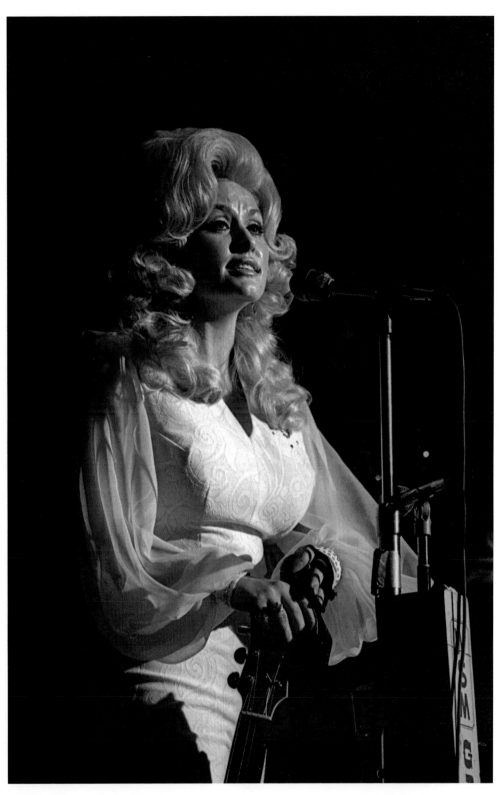

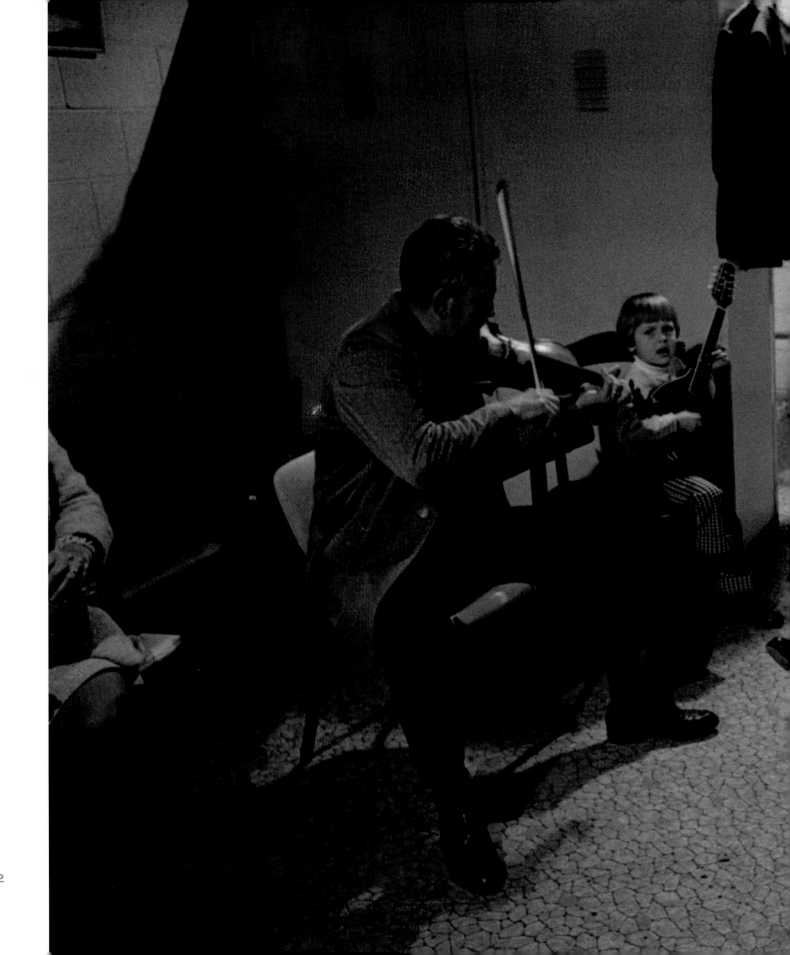

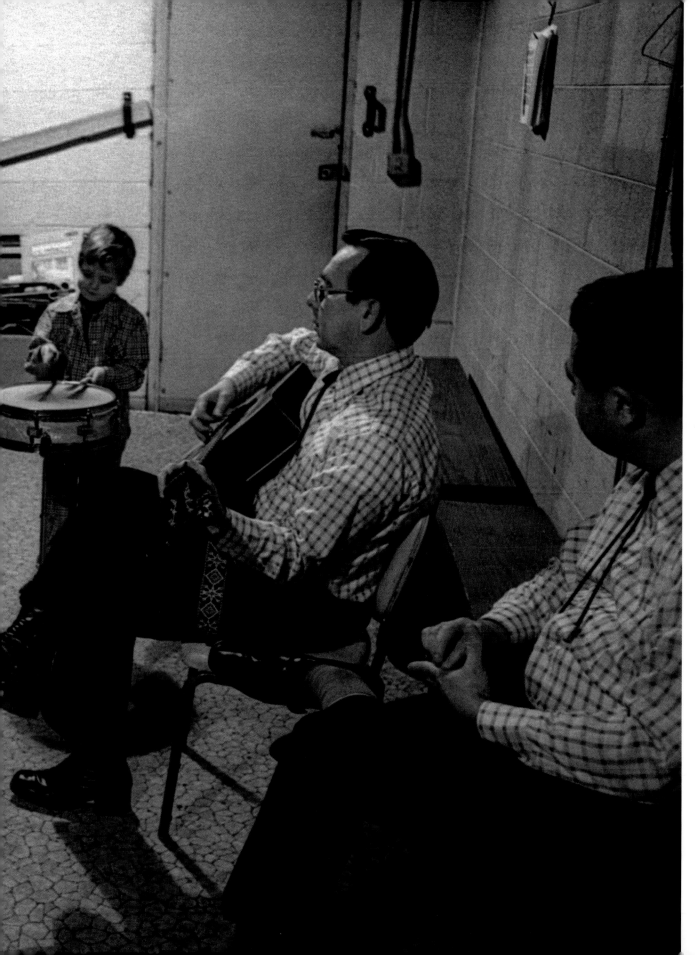

*Charlie Collins*
Charlie picks a tune with an unidentified fiddle player in between shows in Acuff's dressing room. Fiddler Howdy Forrester looks on as two future musicians join in.

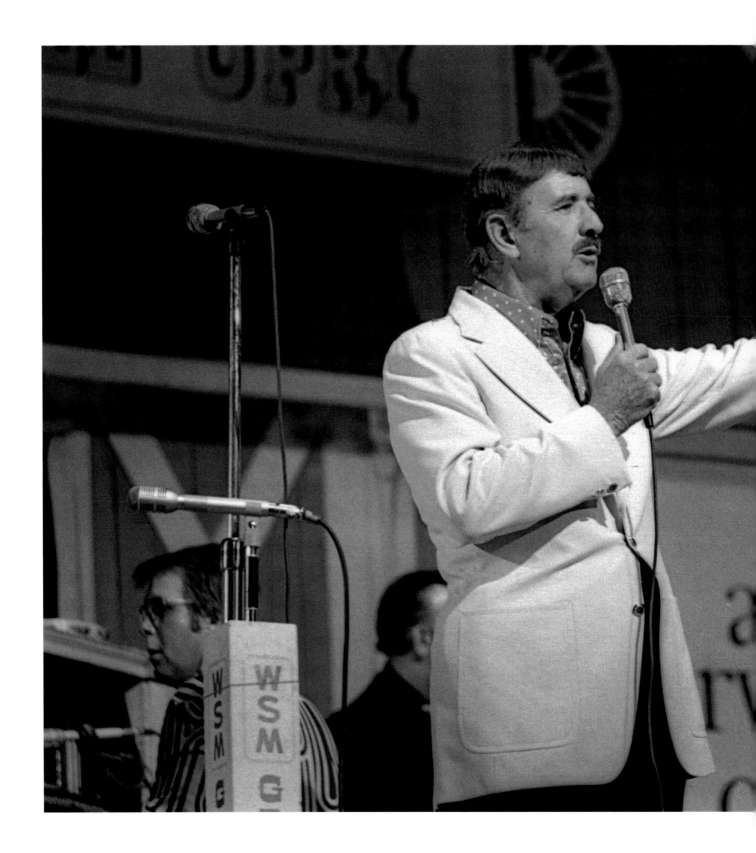

*Archie Campbell*
Born in the Smoky Mountains of East
Tennessee, Archie brought the house down
with his tongue-twisting stories and wry
humor. He joined the Opry in 1958, had many
big records for RCA, and was later a regular on
the TV show *Hee Haw.*

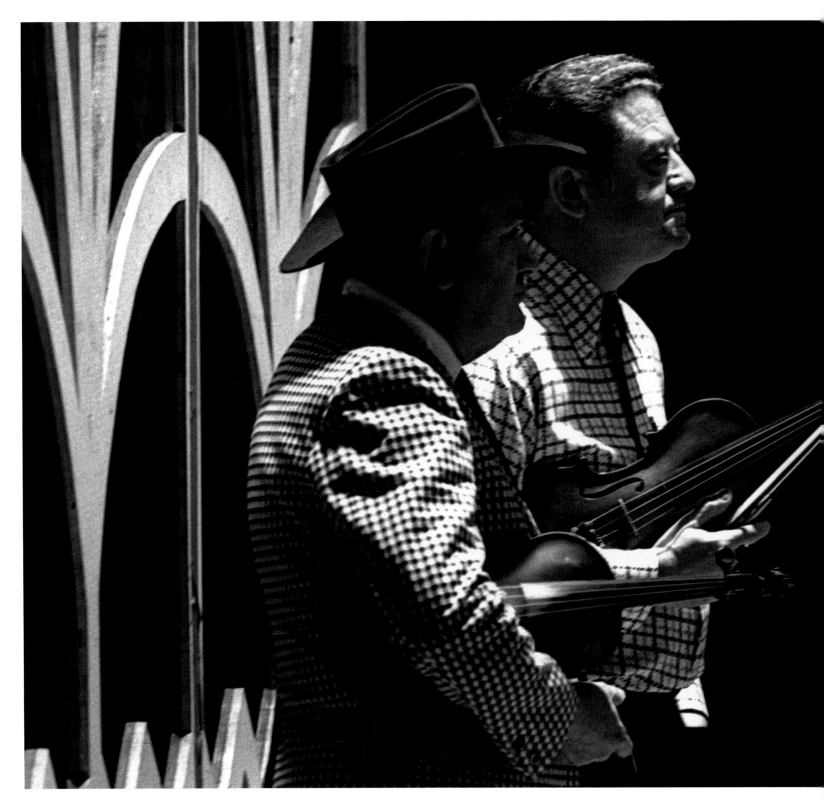

*Fiddlers Backstage*
Fiddlers Paul Warren and Howdy
Forrester stand at the rear of the Ryman
stage watching the live performance.

*Bud Wendell and Grant Turner*
Onstage during a Saturday night show, Opry manager Bud Wendell and announcer Grant Turner review the handwritten notes of the show schedule. Informal though the show was, it always seemed to flow naturally, without a hitch.

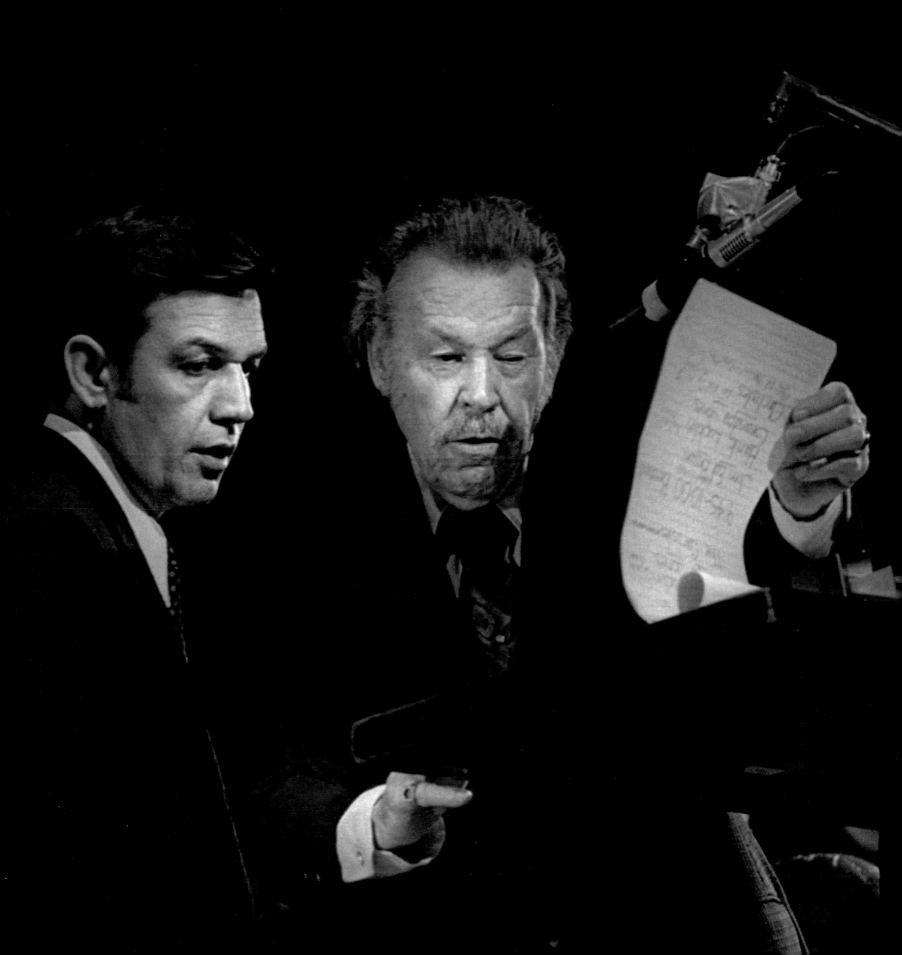

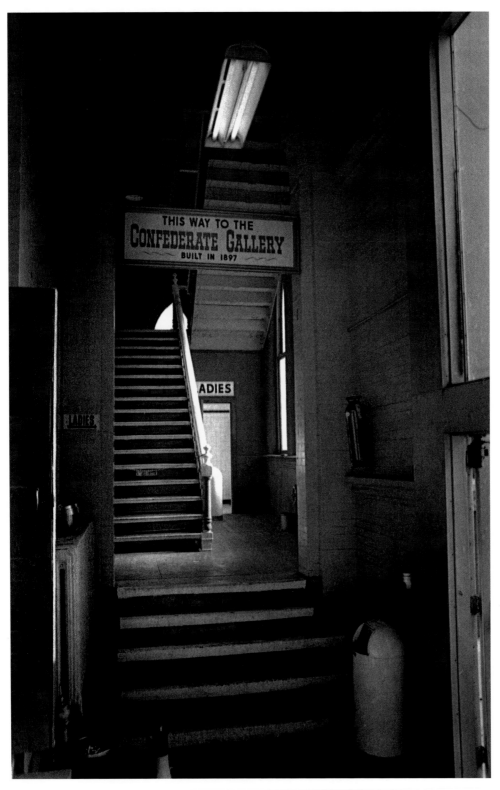

*Ryman Stairwell*
Stairwell to the balcony, which is known as the Confederate Gallery because it was built in 1897 to accommodate a Confederate Veterans reunion gathering. This was the view from the Fifth Avenue main entrance.

*Quiet Moment*
A rare quiet moment for banjo player Mike Lattimore as he takes time to rehearse a tune.

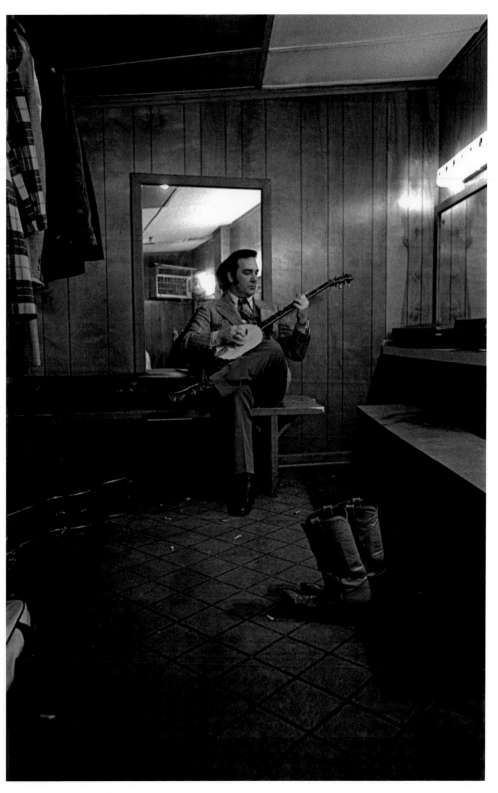

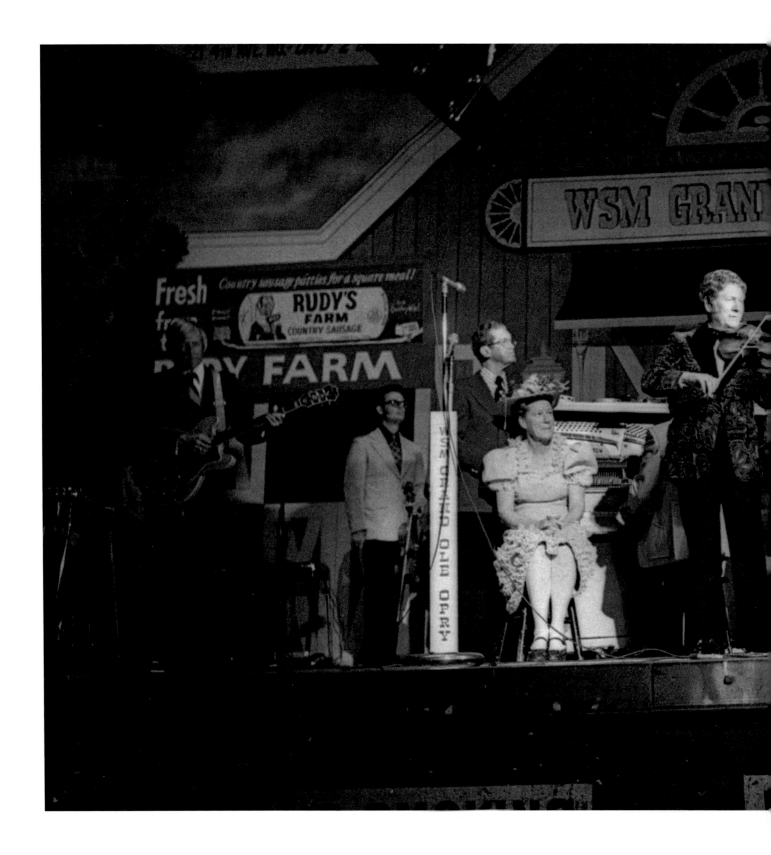

*Old Timers Night*
Roy Acuff and Minnie Pearl listen with great nostalgia as the great Redd Stewart and Pee Wee King sing "The Tennessee Waltz," a classic country song they wrote together in 1947. It was recorded in 1950 by Patti Page and by Les Paul and Mary Ford and became a huge crossover pop hit. The song was earlier recorded by Roy Acuff. Onstage *(left to right)* are Spider Wilson, Joe Edwards, Roy and Minnie, Redd Stewart, Pee Wee King, and Billy Linneman.

*Backstage*
The great Sam McGee strums some
chords to fiddler Paul Warren as they
wait their turn to go on.

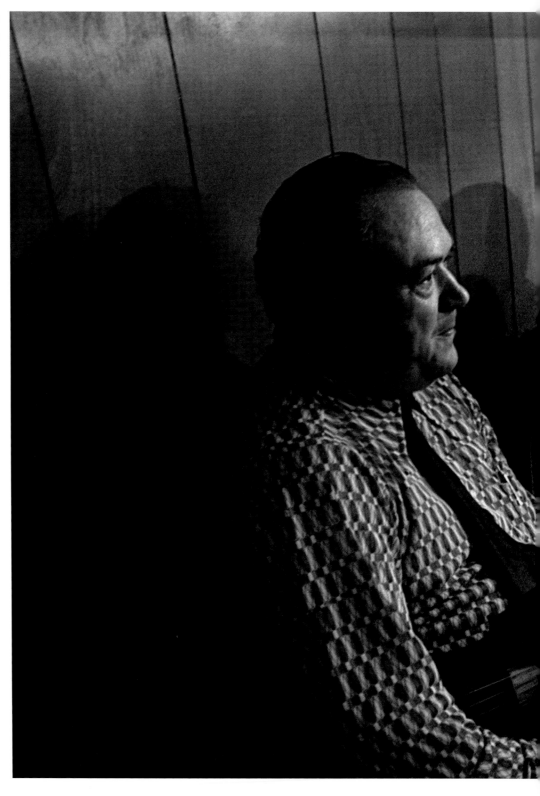

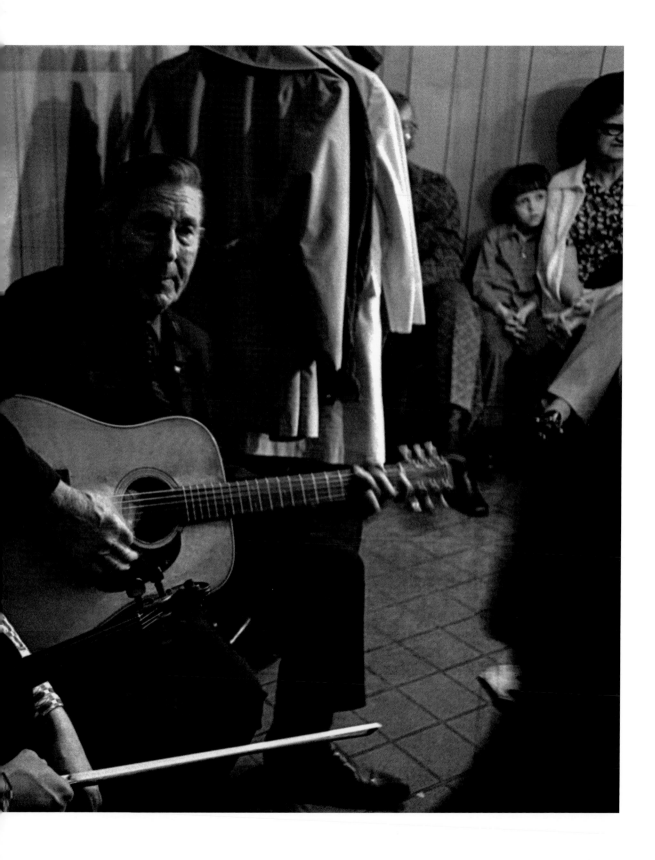

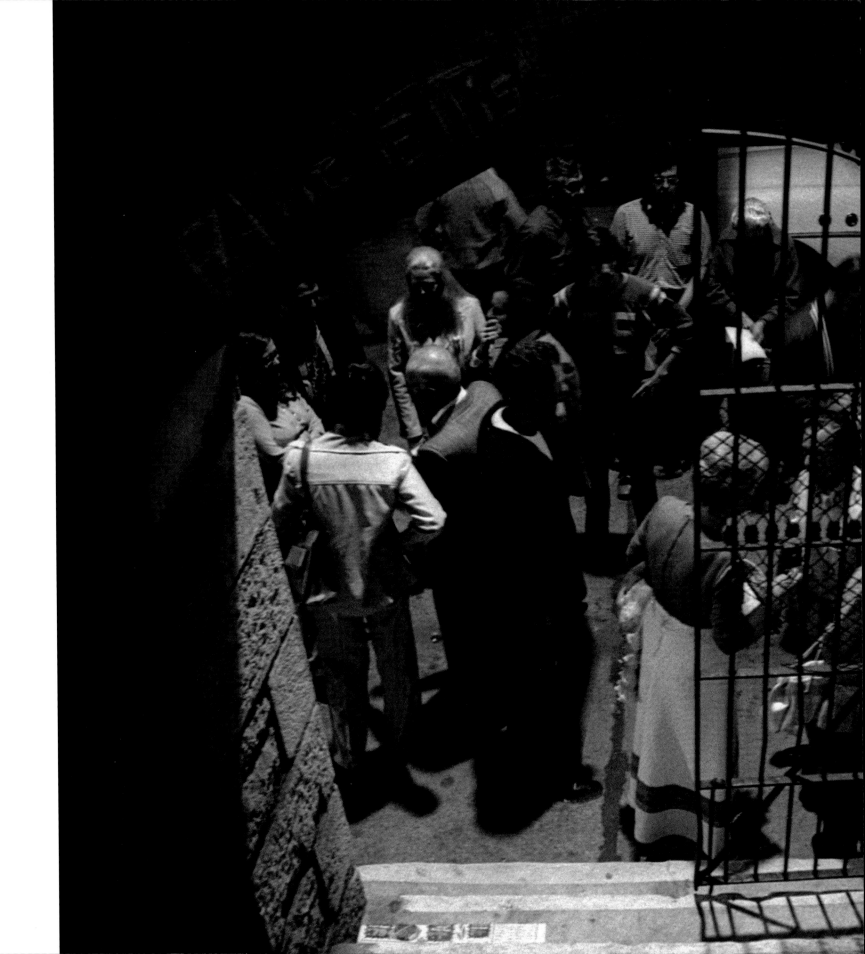

*Backstage Entrance*
This is a view from inside the Ryman looking down the steps to the backstage entrance. This was the entrance closest to Fifth Avenue. There were always people in the alley waiting to get an autograph or meet their favorite performer.

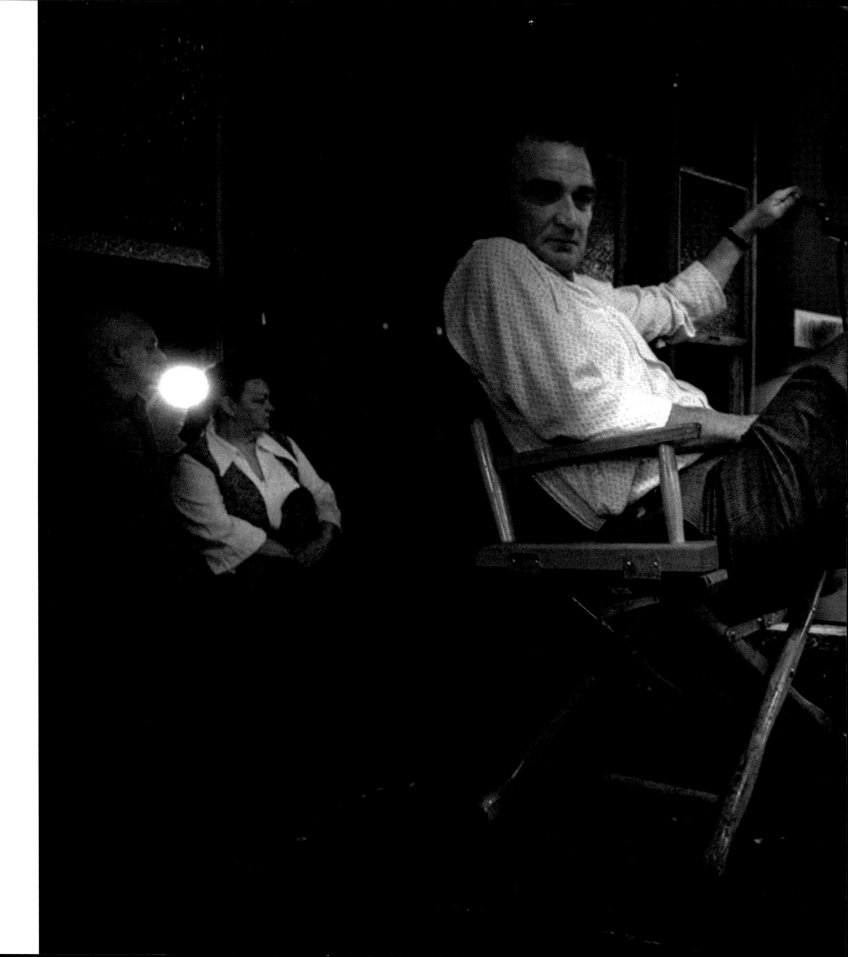

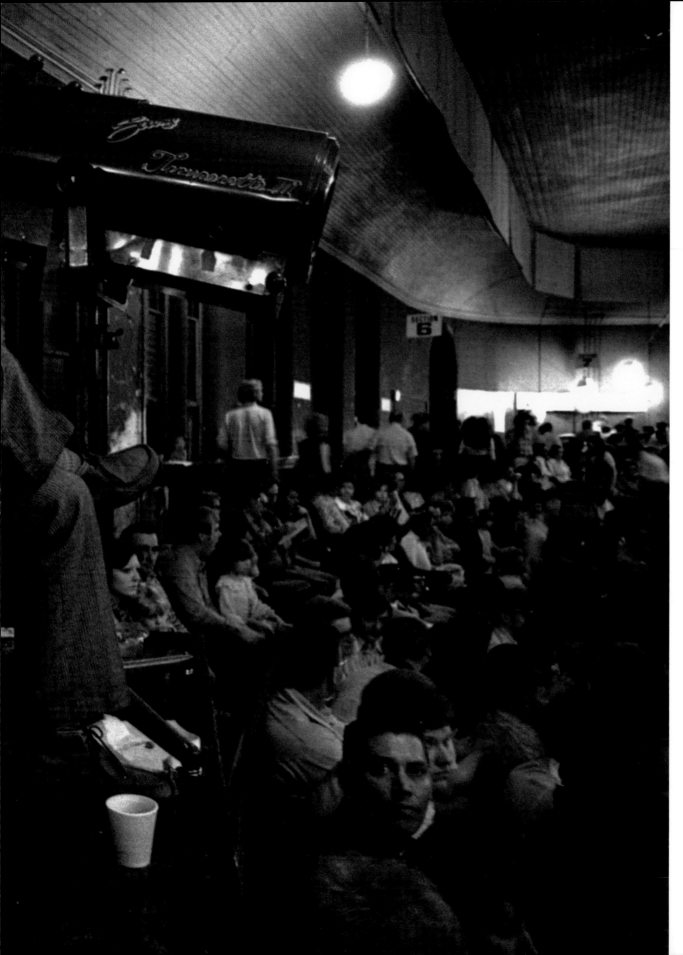

*Lighting Guy*
Donald Burnhardt was the stagehand who operated the spotlight that followed performers as they moved around onstage. The spotlight was on a platform at the very top of the balcony, about as high as one could get in the building. Burnhardt had a very hot job in the summer.

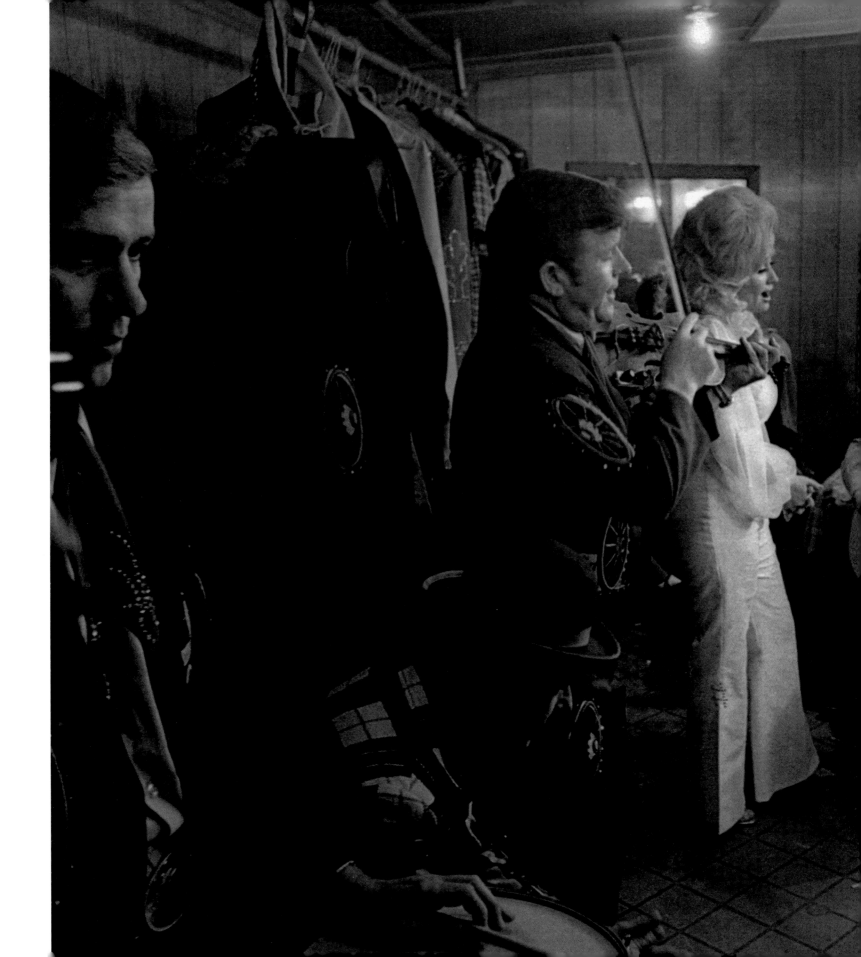

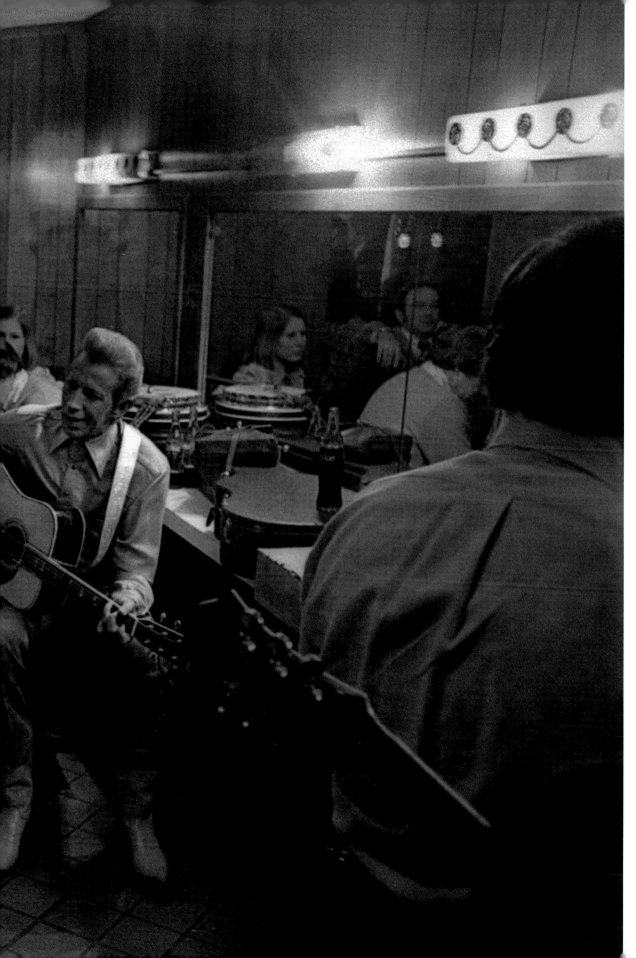

*Dressing Rooms*
Dressing room—hardly! In fact, conditions were so tight backstage that there was little or no privacy. Performers came dressed to go onstage. The cramped dressing rooms were shared by two or three performers and sometimes their bands, providing at best some semi-seclusion where artists and their bands could do a last-minute rehearsal before hitting the stage, just a few feet away. Shown here, Porter and Dolly rehearse a new song before going onstage as fiddler Mac Magaha joins in.

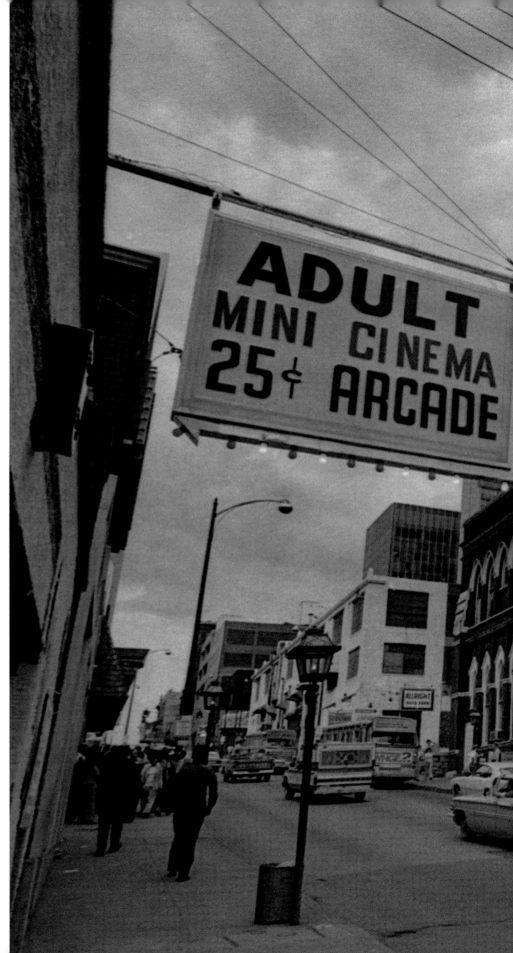

*Saturday Matinee*
Fans from across the country line up early
along Fifth Avenue to get the best seats for
the Grand Ole Opry.

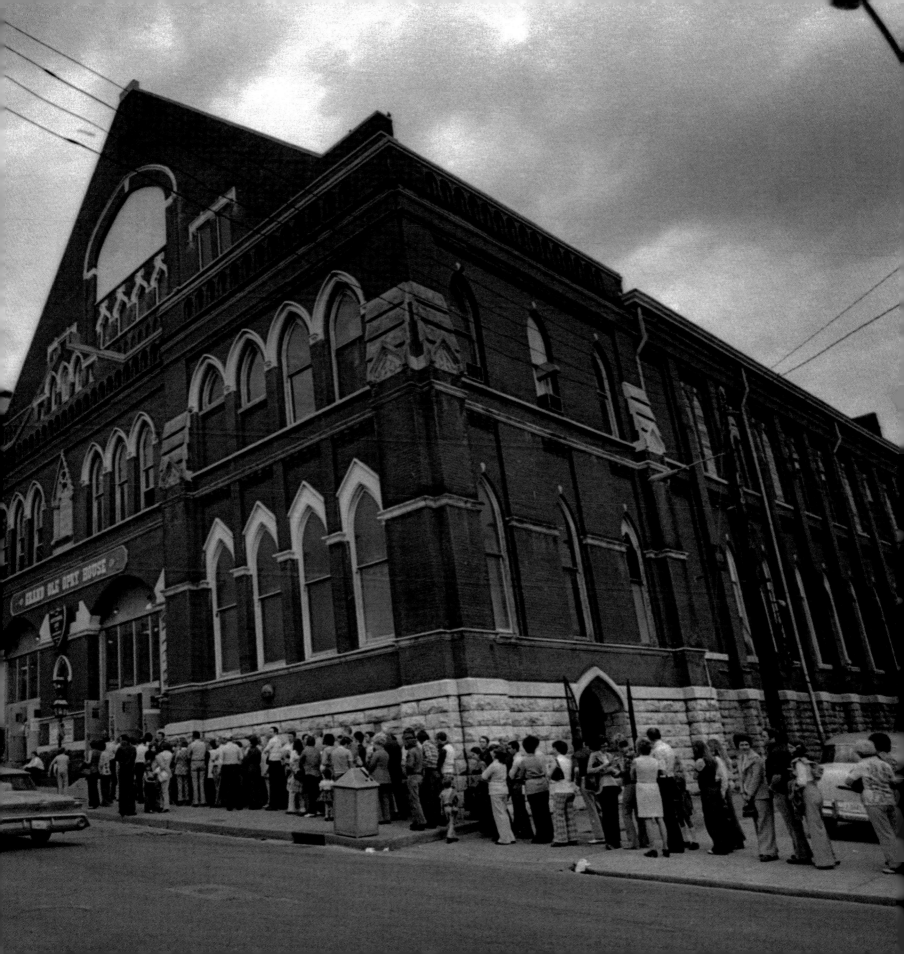

*Opry Tours*
Fans line up on Fifth Avenue, across the street from the Ryman. These were people waiting for a tour of the building or another tour of the city offered by Grand Ole Opry Tours.

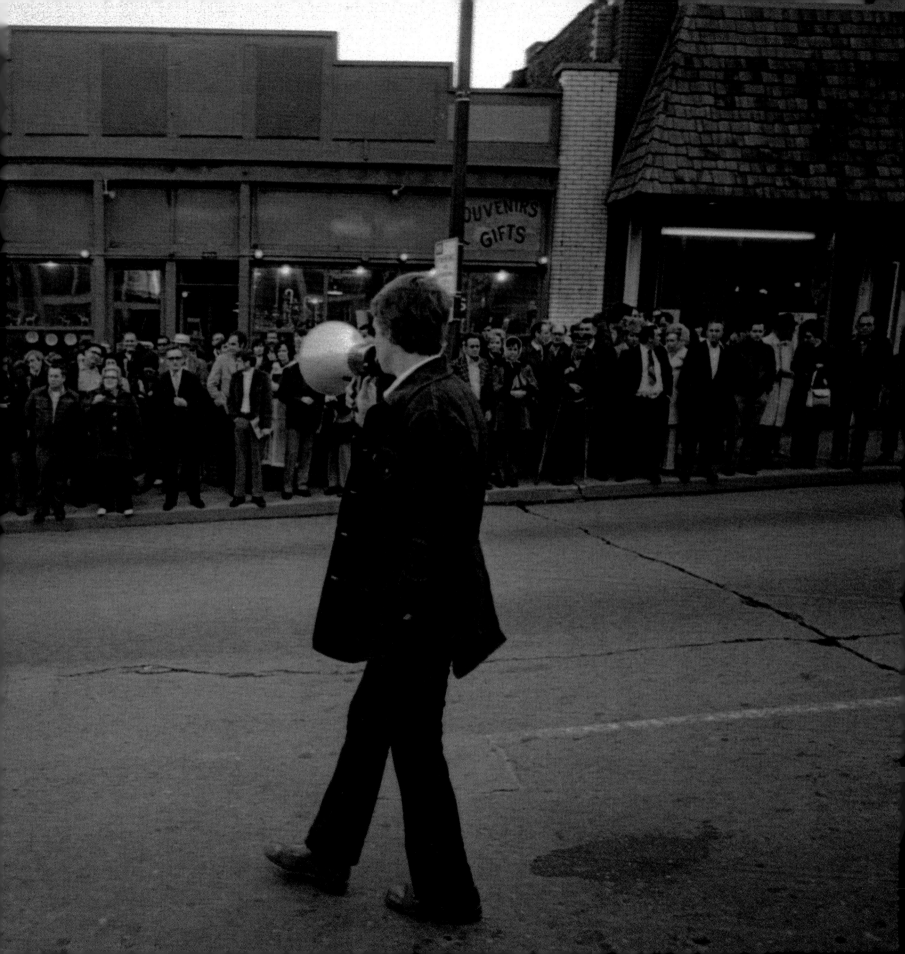

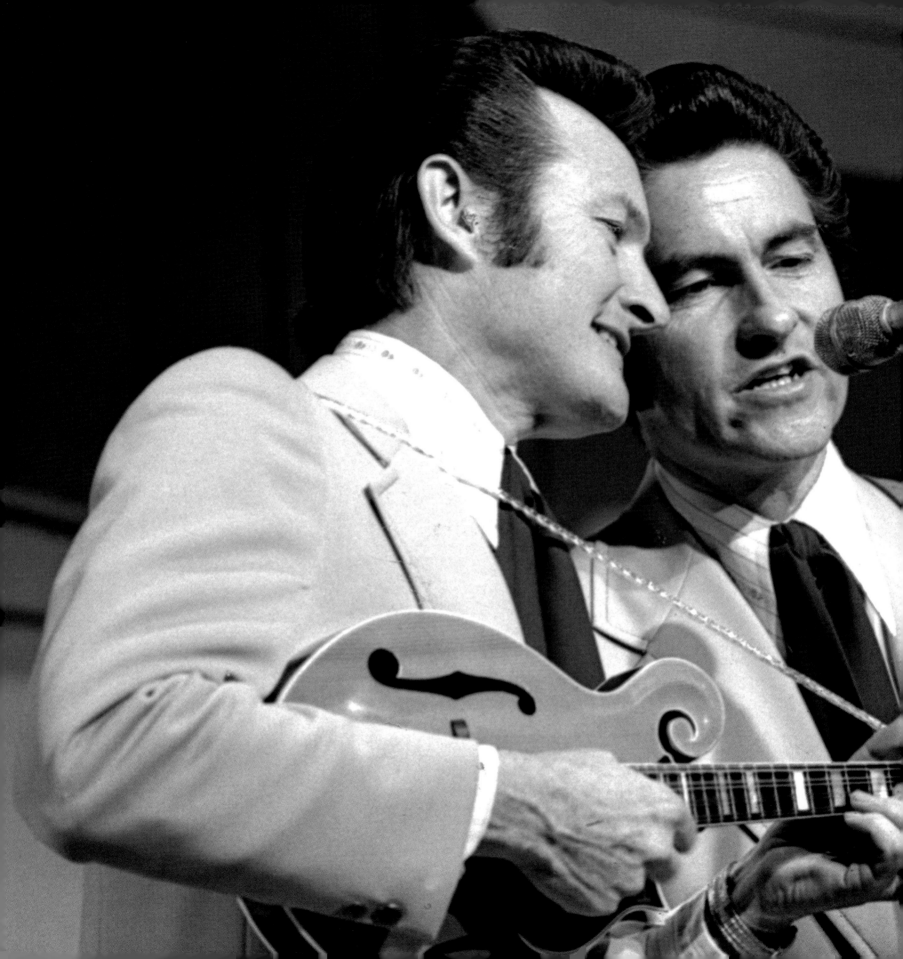

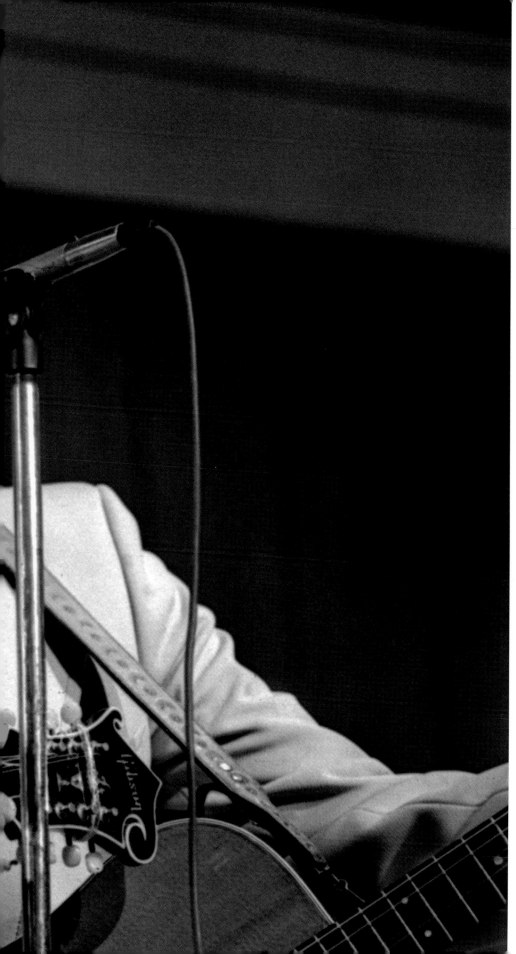

*Jim and Jesse*
Hard-core traditional bluegrass, from Southwestern Virginia. The McReynolds brothers were best known for their famous "brother" harmony singing and for Jesse's inventive cross-picking mandolin style.

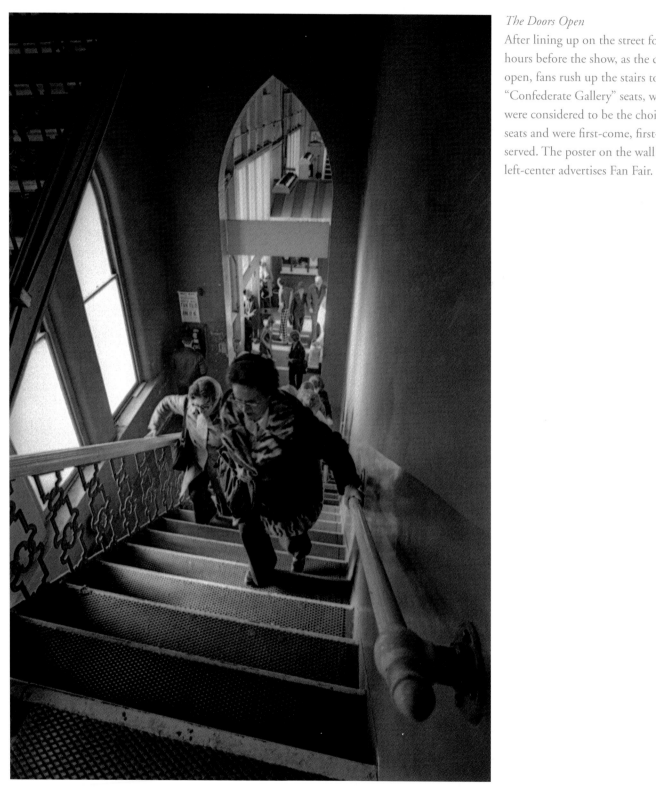

*The Doors Open*
After lining up on the street for hours before the show, as the doors open, fans rush up the stairs to the "Confederate Gallery" seats, which were considered to be the choice seats and were first-come, first-served. The poster on the wall at left-center advertises Fan Fair.

118

*A Minnie Moment*
Roy Acuff and Minnie Pearl were two of the most beloved members of the Opry. They were a standing reminder of where the Opry came from at a time when no one really knew where it was going, and the fans knew it. This image was captured on Old Timers Night. It was apparent to them both, and everyone watching, that times were about to change.

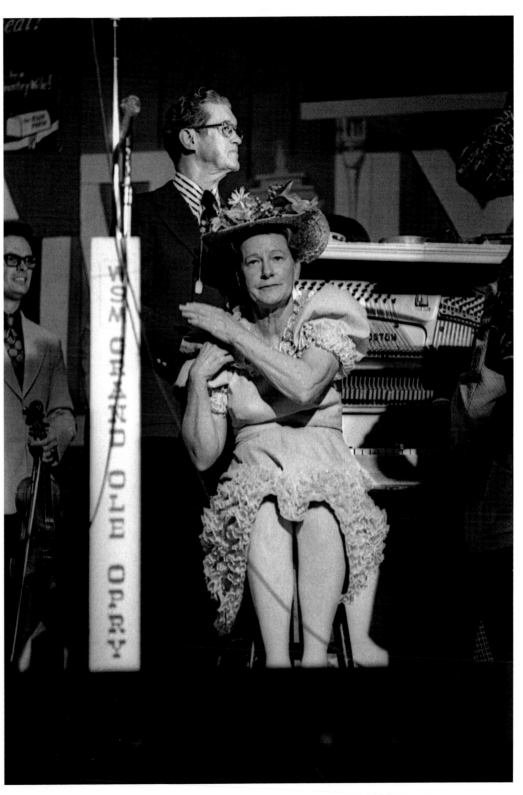

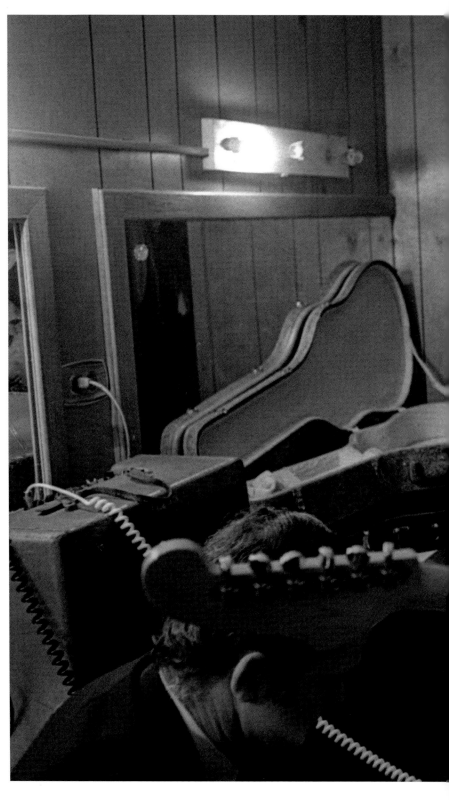

*Hank Snow*
A typical Saturday night in a crowded dressing room. Hank Snow rehearses a song with band member Curt Gibson as Opry member Billy Grammer looks on.

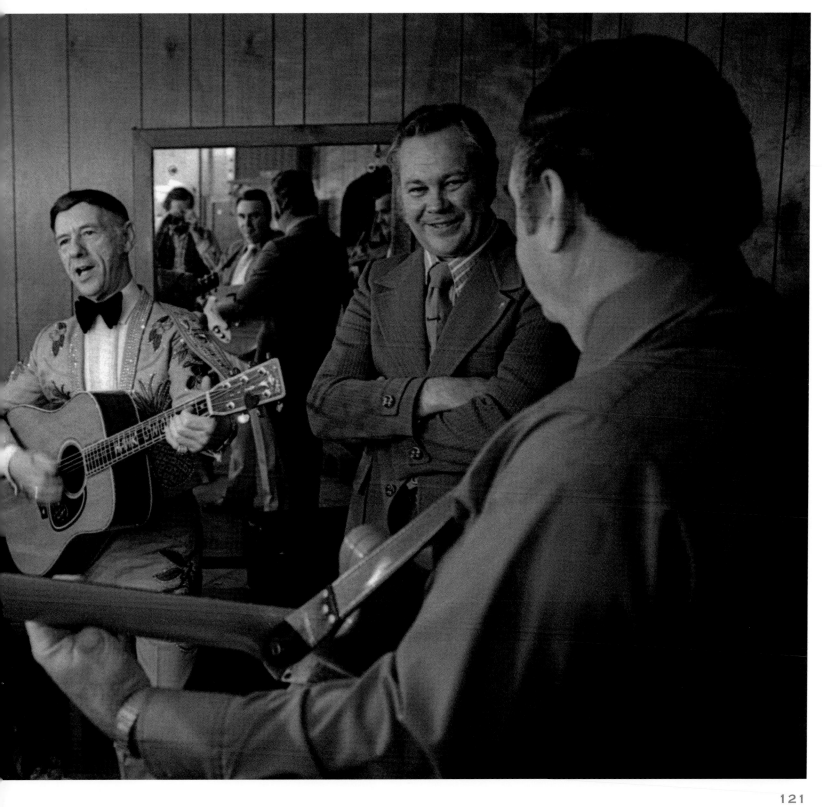

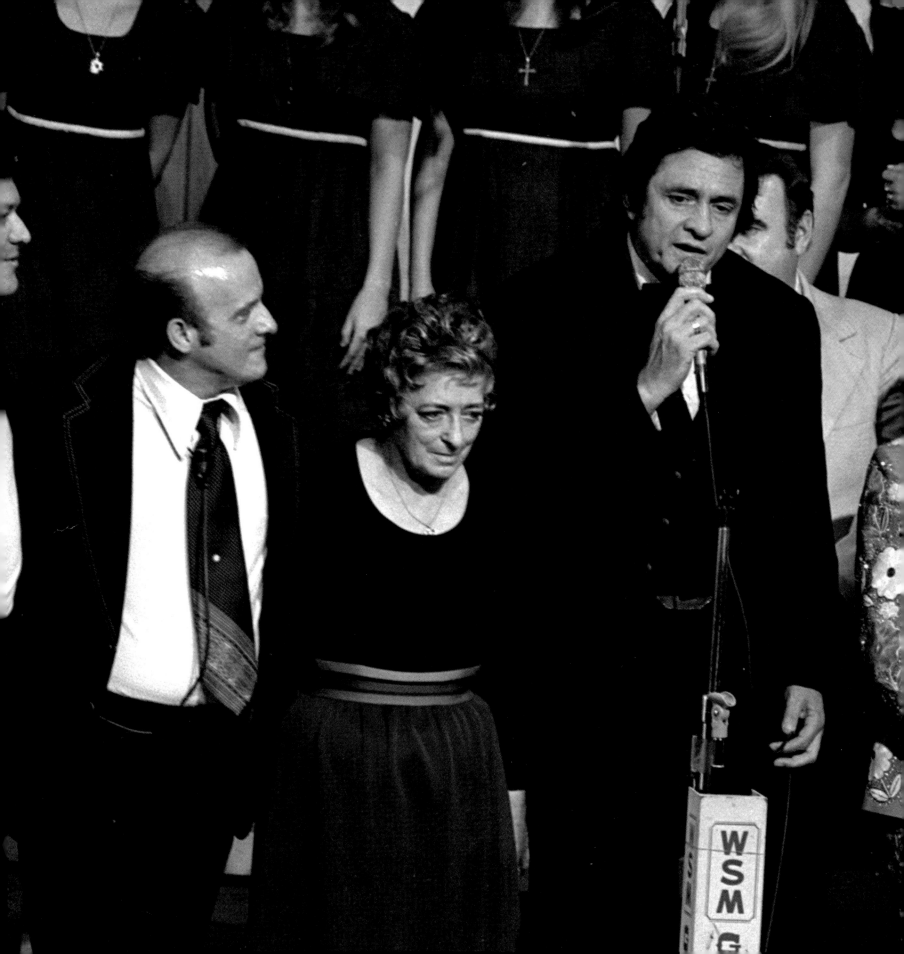

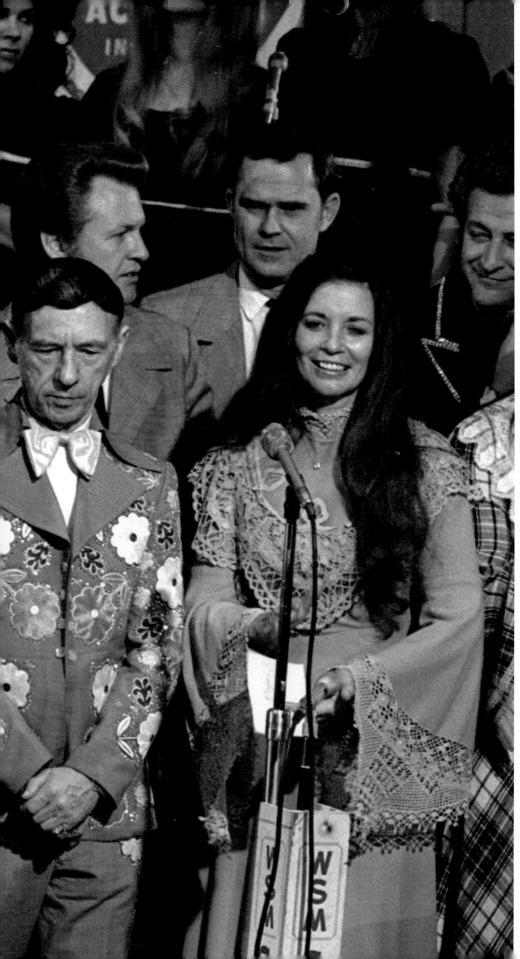

*Final Performance*
Onstage *(left to right)* are the Reverend Jimmie Snow, Mother Maybelle Carter, Johnny Cash, Hank Snow, and June Carter Cash. This image was recorded from the balcony during Jimmie Snow's Grand Ole Gospel Show after the regular Ryman performance and captures the scene during the last music onstage on the final night before the Ryman closed.

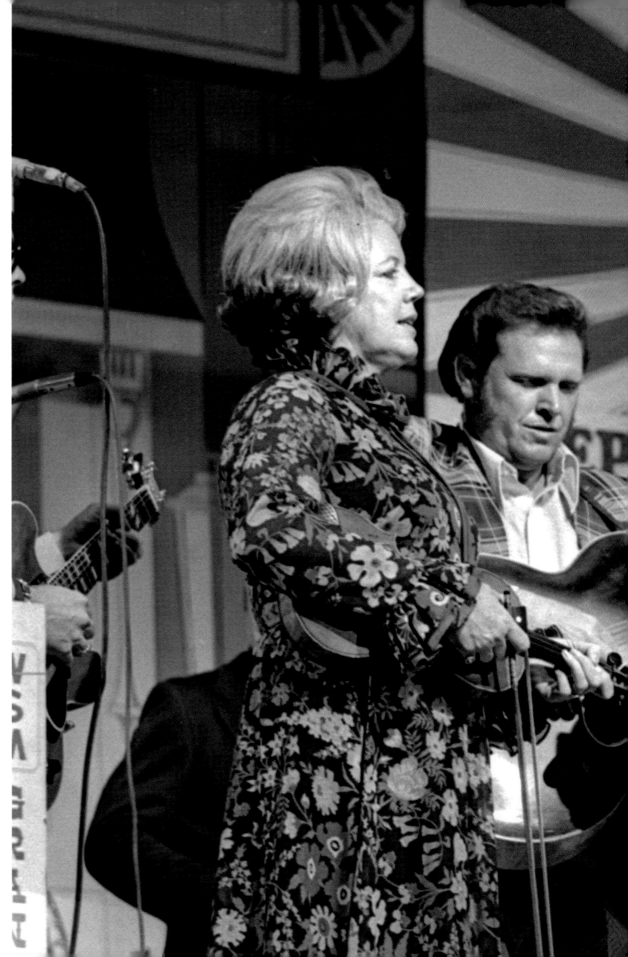

*Grandpa Jones*
Onstage during the Beech-Nut Tobacco segment of the show, the one and only Grandpa Jones frails off a number with the help of his wife, Ramona, on fiddle and George McCormick on guitar.

124

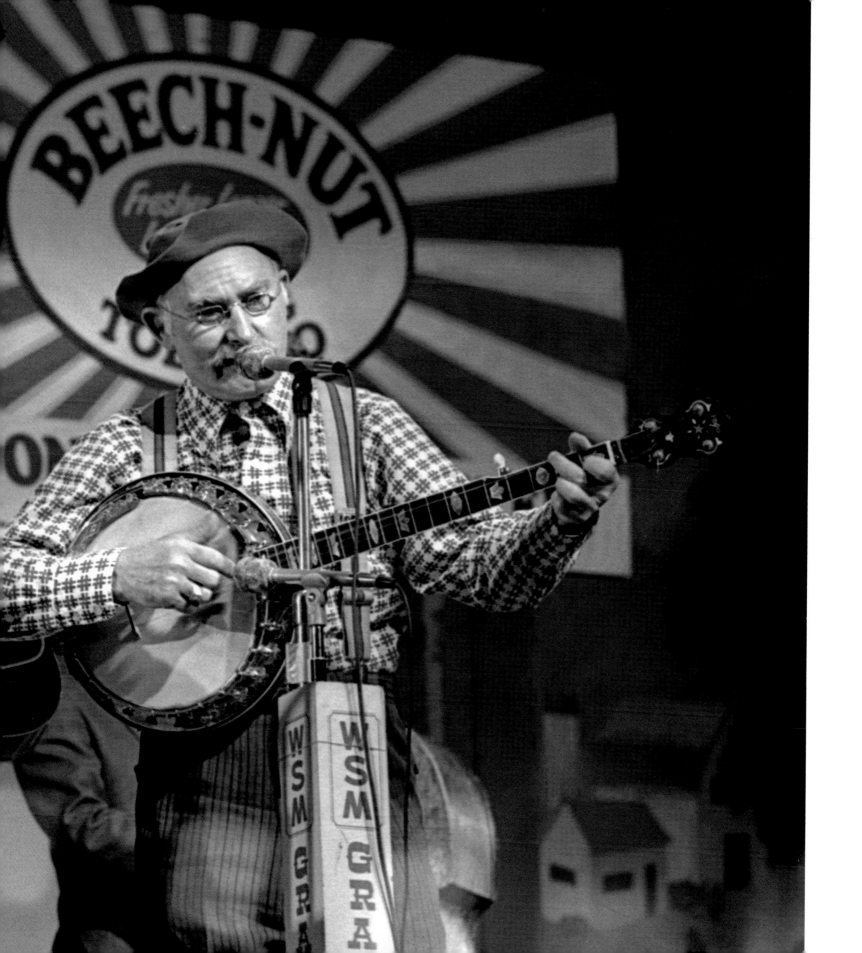

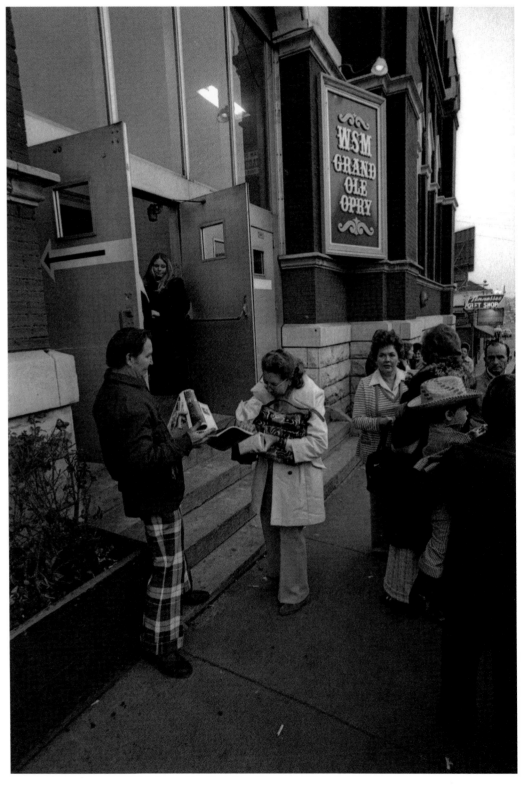

*Buying a Book*
A fan buys the official *WSM Grand Ole Opry History-Picture Book* with stories and photos of all the Opry cast members.

*Bare and Bare, Jr.*
The great Bobby Bare and his son
perform their hit duet, "Daddy,
What If," onstage. Bare Junior, as
he is known now, has become an
accomplished singer and songwriter in
the Nashville music scene.

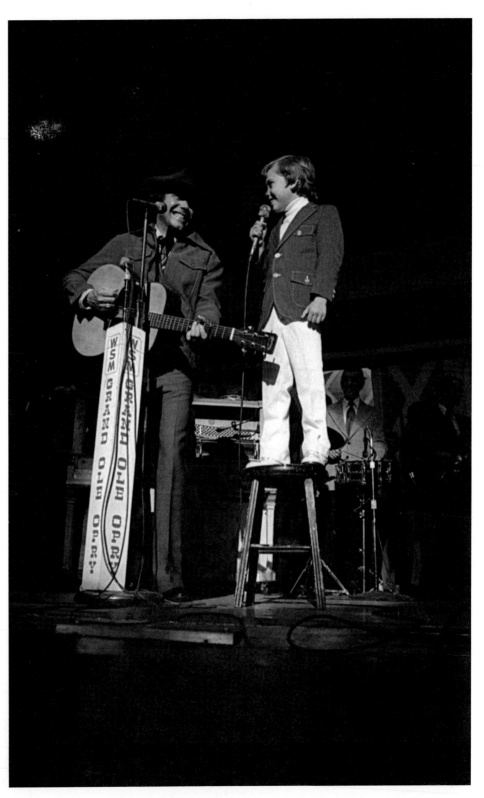

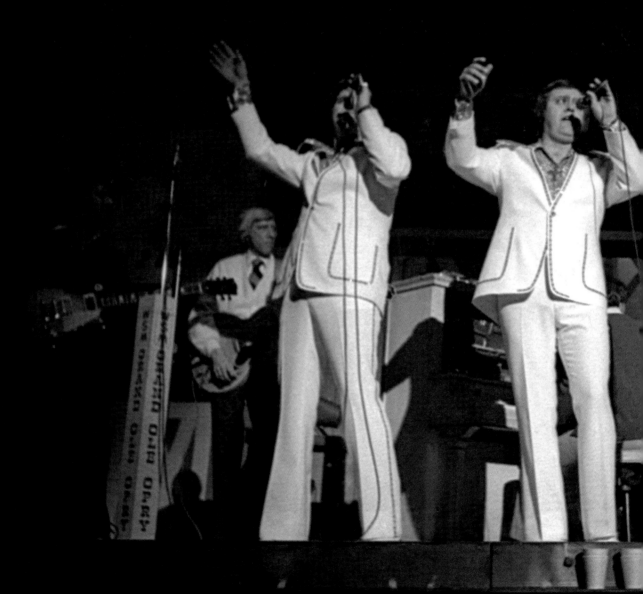

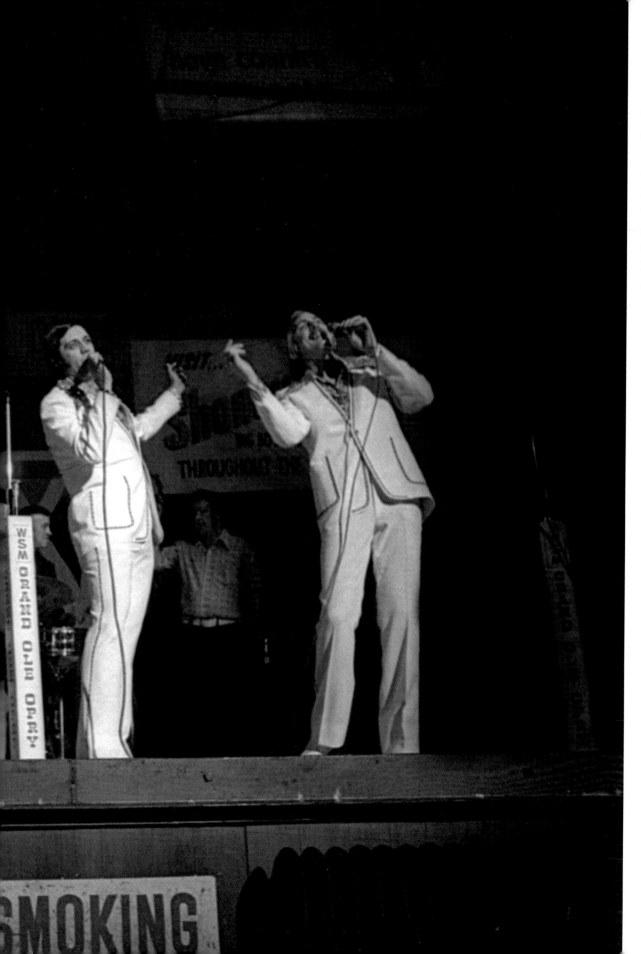

*The Four Guys*
This popular vocal group from Ohio became Opry members in 1967 and played through various configurations for 33 years. In later years, they sang background vocals for many of the Opry regulars and guest performers. Onstage here are Gary Buck, Brent Burkett, Sam Wellington, and Richard Garratt.

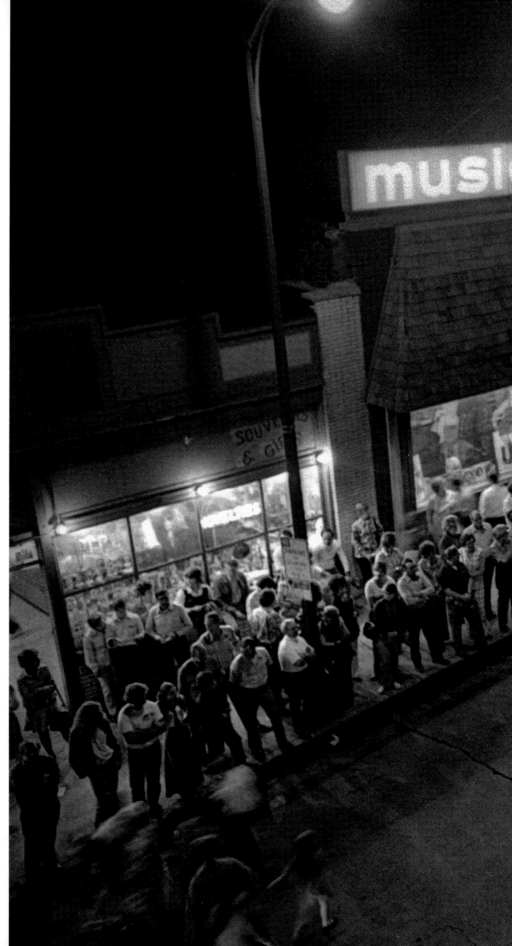

*Saturday Night on Fifth Avenue*
I shot this out of a window on the upper level of the Ryman. An Opry staffer with a bullhorn stands in the middle of Fifth Avenue, organizing the large crowd into lines before the early show.

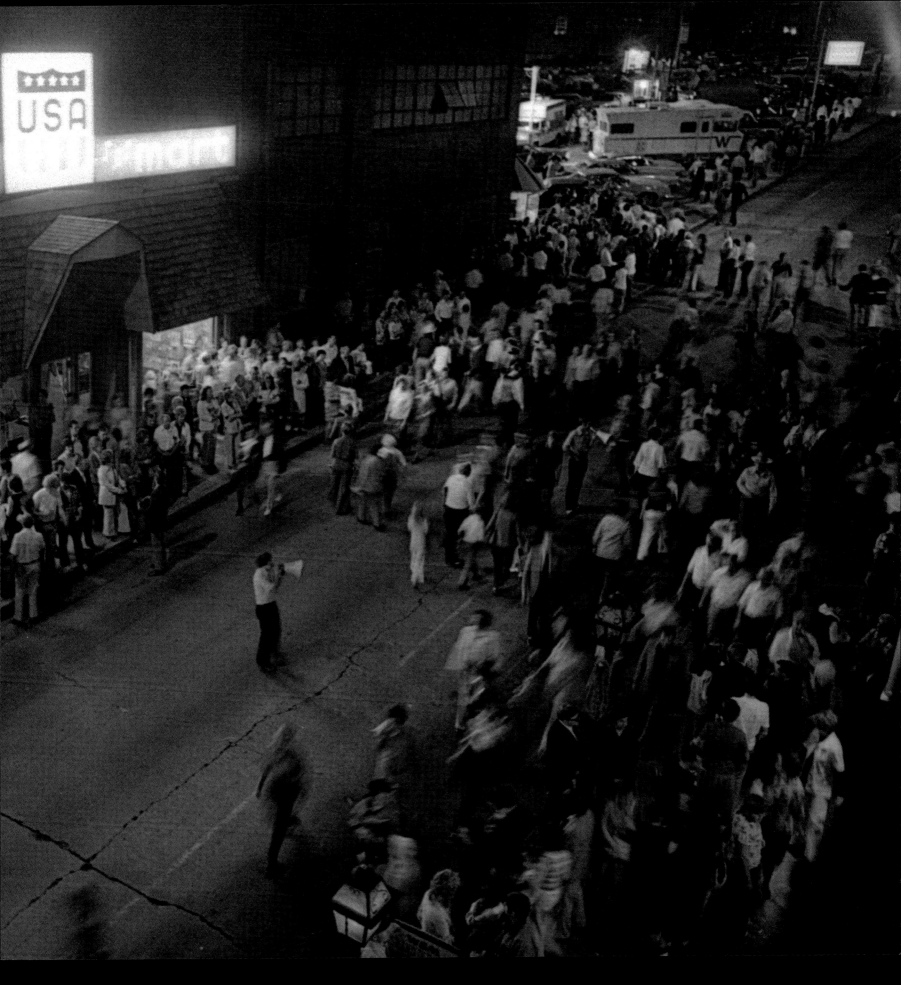

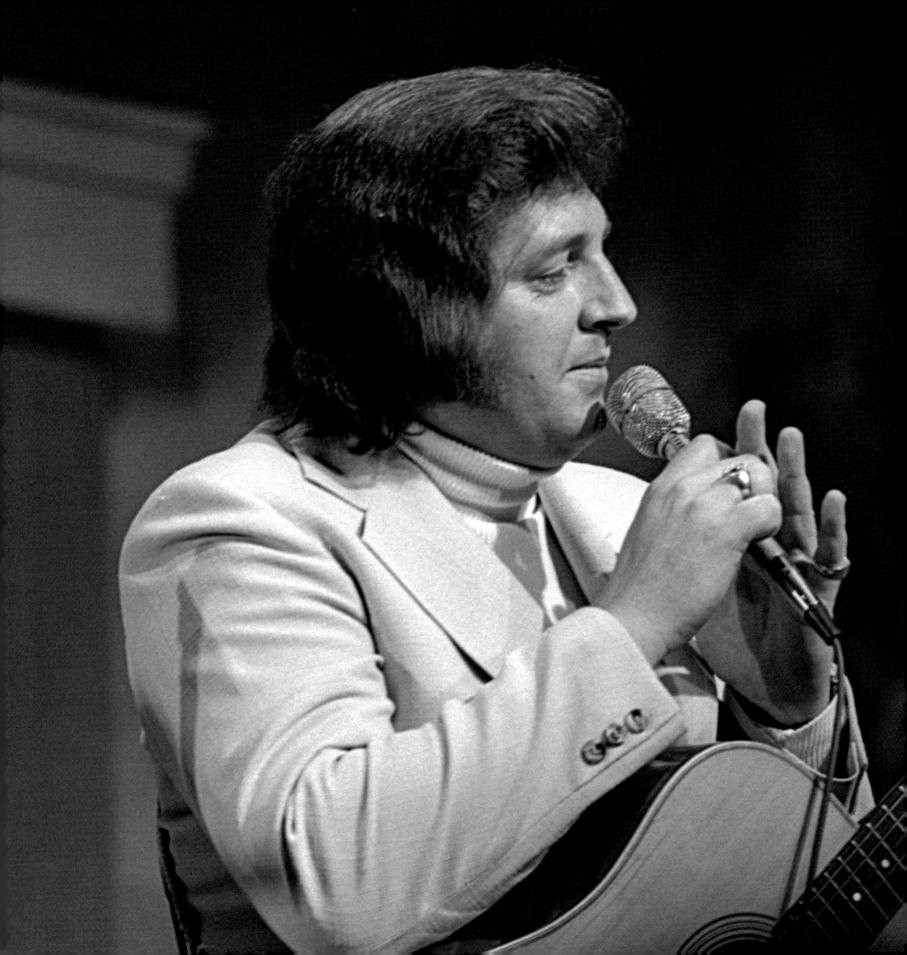

*Bob Luman*

Born in East Texas, Bob Luman became fascinated with rockabilly music after seeing a young Elvis Presley play a series of concerts in East Texas and Louisiana in 1955. In 1956 he joined the Louisiana Hayride and found a sixteen-year-old guitar player named James Burton. After three years of struggling to make it in the music business, he was about to accept a baseball contract with the Pittsburgh Pirates in 1959. However, the Everly Brothers talked him into recording "Let's Think About Living," which became a top-ten record, and he was on his way. He joined the Opry in 1965 and went on to have many records in the country charts until his untimely death at age 41, from pneumonia.

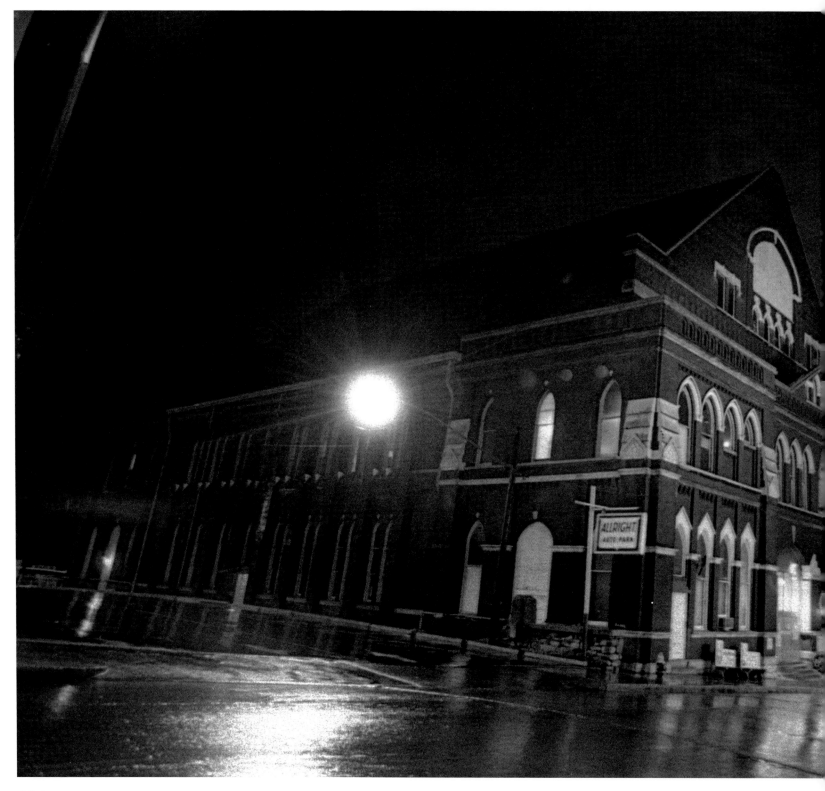

*Ryman in the Rain*
This was one of many attempts to record
the lightning shot used on the cover of this
book.

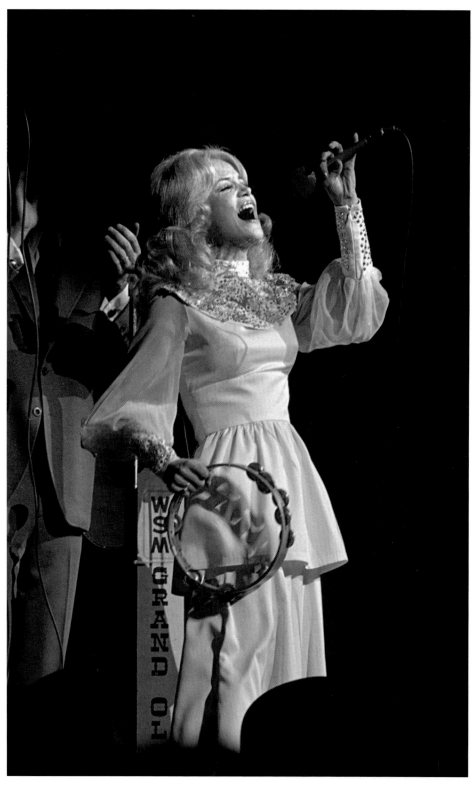

*Barbara Mandrell*
Playing music on the road from the age of 13, Barbara Mandrell played many instruments including steel guitar, accordion, and saxophone. Always lively onstage, she was one of the fans' favorites.

*Lester Flatt*
Lester Flatt has a smoke after a Saturday night performance. After playing with the great Bill Monroe band, he and Earl Scruggs joined up as Flatt and Scruggs and played together for more than twenty years. When Lester and Earl split in 1969, Lester formed his own band, the Nashville Grass.

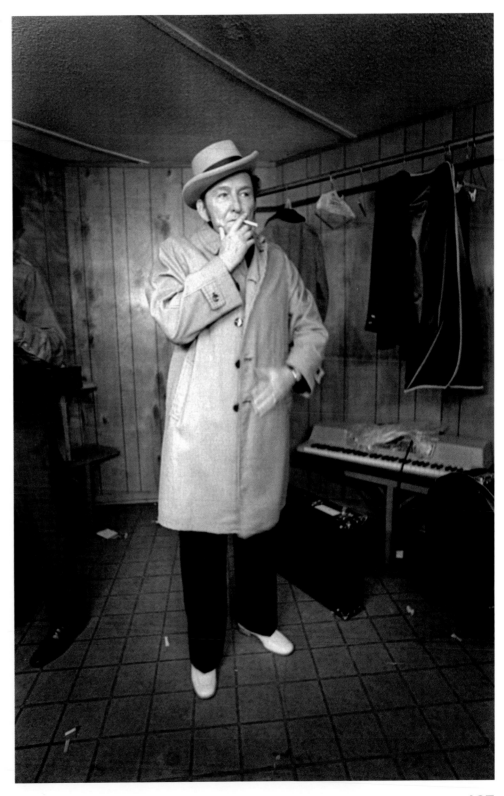

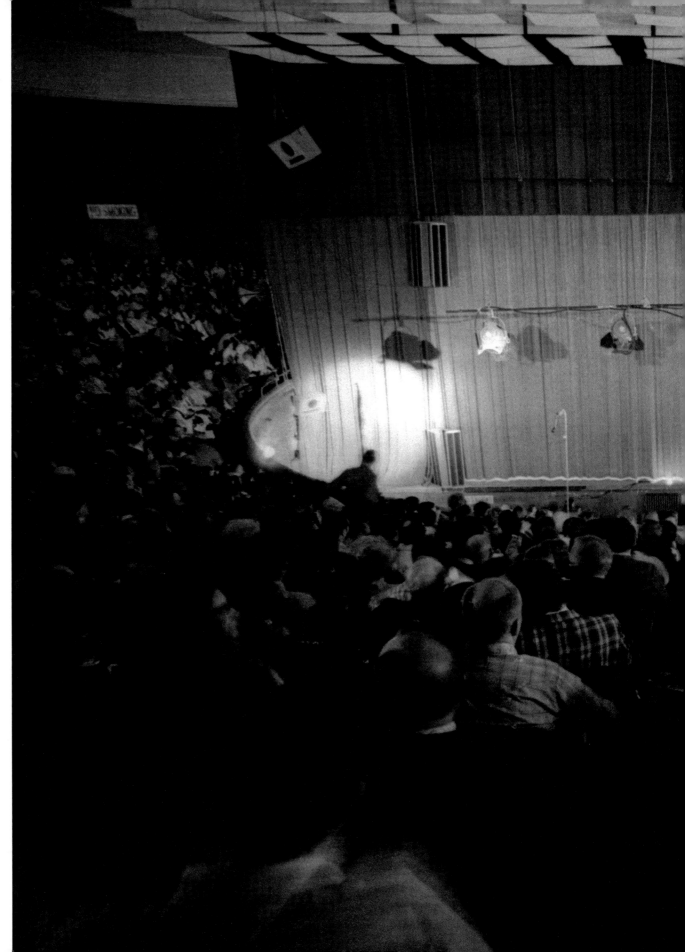

*Final Opry Segment*
The packed house waits for the curtain to part for the final Opry performance in the Ryman before the move. This picture was shot from the center of the very back of the balcony.

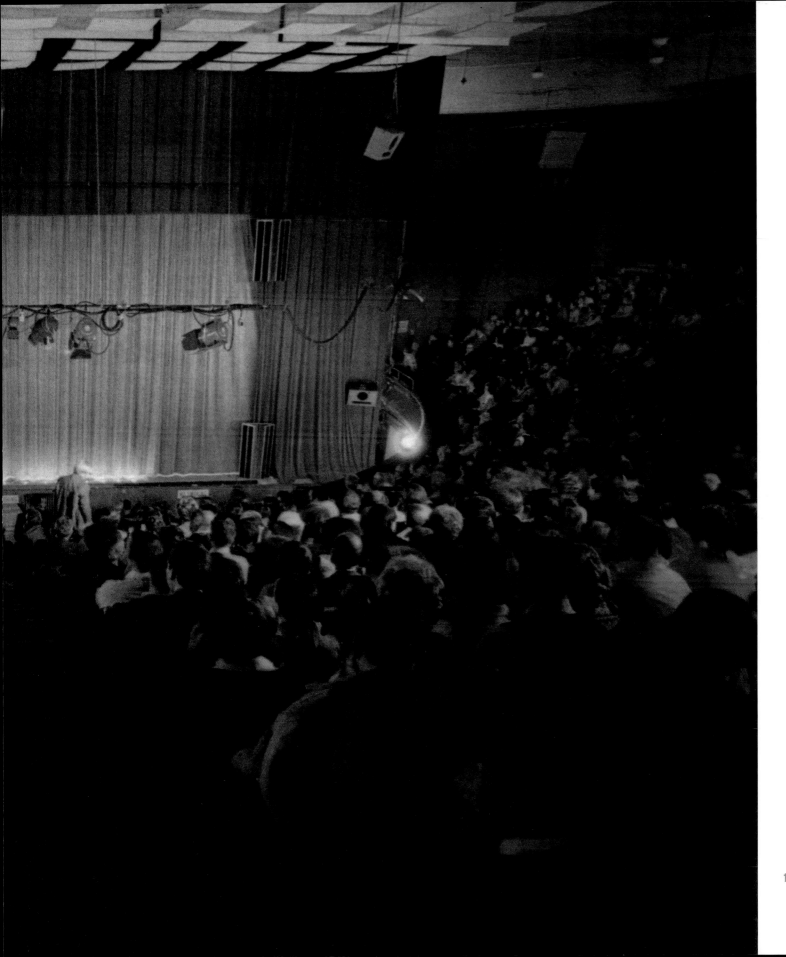

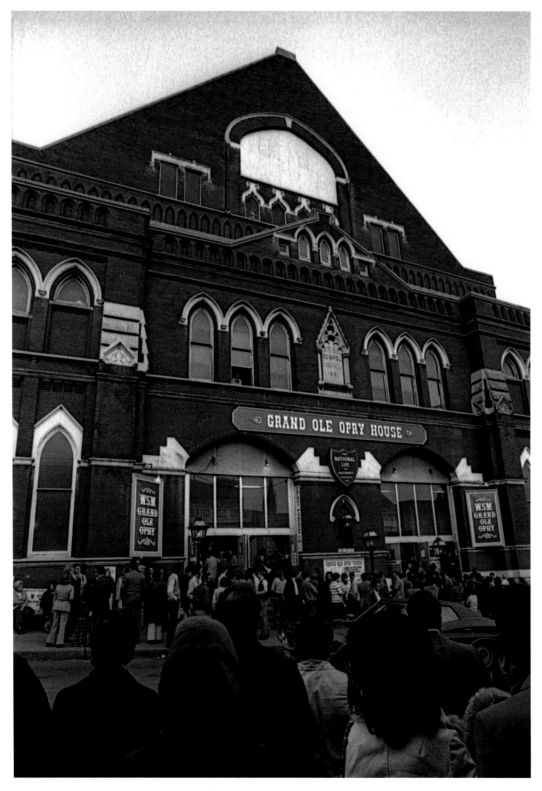

*Ryman Alley*
This was the alley that ran alongside the Ryman between Fourth and Fifth avenues. There were always fans waiting to see their favorite Opry stars as they came and went.

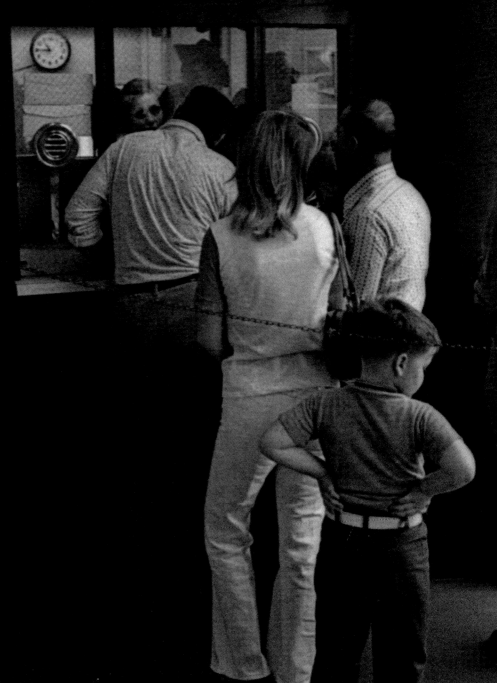

GRAND OLE OPRY HOUSE

1st SHOW 6:30-9:00
2nd SHOW 9:30-12:00
RESERVED SEATS      $3.00
GENERAL ADMISSION   $2.00

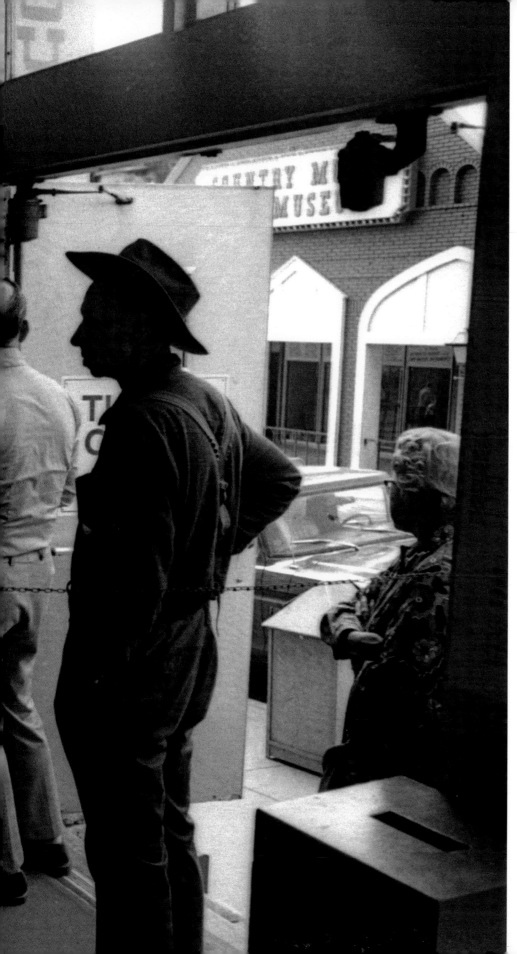

*Fans Buying Ticket*

For me, it was always interesting to see who was in this Opry audience. The ones that would actually make the trip. Mostly hard, white faces from hard-working towns, far away. Babies to wheel chairs. A few city folks mixed in… but not many. This is the ticket window at the Fifth Avenue entrance. Fans could buy tickets to one of the greatest shows on earth. For $3.00.

143

*Ryman Entrance*
This is the main entrance to
the Ryman on Fifth Avenue. In this
image, the staff is opening the doors
for an evening's performance.

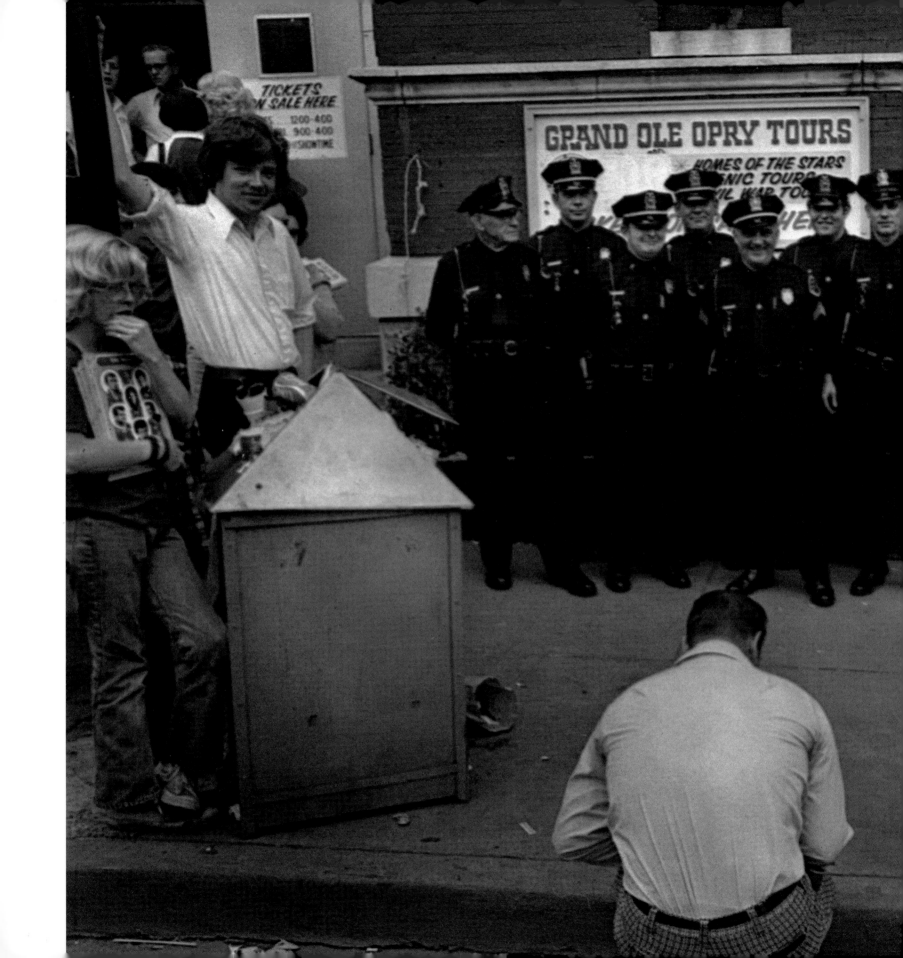

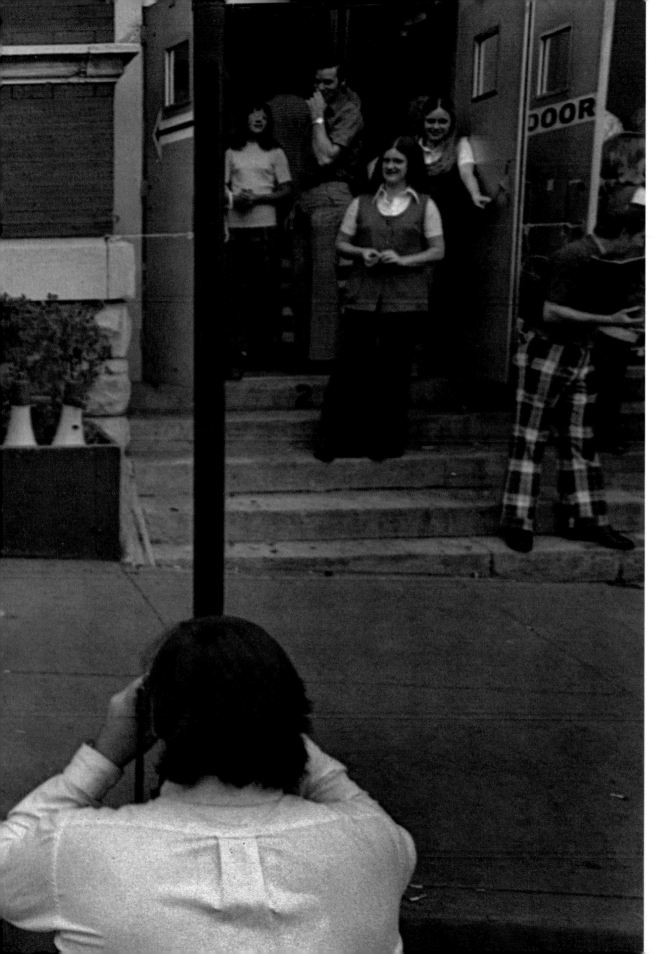

*Friendly Cops*
Opry security was mostly off-duty metro firemen wearing their very official looking uniforms. Their main challenge was to keep people from climbing in through the windows.

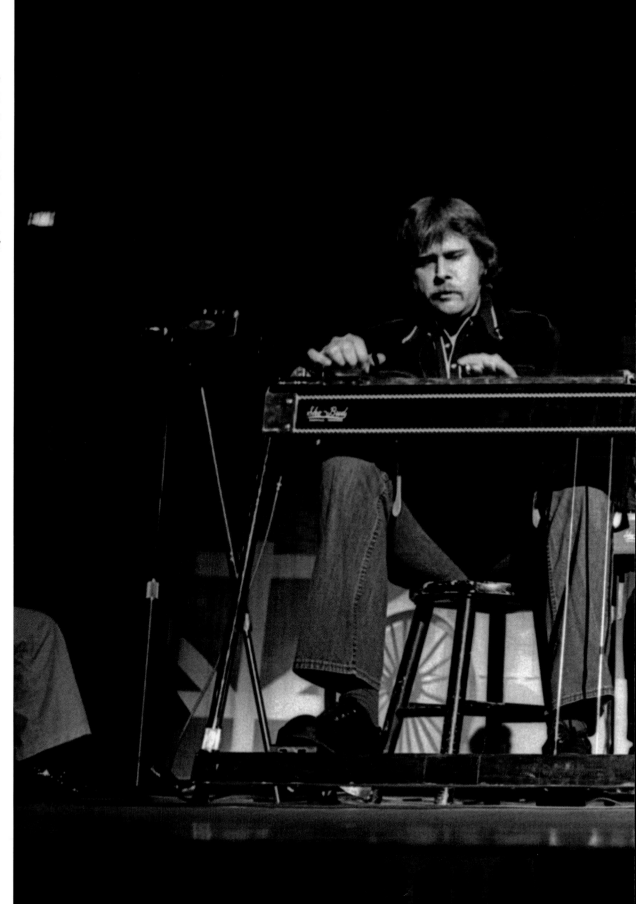

*Hal Rugg and Weldon Myrick*
Two of the legendary pedal steel guitar players were both in the Opry house band and would back up various performers who didn't bring their own bands. Hal Rugg and Weldon Myrick recorded an album with another Opry pedal steel guitarist, Sonny Burnette, called *Steel Guitars of the Grand Ole Opry.*

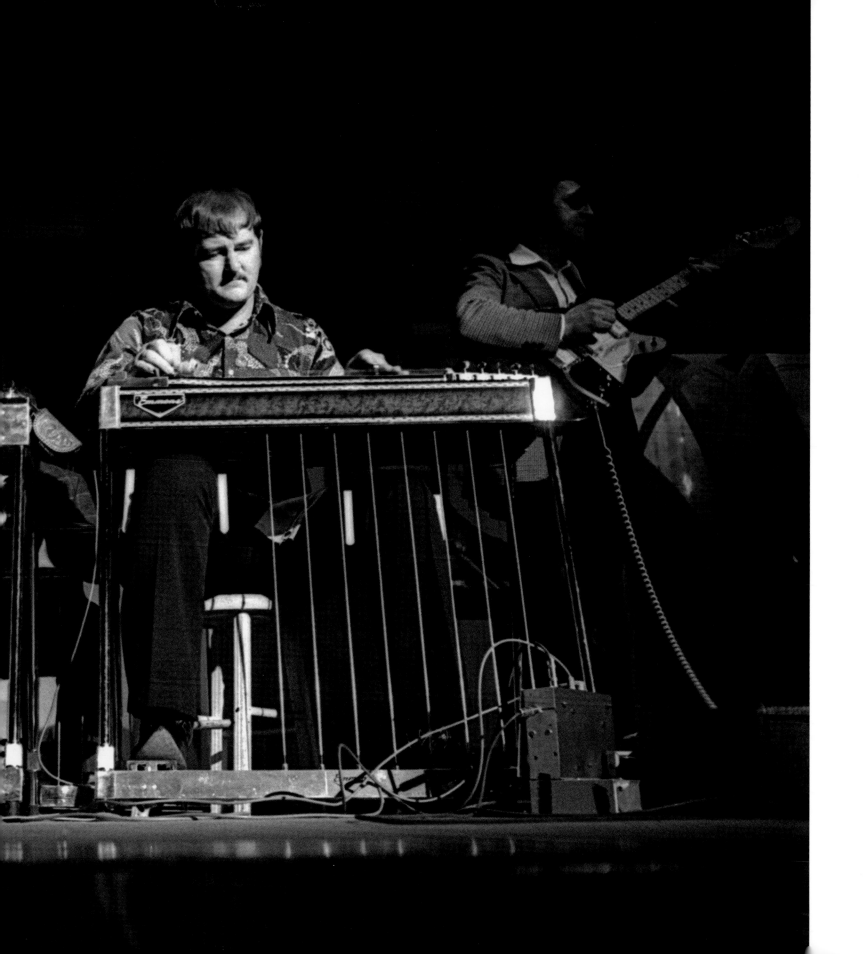

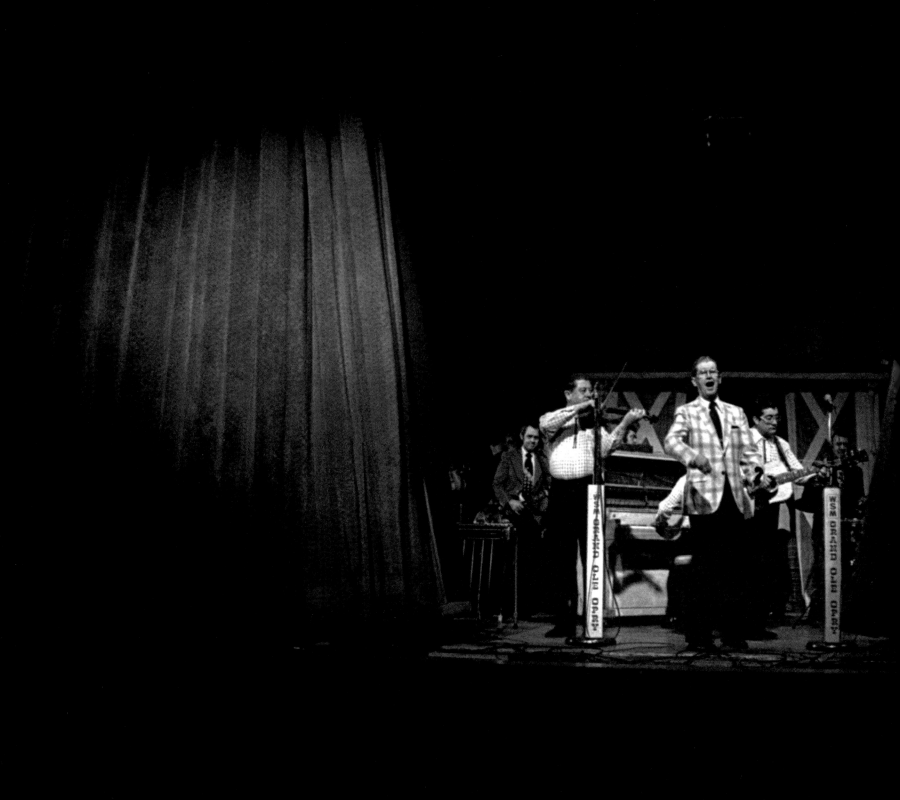

*Final Performance*
The curtain opens for Roy Acuff on the final Opry segment of the final night. Mr. Acuff always claimed that he couldn't wait to move into the new Grand Ole Opry House, but no one knew whether to believe him.

*Bill Anderson*
Given the name "Whispering Bill" for his smooth and soft singing style, Bill Anderson has been a performing Opry member since 1961. He has a truckload of awards and in recent years has continued his prolific songwriting. Many of his songs have been recorded by today's younger country stars.

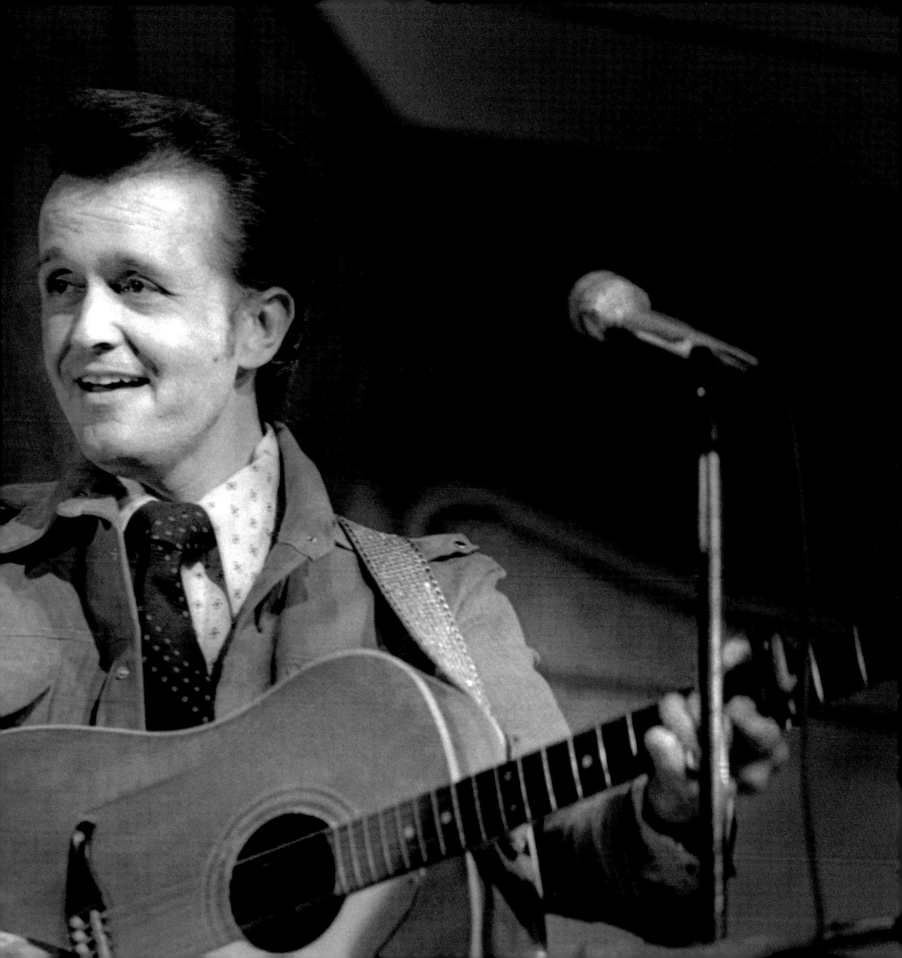

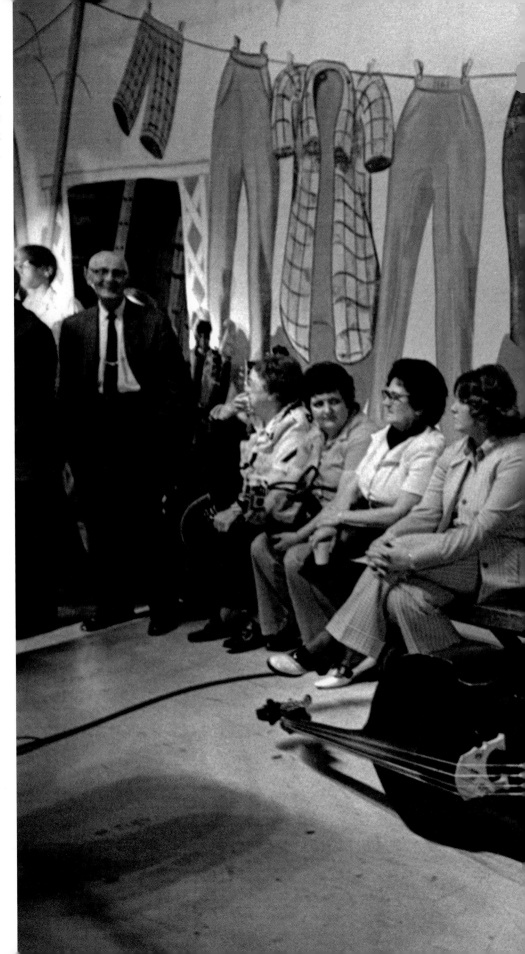

*Stage Seating*
Family and guests of Opry performers sit at the
rear of the stage in front of the "Stevens Work
Clothes" backdrop.

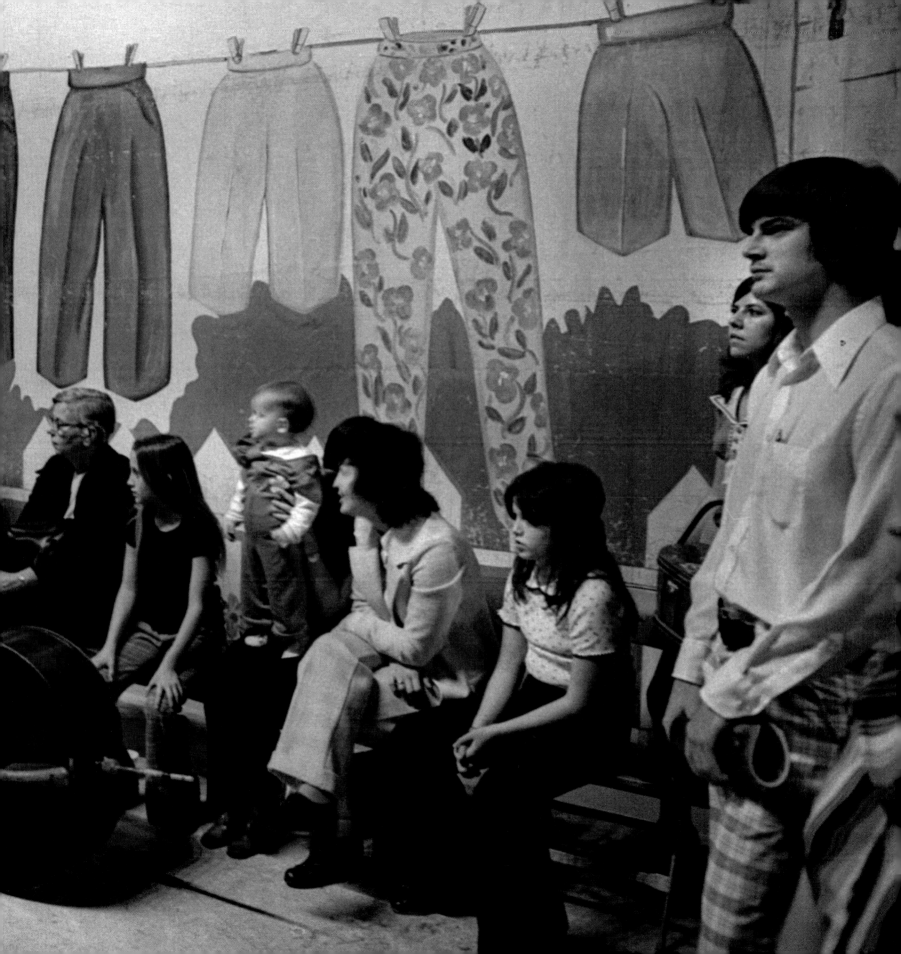

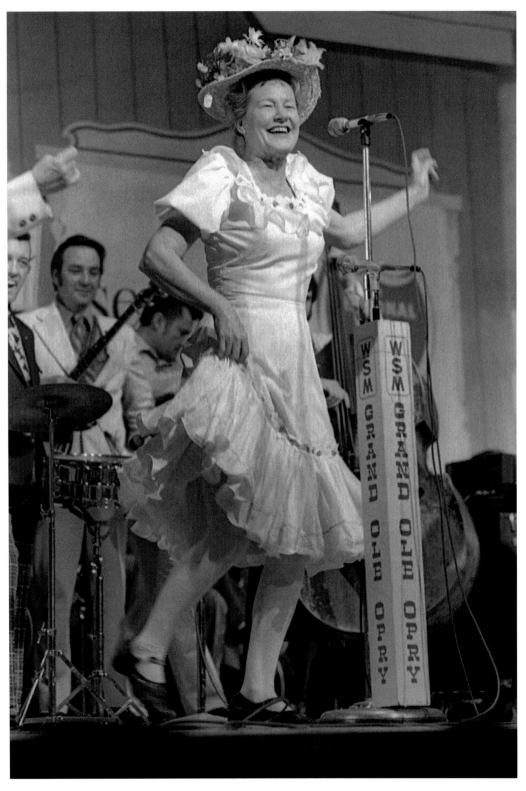

*Minnie Dancing*
The great Minnie Pearl comes alive onstage. As comedian, storyteller, sometime singer, philosopher, and dancer, she became one of the Opry's most popular performers after becoming a member in 1940. Although she was mostly known for her stories about country people and small towns, she never missed a chance to break into spontaneous dance.

*After the Last Show*
Opry staff workers take down signs just after the final Friday night show. This was the staircase to the balcony and was located in the back of the Ryman.

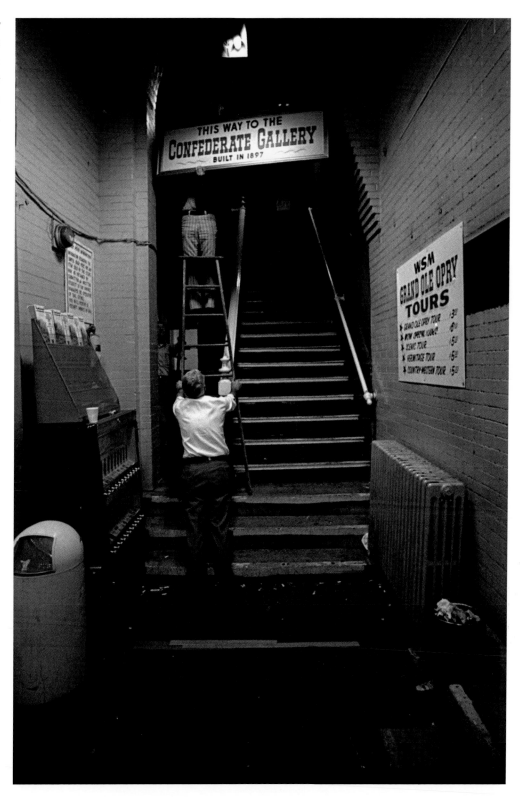

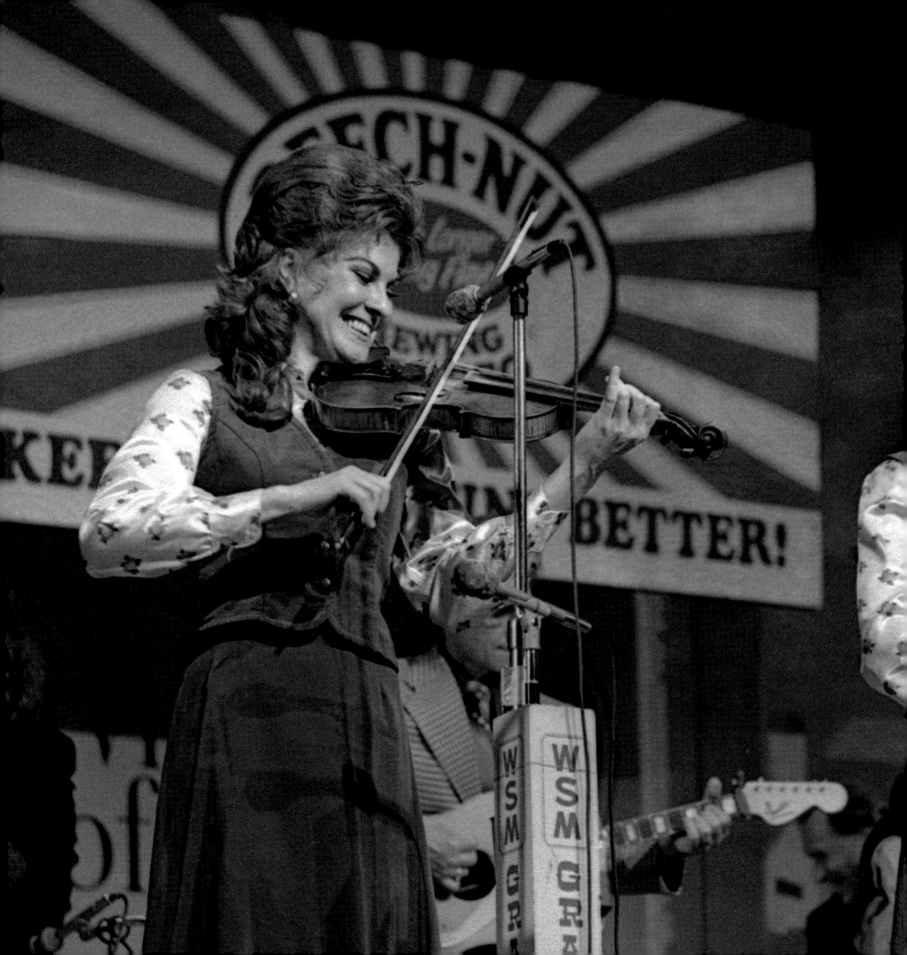

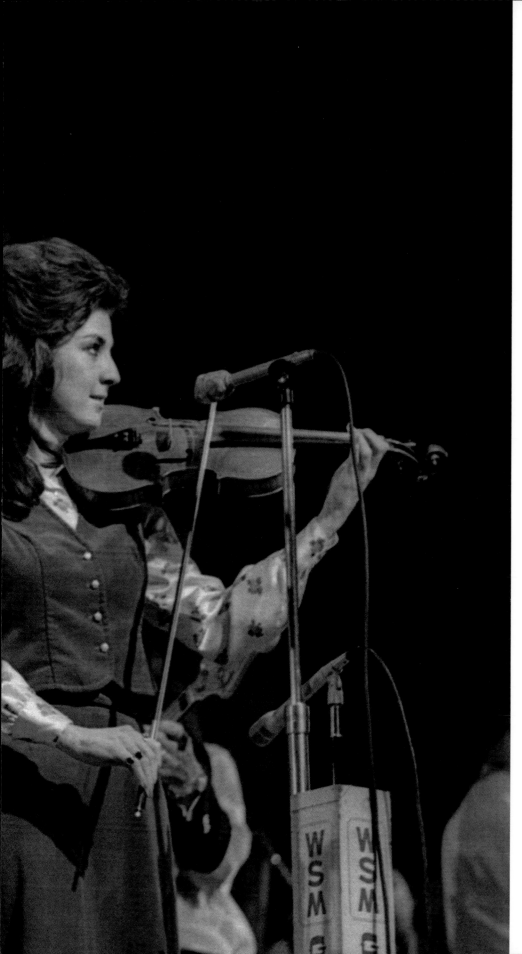

*Cates Sisters*
Originally from Independence, Missouri, the sisters, Marci and Margie, played fabulous twin fiddle numbers that always delighted audiences. They were part of the Jim Ed Brown show and also sang trio harmonies with him.

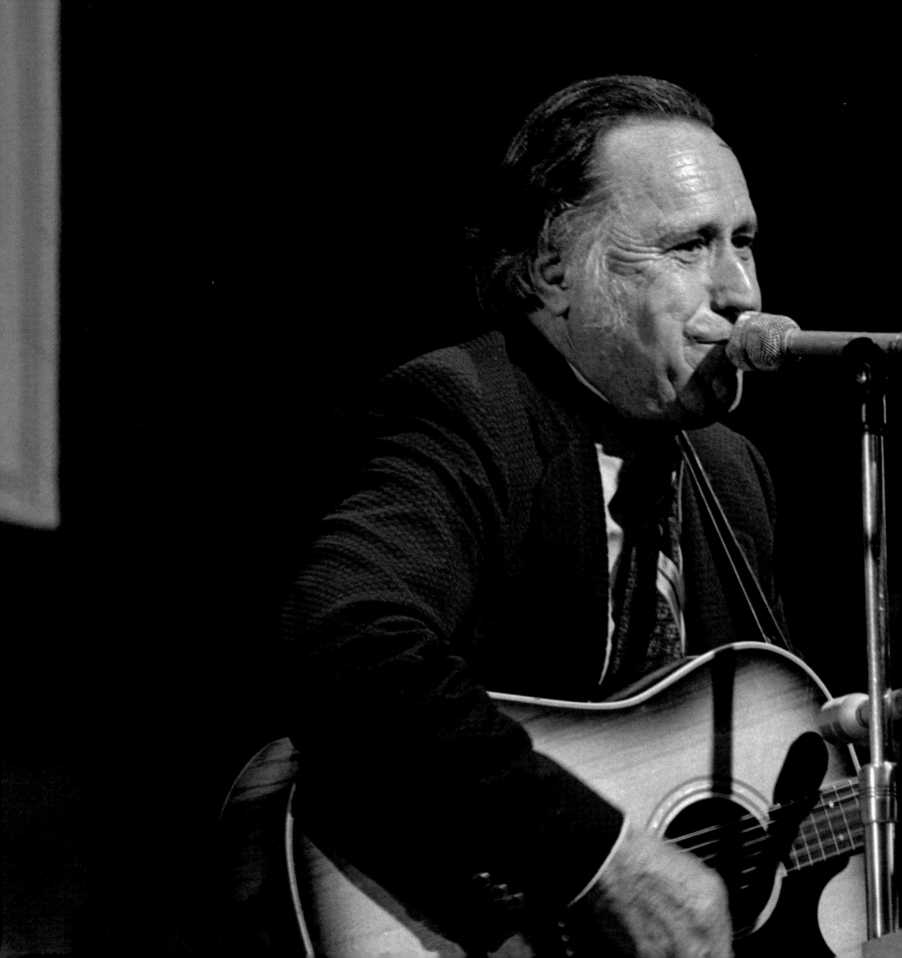

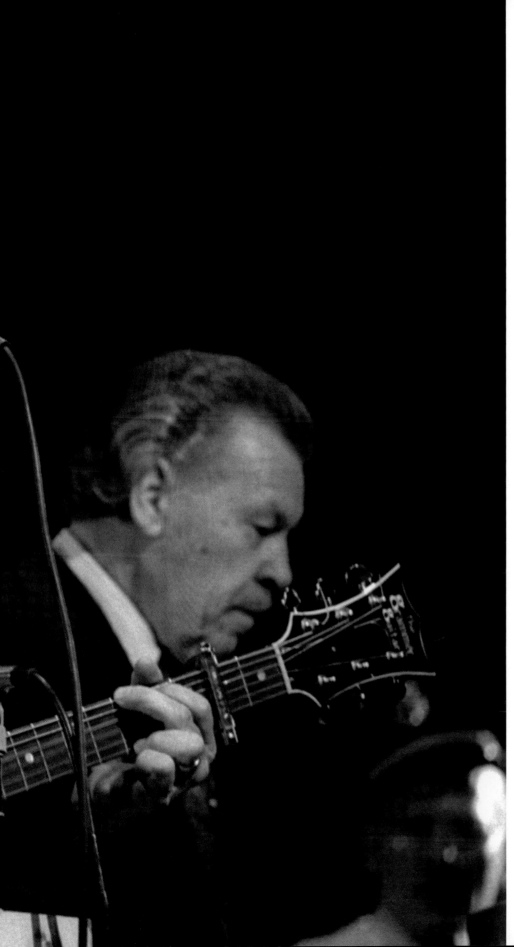

*Bill Carlisle*
Born in 1908 in Wakefield, Kentucky, Bill Carlisle performed with his brother Cliff in the very popular duo the Carlisle Brothers during the 1930s. He earned the nickname "Jumpin' Bill Carlisle" for his wild stage antics, often jumping into the air and throwing things from the stage while performing.

*Billy Walker Onstage*
Known as "the Tall
Texan," Walker was an
Opry member from
1960 until his untimely
death in 2006 in a tragic
car accident. Here he
sings at center-stage
with the Opry staff band
behind him.

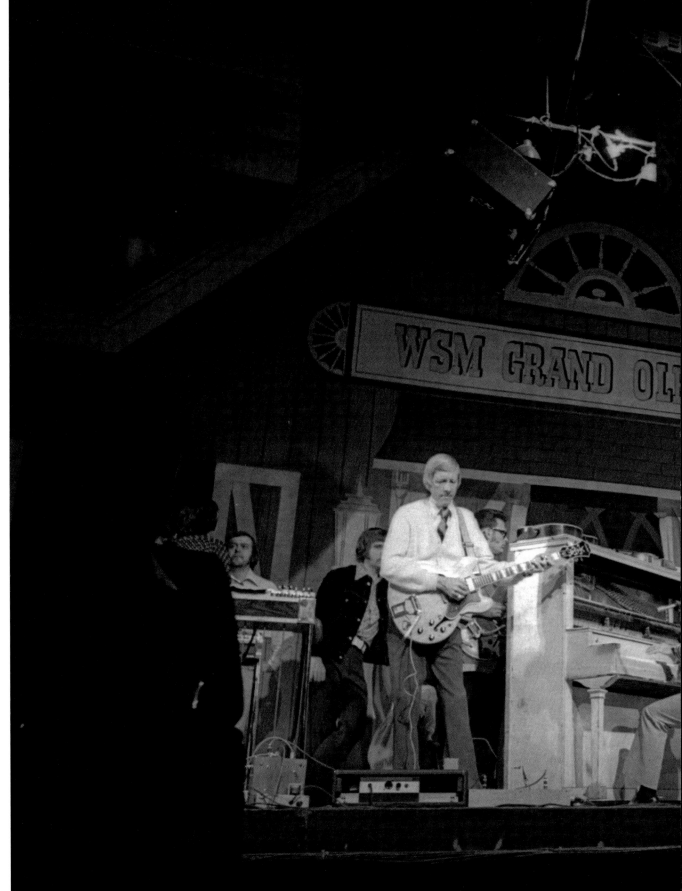

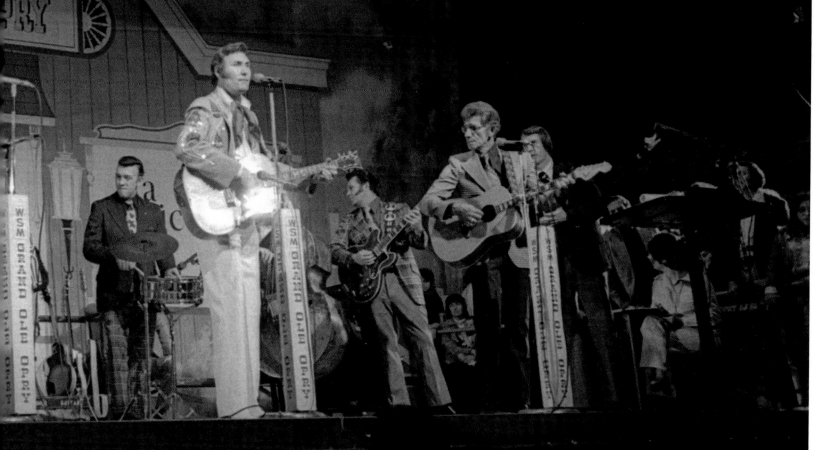

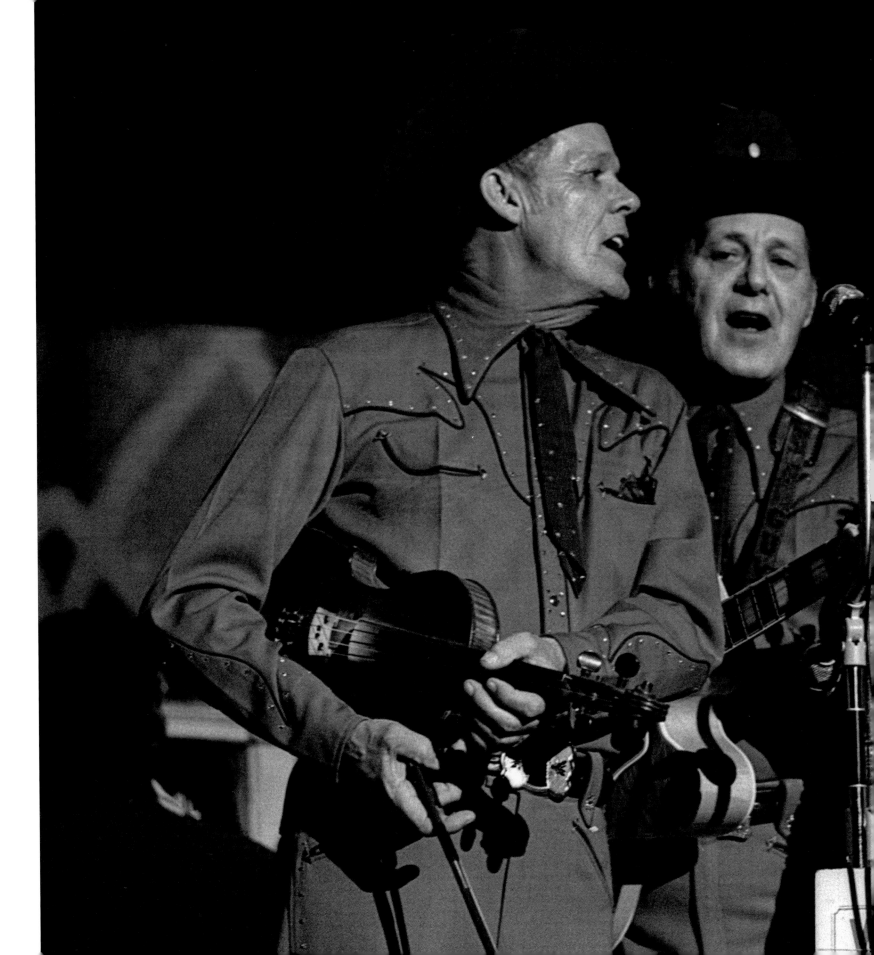

*The Willis Brothers*
Originally from Oklahoma, Skeeter, Guy, and Vic played everything from cowboy songs to gospel numbers to novelty tunes. Originally called the Oklahoma Wranglers, they had the distinction of backing up Hank Williams on his first recordings.

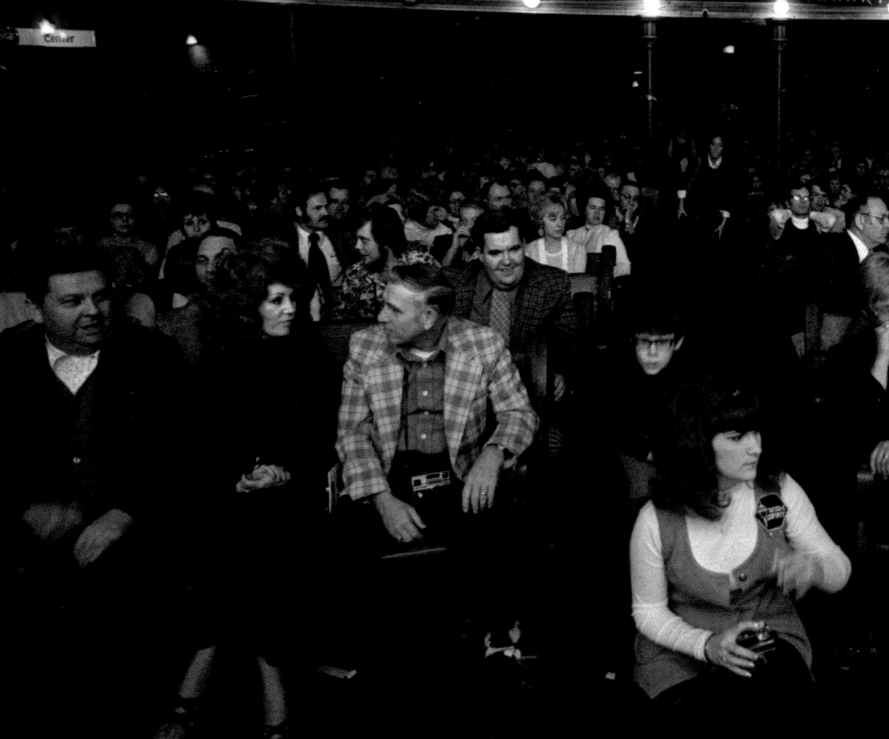

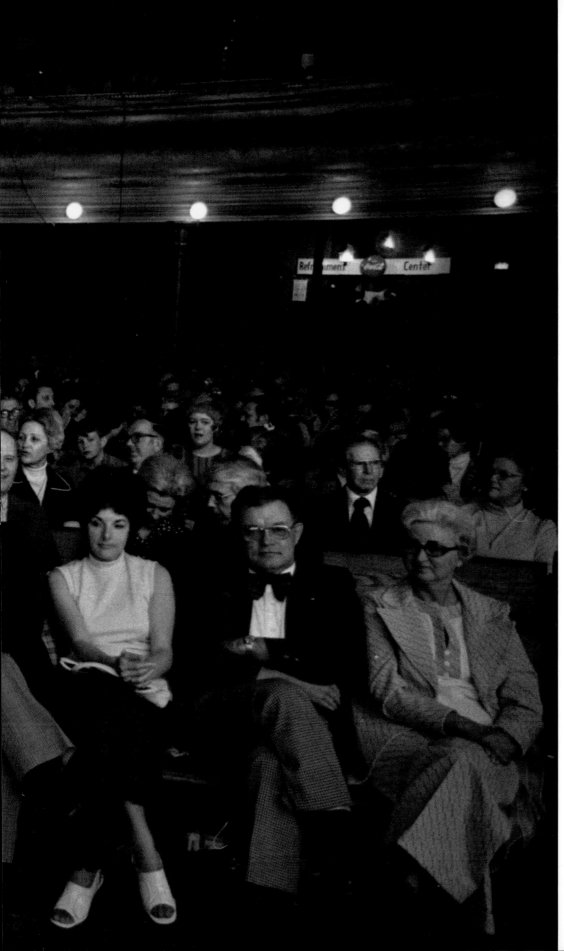

*Front Row Seats*
Fans with choice seats, front row
center, sit just a few feet from the
center of the stage. In front is an Opry
staff member, responsible for ushering
people to their reserved seats.

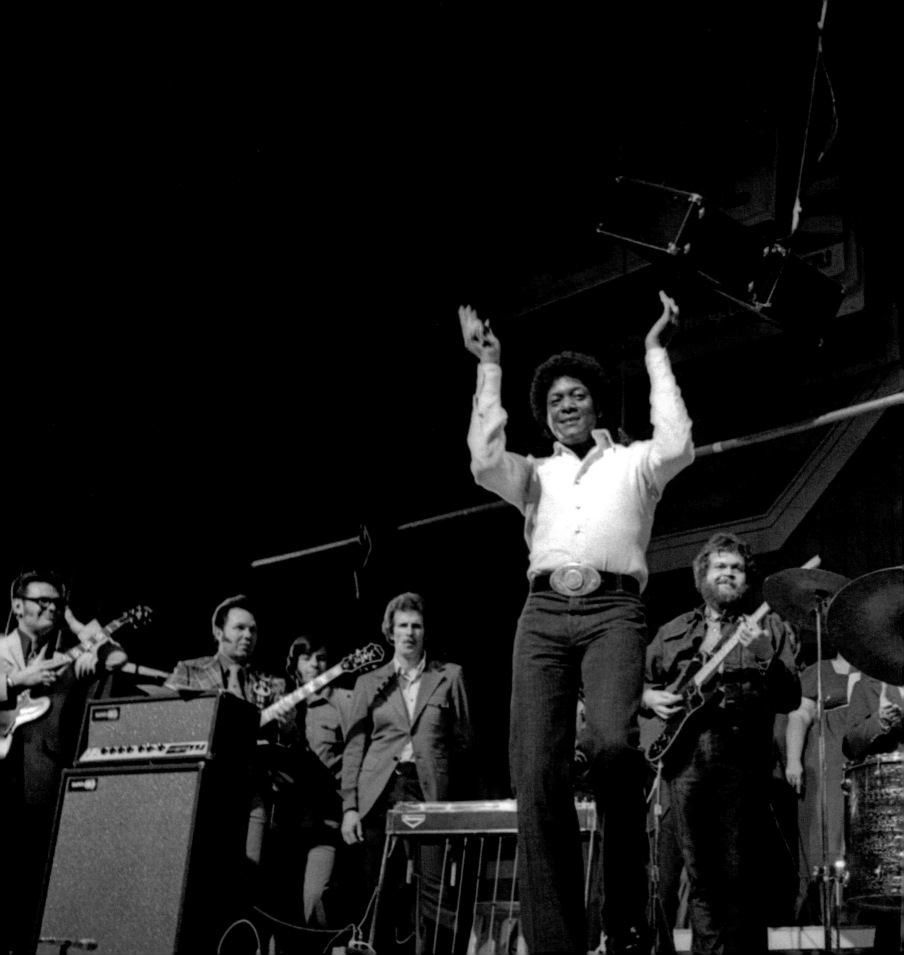

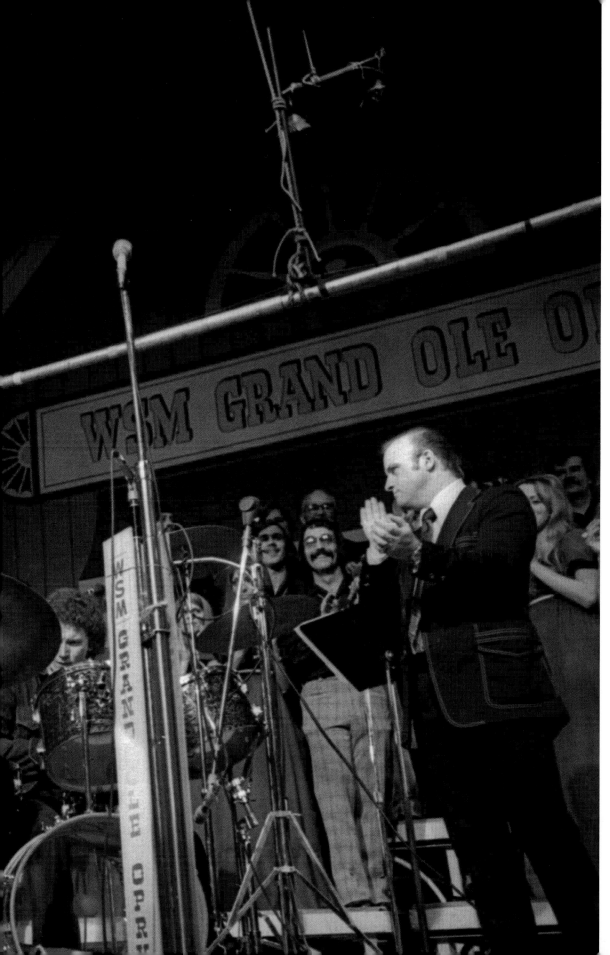

*Dobie Gray*

Born in 1940 into a family of sharecroppers near Houston, Texas, Dobie Gray grew up surrounded by Texas roots music from country to gospel to R&B. He moved from Texas to California in the 1960s and was mentored by Sonny Bono, who was head of A&R for Specialty Records. His first big hit was "The In Crowd" in 1965, but his signature song was "Drift Away," penned by Mentor Williams, a huge hit in 1973. Although a longtime resident of Nashville, he was never a member of the Opry but is seen here making a guest appearance on the Reverend Jimmie Snow's Gospel Hour just after the last regular Opry performance on the final night, March 15, 1974.

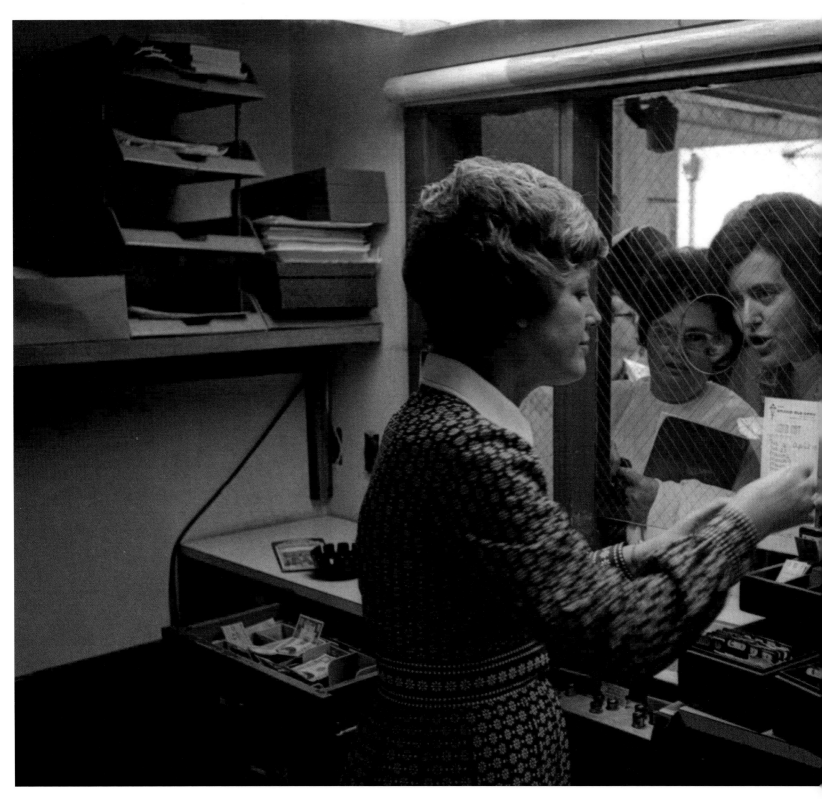

*Opry Tickets*

Many of the ladies who worked the Opry ticket booth were also full-time employees of the National Life and Accident Insurance Company, the Opry's parent company. Reserved tickets were sold out months in advance. Here, Jo Walker looks for tickets for a couple of fans. Jo still works for the Grand Ole Opry, watching over the backstage entrance at the Opry House and making sure that performers check in and get their dressing room assignments.

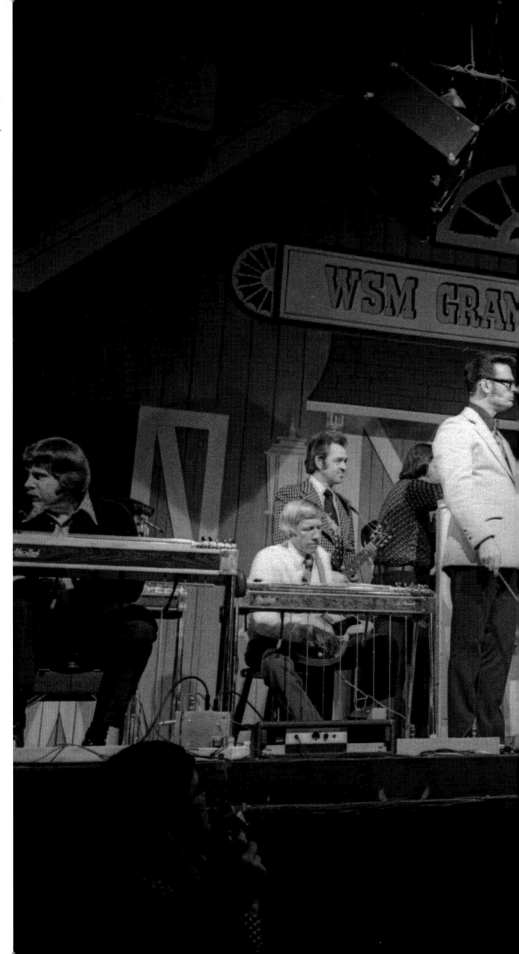

*Minnie*
On center-stage, Minnie Pearl tells one
of her beloved stories while Roy Acuff
looks on.

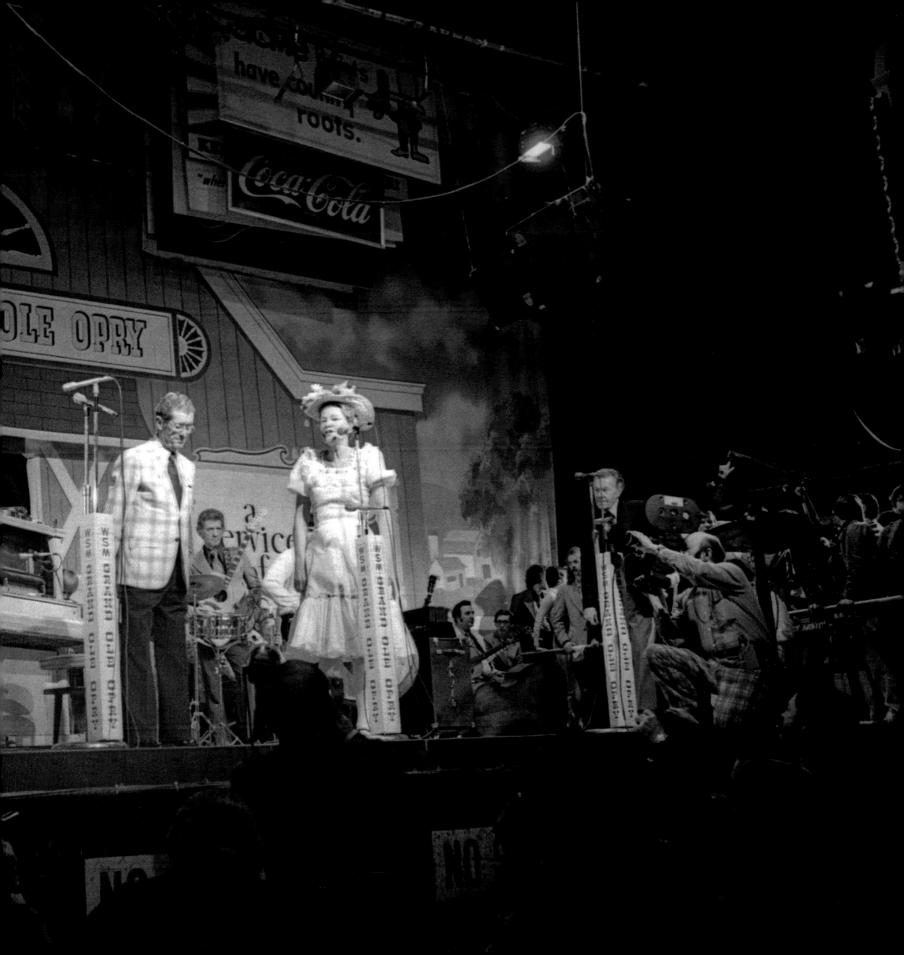

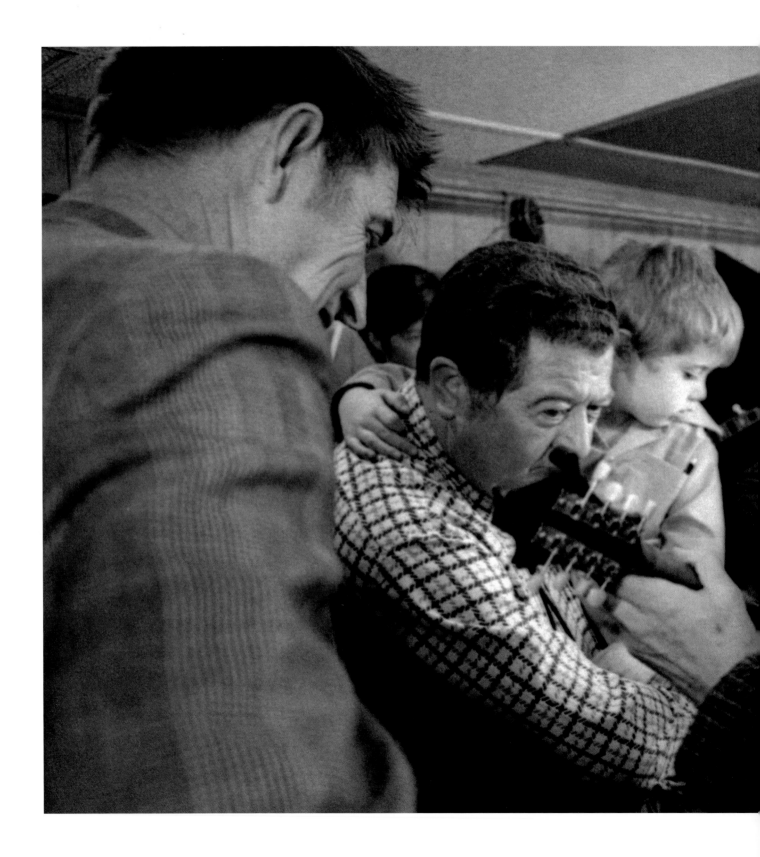

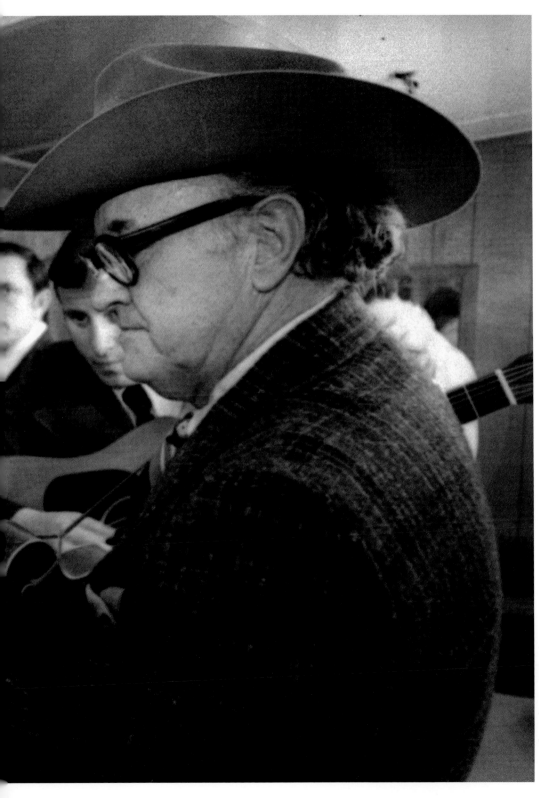

*Monroe Style*
Bill Monroe shows fiddle player Howdy Forrester a new song in Acuff's dressing room. Looking on is Dr. Perry Harris, who started the Grand Master Fiddler Championship and was a longtime friend of Mr. Acuff.

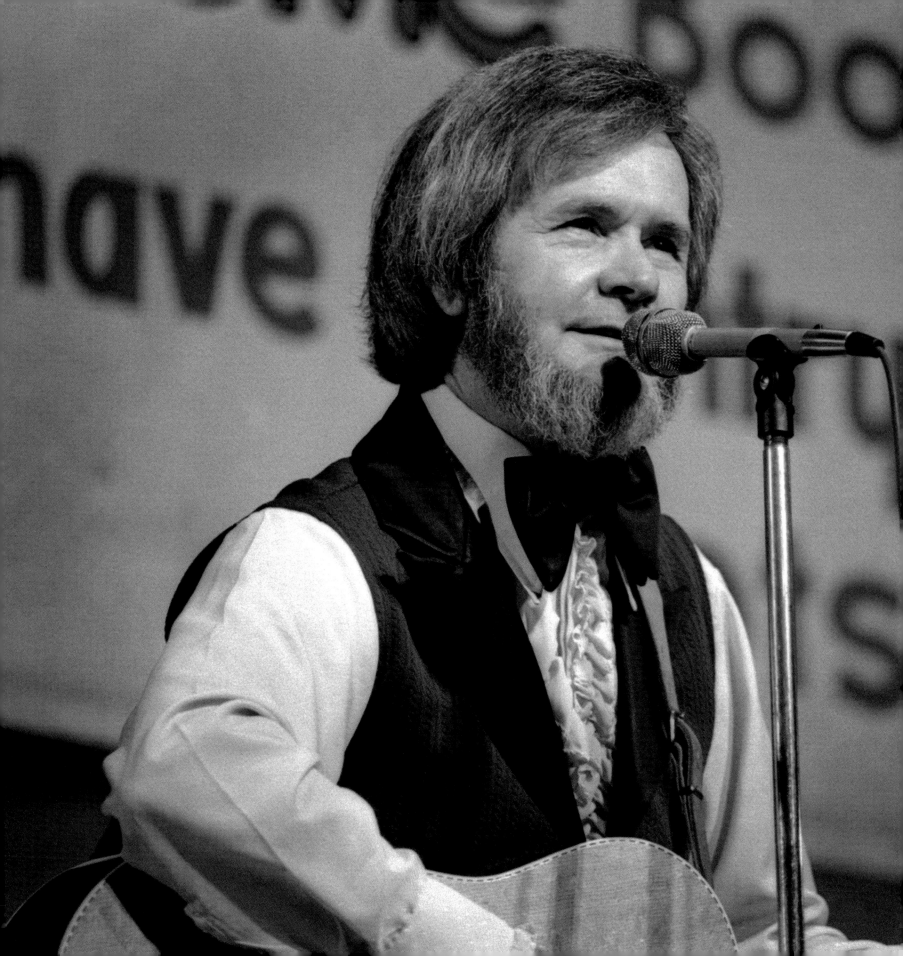

*Hank Locklin*
Originally from Florida, Hank is considered
to be one of the all-time finest tenor singers
in country music. He is also credited with
pioneering some of the first concept albums on
his long stint with RCA records in Nashville.

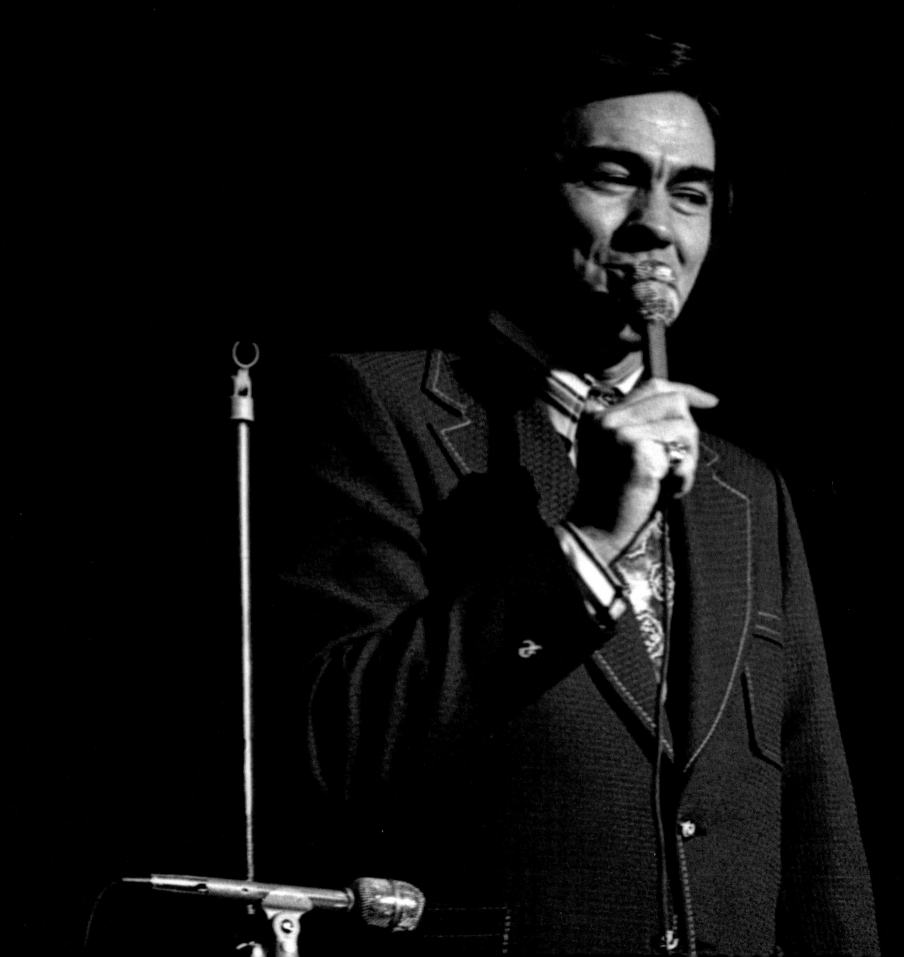

*Jim Ed Brown*

Jim Ed Brown began performing with his sisters, Maxine and Bonnie. Known as the Browns, they had several number-one records on the country charts in the late 1950s. When the sisters decided to quit the road, he continued as a solo performer and had several other female singing partners through the years, including the Cates Sisters and Helen Cornelius.

*Ryman Benches*
Fans take a break, relaxing on the benches in front of the Ryman on Fifth Avenue.

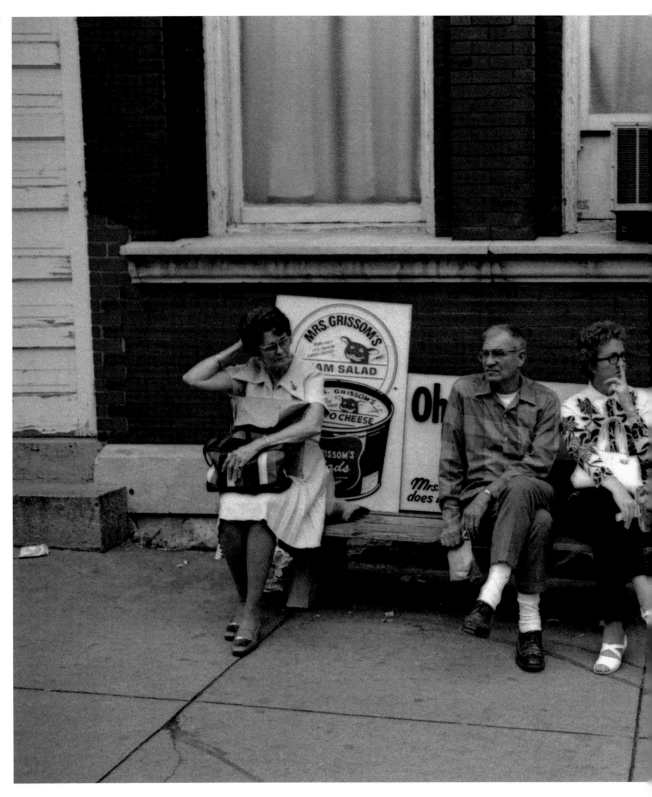

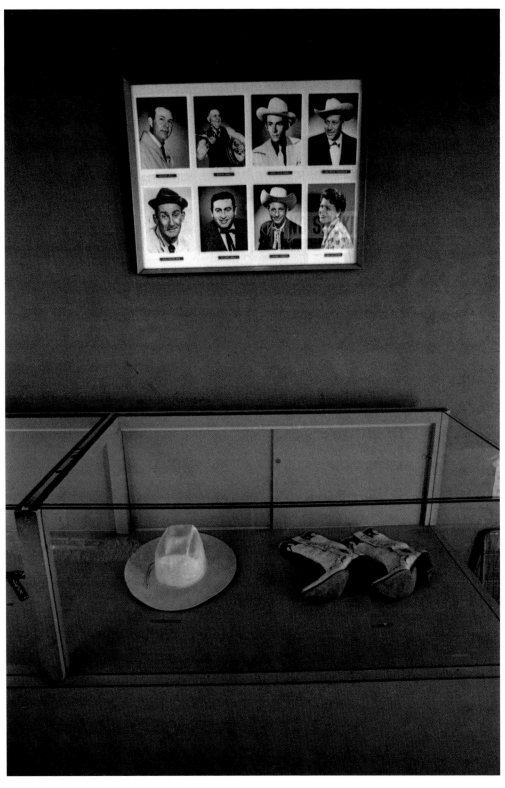

*Ryman Display*
This display case contains boots and a hat that belonged to Patsy Cline. On the wall are some of Opry photographer Les Leverett's black-and-white portraits of Opry stars who had passed away.

*Larry Gatlin*
A very popular star of the day, Larry did many solo shows. He also teamed with his brothers, Steve and Rudy, and the three together performed as the Gatlin Brothers.

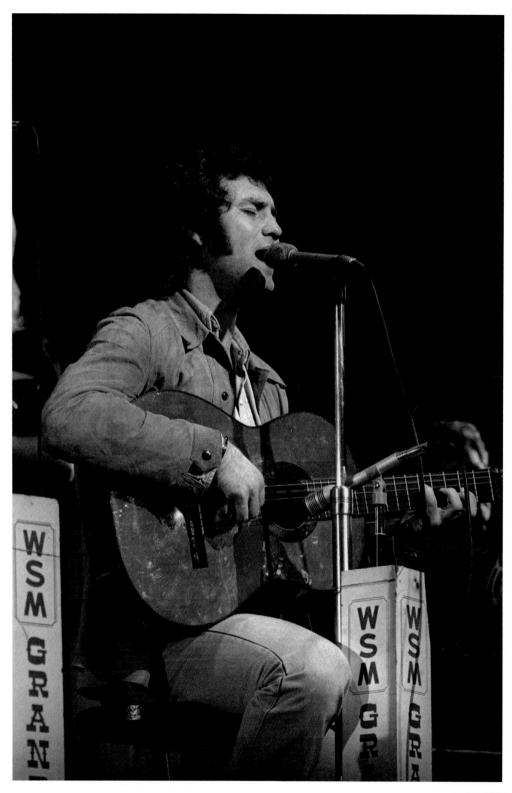

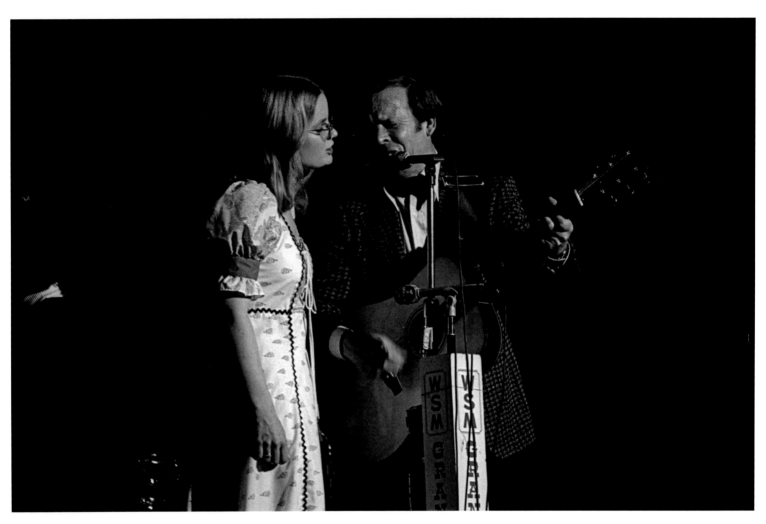

*Charlie Louvin*

For many years Charlie worked with his brother Ira. The Louvin Brothers made many classic country recordings and were known for their tight "brother" harmonies. They became Opry members in 1955. In 1965, Ira died in an accident and Charlie continued his career as a solo artist. Here he performs on the Ryman stage with Ira's daughter, Kathy.

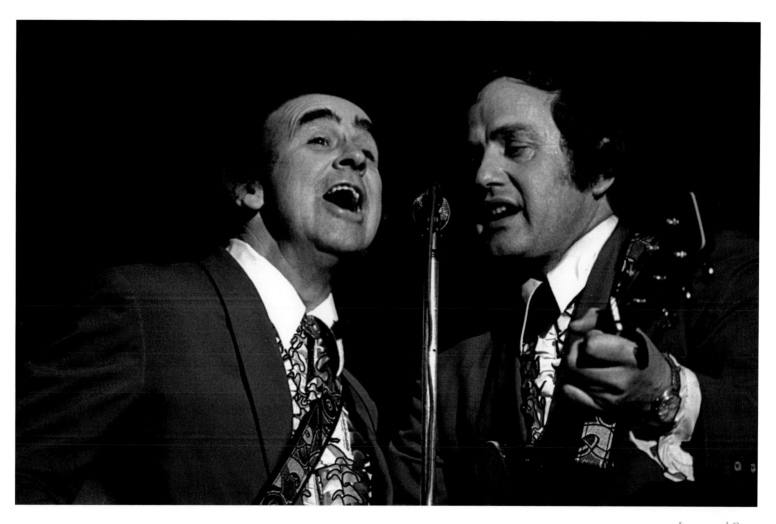

*Lonzo and Oscar*

Rollin Sullivan and Dave Hooten are their real names, but the fans knew them as Lonzo and Oscar. They were loved for their funny songs and quirky humor and had an extensive career in television and touring. Hooten was Sullivan's third "Lonzo" duet partner.

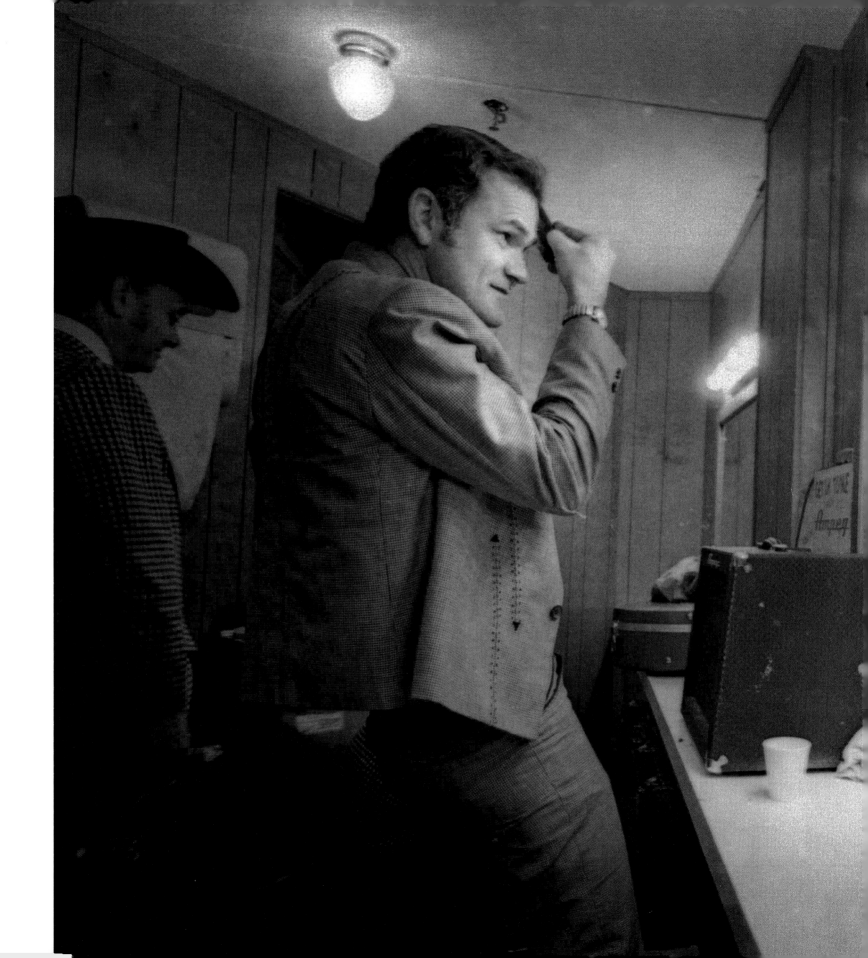

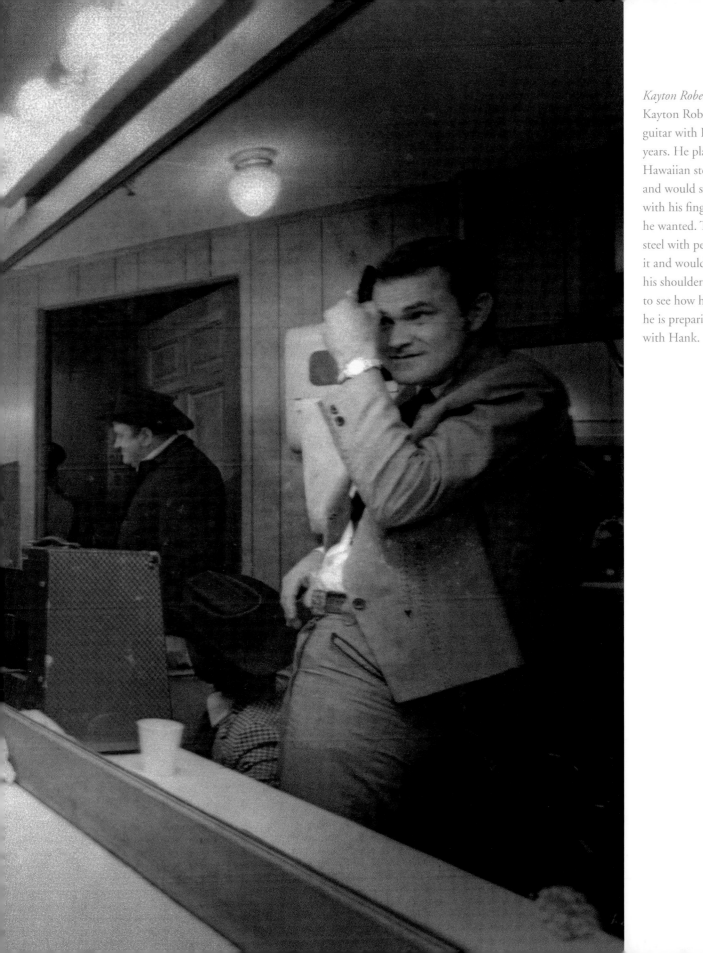

*Kayton Roberts*
Kayton Roberts played steel
guitar with Hank Snow for many
years. He played the old-style
Hawaiian steel without pedals
and would stretch the strings
with his fingers to bend the notes
he wanted. The guys who played
steel with pedals couldn't believe
it and would stand and look over
his shoulder when he was onstage
to see how he was doing it. Here
he is preparing to go onstage
with Hank.

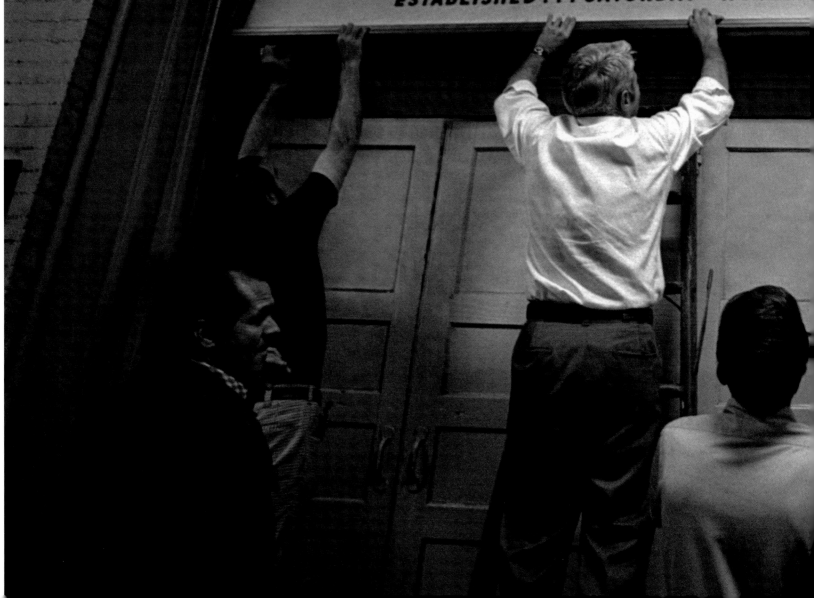

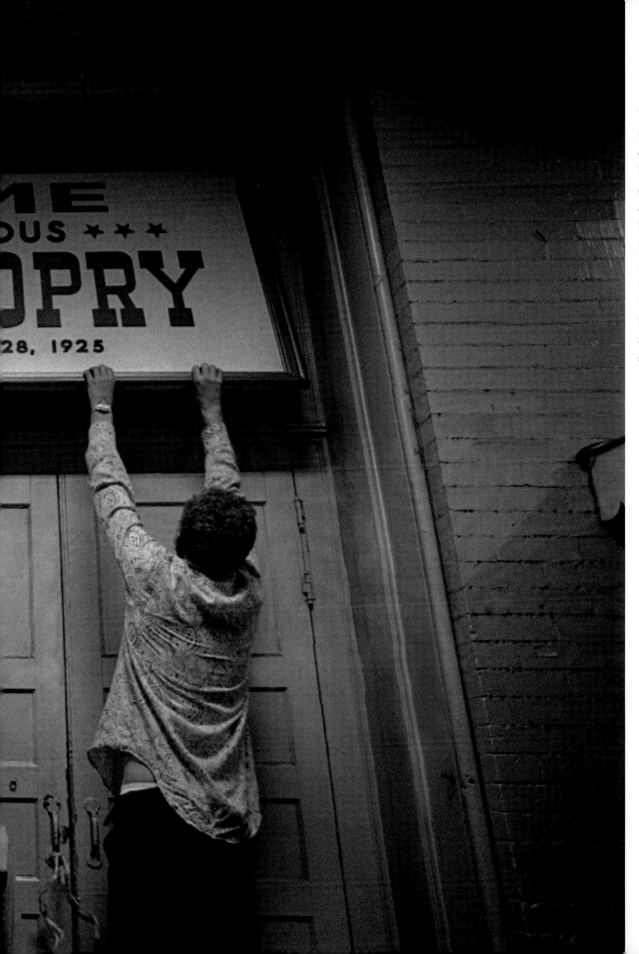

*Taking Down the Welcome*
When the music faded from the stage on that final night, no one knew quite what to expect. It was historic. There was concern that the fans would go crazy and begin destroying the building in search of bits of the Ryman and a piece of country music history to take with them. But it didn't happen. Here the stagehands remove the welcome sign over the Fifth Avenue entrance just minutes after the last notes rang out.

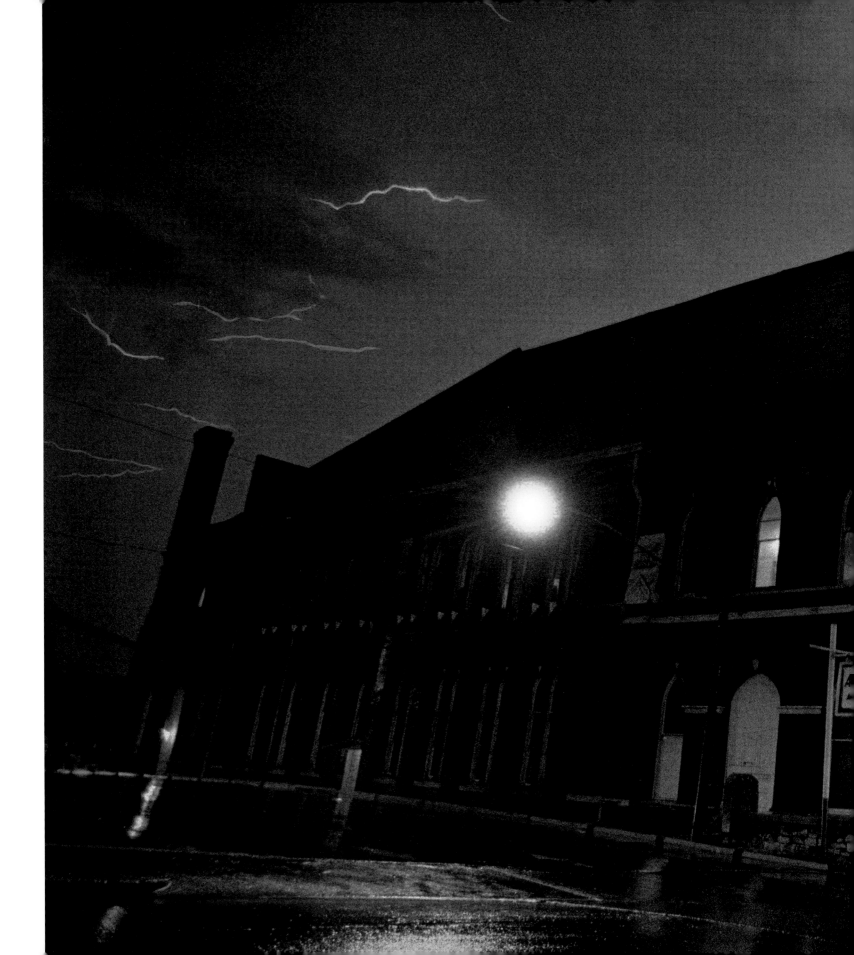

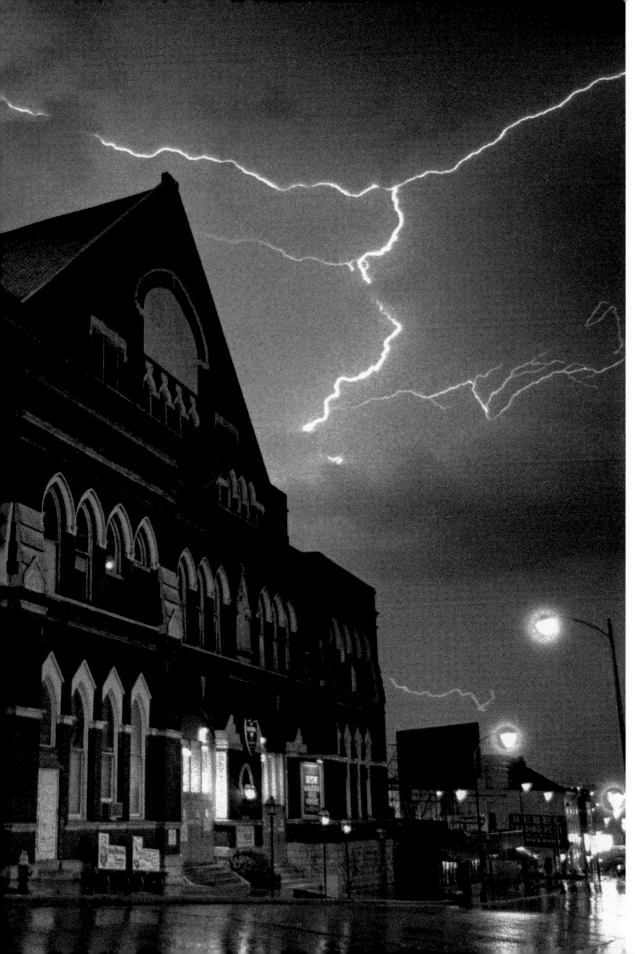

*End of an Era*
The idea for this shot came to me shortly after I got the word that the Ryman might be torn down. For the better part of a year, every time there was a thunderstorm, I would drive down to the deserted building with this image in mind. And one night I got lucky. The photograph was shot in a thunderstorm with a Nikon F, 35mm camera and Tri-X film, with camera resting on the open window sill of my 1955 Buick. Three of the best seconds of my life.

# Notes on the Photographs

These notes, listed by page number, attempt to include all aspects known of the photographs. Each of the photographs is identified by the page number, photograph's title or description, photographer and collection, archive, and call or box number when applicable. Although every attempt was made to collect all available data, in some cases complete data was unavailable due to the age and condition of some of the photographs and records.